Drawing and Painting

Materials and Techniques for Contemporary Artists

Thames & Hudson

Cover image credits
Front cover: Angela A'Court, photographed by Ty Cole
Back cover: Neal Grundy

First published in hardback in 2015
by Thames & Hudson Ltd.
181A High Holborn, London WC1V 7QX

This paperback edition first published in 2017

Copyright © 2015 RotoVision SA

Publisher: Mark Searle
Commissioning Editor: Jacqueline Ford
Editor: Angela Koo
Assistant Editor: Tamsin Richardson
Art Director: Lucy Smith
Design: JC Lanaway
Photography: Neal Grundy

Text and sourcing of images by Kate Wilson,
except Chapter 8 (Simon Laurie RSW RGI), Chapter 10 (Eleanor White),
Chapters 13 and 15 (Simon Burder), and Chapter 14 (Alison Harper).

Other contributing authors: Philip Archer,
Martin Beek, Chris Hough, and Marion Thomson.

British Library Cataloguing-in-Publication Data
A catalogue record for this book is available from the British Library.

ISBN: 978-0-500-29316-4

Printed and bound in China

To find out about all our publications, please visit
www.thamesandhudson.com. There you can subscribe
to our e-newsletter, browse or download our current
catalogue, and buy any titles that are in print.

Acknowledgements

Thank you to all of the artists who generously allowed their work to be
reproduced, and the galleries who have been kind enough to source and
provide images: Susan Swenson (Pierogi Gallery); Julia Wunderlich (Hauser
and Wirth); Kate Perutz (White Cube); Chloe Barter and Harriet Mitchell
(Gagosian Gallery); Jennifer Gilbert (Pallant House); Hope Dickens
(David Zwirner Gallery); Edwige Cochois (Greengrassi); Dennis Kimmerich
(Kimmerich Gallery); Toby Clarke and Pia Austin-Little (Vigo Gallery); Julia
Loeschl and Matthias Bildstein (Georg Kargl Fine Arts); Sue Hopper on behalf
of Paula Rego RA, and Mary Miller, Frankie Rossi and Tabitha Philpott-Kent
(Marlborough Fine Art); Kristin North and Gregory la Rico (Lehmann Maupin);
Asya Geisburg (Asya Geisberg Gallery); Lori Sottile and George Krevsky
(George Krevsky Gallery); Eva Coster (Grimm Gallery); Stuart Morrison (Hales
Gallery); Celia Irvin on behalf of Albert Irvin RA, and Lukas Gimpel (Gimpel Fils);
Andrea Harari (jaggedart); Catherine Belloy (Marian Goodman Gallery); Edna
Battye (Chappel Galleries); Lee Welch (Kerlin Gallery); Nadine van der Vlies
and Debbie Broekers (Annet Gelink Gallery); Philip Ennik (Betty Cuningham
Gallery); Alex Goodman and Brian Pinkley on behalf of Kehinde Wiley; Carol
Tee (Messums Gallery); Erika Davis-Klemm (Davis Klemm Gallery); Carrie Plitt
(Canongate Publications); Jessica O'Farrell (Pilar Corrias); Hélène Trintignan
(Galerie Hélène Trintignan); the Jessica Silverman Gallery; Alexandra Giniger
for Wangechi Mutu; Michael Richardson (Artspace Gallery) for Paul Gopal-
Chowdhury; Gareth Wardell on behalf of Barbara Rae CBE RA RE; Lauren Licata
(Mike Weiss Gallery); and Koulla Xinisteris.

Thank you to all the artists, educators, friends and colleagues who have
provided encouragement, advice and content. I'd like to thank in particular:
Simon Burder, Martin Beek, Alison Harper, Marion Thomson, Philip Archer,
Eleanor White, Chris Hough, Simon Laurie, Marie-Anne Mancio, Frances Hatch,
Jill Evans, Susan Absolon, Oliver Bevan, Helen Berggruen, Caia Henderson,
Anne Booth, Pamela Clegg, Joanne Haywood, Rachel Carlyle, Cass Breen and
my daughters Lizzie and Esther. I'd also like to acknowledge the support of
the City Lit in London, Leith School of Art, Bridge House Art and the Essential
School of Painting.

It's been a pleasure to work on this project with everyone at RotoVision –
particularly with Isheeta Mustafi, Lucy Smith, Neal Grundy and Tamsin
Richardson. Thank you, too, to Jane Lanaway, for her design work. A special
thank you goes to my editor, Angela Koo, for her calm and sensible advice.
Finally, I'd like to thank my family for their love and support.

Contents

DRAWING MATERIALS AND TECHNIQUES

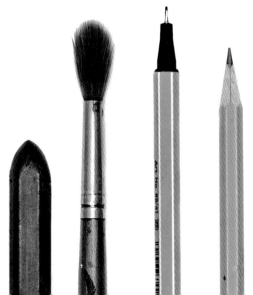

2

PAINTING MATERIALS AND TECHNIQUES

3

THE BIGGER PICTURE

FOREWORD

WITH THE ADVENT OF POSTMODERNISM in the 1960s, the preciousness of the artist's hand – their mark (that modernist proof of authenticity) – was disputed. Artists quoted their predecessors in playful riffs on the original. For a while, concept predominated; art historians looked to the 'frame', the context – sometimes at the expense of discussing the materiality of the work itself. The challenge of the information age has since been embraced, evidenced by a plethora of works inspired by social networking, internet searches, pixellation, even Second Life; some existing solely online. Manfred Mohr was one of the digital art pioneers, shifting from Abstract Expressionism to computer-generated algorithmic geometry.

As I write, we are still witnessing the consequences of the collapse of neo-liberal economics on art practice. The ensuing 'recessional aesthetics' are manifested in the proliferation of community-driven models and art activism (see artist James Bridle, who creates installations comprising computer-generated outlines of drones and who also self-identifies as an activist). These encouraged a reinterpretation of the definition of 'materials' and a re-examination of their potential for social change. Given the nature of much contemporary practice, then, what is the role of a book on materials?

On a purely practical level, it facilitates knowledge sharing around working with both traditional (pencil, oil, acrylic, watercolour, canvas, paper, board, wax) and non-traditional materials. The emphasis on critical theory in art schools has sometimes overshadowed the acquisition of what were once considered fundamental skills like life-drawing or colour mixing. (Jonathan Delafield Cook's detailed charcoal drawings could be read as a renewed celebration of technique.) This knowledge-sharing is timely: a further consequence of recessional aesthetics was the 'return to craft', and hence 'making', often through labour-intensive processes, with materials sometimes chosen for their availability or, as in the case of Jen Stark's innovations with paper, their affordability. It also comes at a time when art historians are re-evaluating the object once more.

Secondly, despite the tedious rehearsal of the 'Painting is dead, long live painting' routine, painting is popular again. Whether an artist working with traditional materials in a traditional way – Jan De Vliegher's illusionistic plates, painterly blossoms, gardens and chandeliers – can still be considered contemporary is contentious. But contemporary artists have clearly not stopped experimenting, often deploying materials for their connotations: note the fur and glitter and magazine clippings of Wangechi Mutu's collages, or the plasticine, coconut oil and rubber of Ellen Gallagher's; Raqib Shaw's embossed gold outlines recall techniques used in early Asian pottery; Diane Victor's portraits in smoke emphasise the ephemeral nature and vulnerability of the depicted disappeared; Zheng Chongbin manipulates ink in a traditional and radical way, referencing late fifth-century Chinese artist-theorist Xie He; Wendy Elia deliberately makes portraits in oil paint rather than acrylic to query the genre's traditional association with the white upper classes.

If all these artists teach us anything, it is that ultimately, base material is there to be transformed, made to resonate. Whether this happens by chance or after decades of concerted experiments, there is nothing mundane about this process. For, as romantic as it sounds, isn't the artist also always the alchemist?

MARIE-ANNE MANCIO

INTRODUCTION

'VE LONG BEEN INTERESTED in how art materials work. I remember a project at school where we were asked to make a painting, experimenting with food found in the kitchen cupboard and earth from the garden to mix up paint. I also fell in love with that delightful fifteenth-century manual, *Il Libro dell'Arte* by Cennino Cennini, who talks of going out with his father, digging yellow ochre out of the ground, grinding it up and mixing it with egg yolk.

Mastery of the craft will not make you into a great artist, but having a feel for materials does seem to be part of the creative process. The artists featured in this book often talk about the appropriateness of the chosen medium to their idea. Many, when questioned, reveal a personal affinity with the material, and clearly enjoy its physical and tactile qualities. Some would even argue that it is the material that helps them to think in new ways.

In Cennino's world, painting is a craft – a series of recipes and instructions that, if followed, will give a perfect result. I now realise that no book can really teach you how to make art. But I, and the many contributors to this publication, do hope that this one offers some clues to the work you might make, and encourages you to experiment with a variety of media and try out a range of approaches to your subject matter. We aim to give you technical information and inspiration related to current fine art practice and, because many artists now use iPads alongside traditional media, have inserted Digital Options boxes to introduce you to digital drawing and painting tools and the ways in which they can be used.

As an artist and teacher, I have read quite a bit of conflicting information about which materials are and are not intrinsically unstable, and which ways of working will promote longevity. Generally, artists and buyers expect that their paintings will outlast them, and some may hope that they will still exist in a few hundred years' time. We also know that nothing lasts forever. Even if we keep rigidly to all the rules – and conservators say that artists are very likely to break them – every type of paint and surface has some drawback. Oil and alkyd paint and resins become yellow and brittle; acrylic and wax are difficult to clean and may attract dirt; works on paper fade in daylight and are very susceptible to wear and tear. All deteriorate in damp conditions, extremes of temperature and with severe handling.

So while it is sensible to be aware that some materials are unstable, the pursuit of longevity is not this book's main aim. Indeed, too much emphasis on safe methods could mar the work. In this matter, I take courage from the words of Anselm Kiefer, whose monumental multimedia paintings are deliberately made to be vulnerable, and to decay and change over time.

Maybe a work is only finished when it's ruined, no?

KATE WILSON

Right: Sprache der Vogel.
Oil, acrylic, salt, brick, mortar, aluminium and steel on canvas, by Anselm Kiefer.

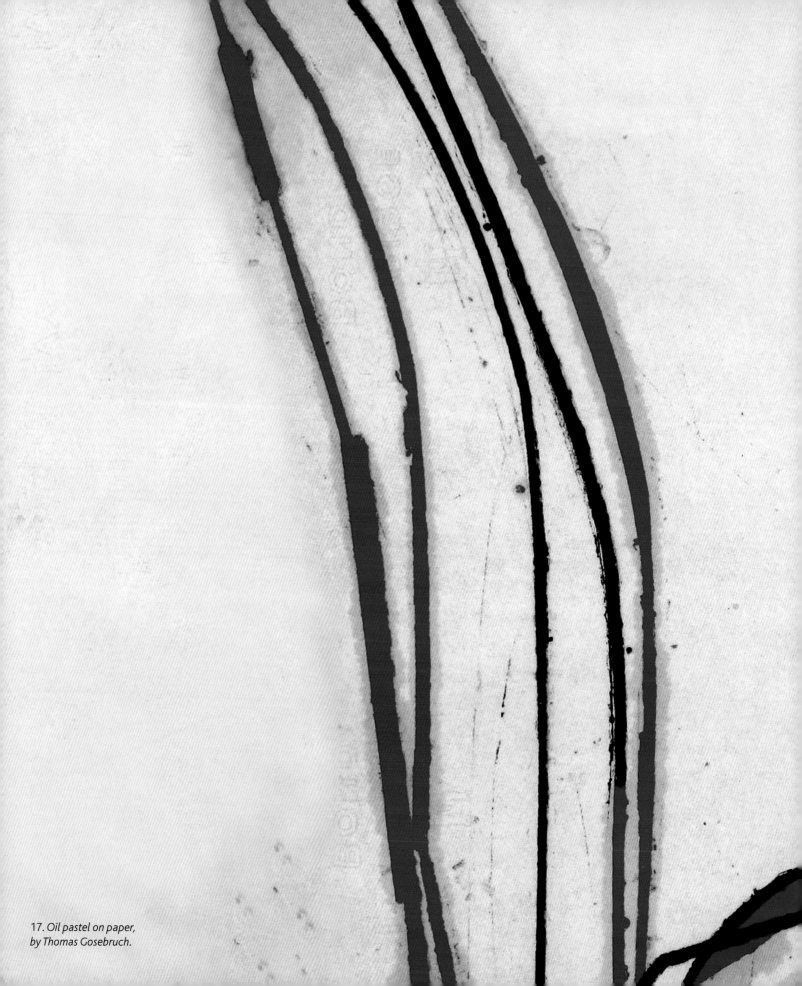

17. *Oil pastel on paper,*
by Thomas Gosebruch.

1

DRAWING MATERIALS AND TECHNIQUES

Chapter One
PENCIL

OVERVIEW

Graphite is generally considered to be a kindly medium. This is because we are all familiar with pencils. We have drawn with them from childhood and continue to use them to jot down words – notes by the telephone, scribbled instructions and diagrams, as well as sketches and finished drawings. Because pencil can be erased easily, it is also forgiving of mistakes.

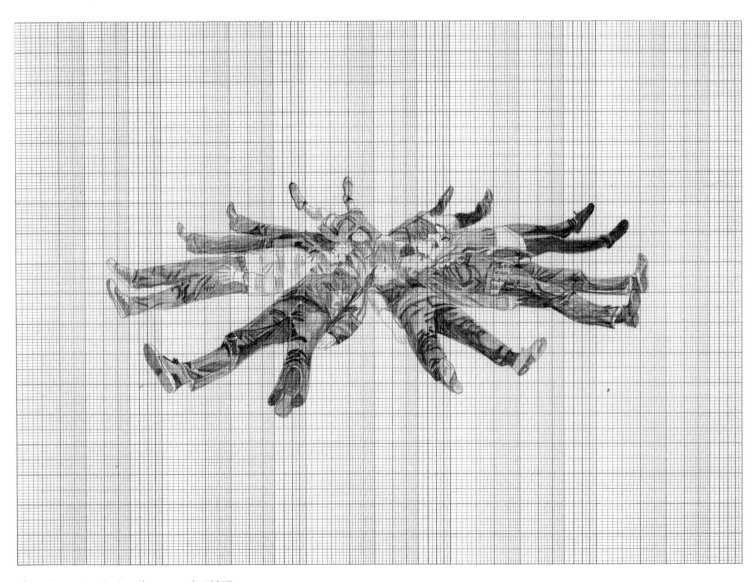

Above: Formation 1g. *Pencil on paper, by Abbi Torrance.*

A graphite drawing can be a good place to start. A sketchbook and a pencil provide a safe and private way to record and explore ideas. All you need is a good all-rounder, such as a 2B, a sharpener and maybe an eraser. Colour can be added easily with a few coloured pencils, with no need for painting skills and the expense and mess of other materials.

Pencil drawings can also be works in their own right. In the past, graphite was mainly considered a preparatory medium – sketches and drawings were of interest because they revealed the intimate thought processes behind a finished painting or sculpture. But a more recent questioning of the perceived superiority of painting, and a re-evaluation of what a 'finished' piece should look like, have resulted in some artists adopting pencil as their medium of choice.

Drawings can be small and intimate, like Abbi Torrance's works on graph paper (left), or enormous, like Daniel Zeller's wall pieces (pp.22–23). The fragility of pencil on paper can also be used as a means of expression, as for Toba Khedoori (see p.212) or Kathy Prendergast (pp.231 and 238). Its association with technical and architectural drawing has led artists such as Paul Noble (p.222) and Torsten Slama (below) to see its potential to conjure up imaginary worlds.

Pencil marks range from thin, hard and pale to dark, wide and shiny. Compare Marion Thomson's continuous line with Liam O'Connor's worked and reworked surfaces (p.25) and Peter White's dark tones (p.24). Rubbings can be taken, and graphite powder can be dropped into glue or paint to build up a tactile quality, or mixed with oil and resin, as with Christopher Cook's work (p.98). Drawings can also be made solely using coloured pencils, as Tomma Abts (p.24) has done, or combined with graphite and other materials, as in the work of Norimitsu Kokubo (p.223) and Mark Cazalet (p.91).

Digital options: THE PENCIL TOOL

Advantages

- The Pencil tool allows for subtle modifications of tone; the line can be richly black, or a more subtle grey or blue.
- With the Eraser tool, it is possible to cut through to underlying layers of tone or texture – which cannot be done with pencil on paper.
- One great advantage over a paper sketchbook is the facility to zoom in or out, allowing you to work finely in some areas, and leave others free of marks.

Disadvantages

- You may miss the resistance of different weights and qualities of paper.
- A stylus or a finger is shorter than a regular pencil, which can, on occasion, limit the type of mark that can be made.
- If working outside, the glare from sunlight can make it hard to see subtleties on a screen.

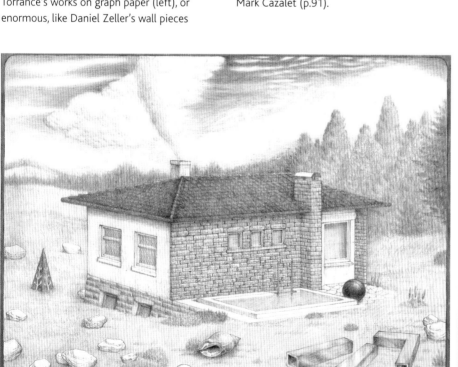

Above: Bungalow for the Magician. *Coloured pencil on paper, by Torsten Slama.*

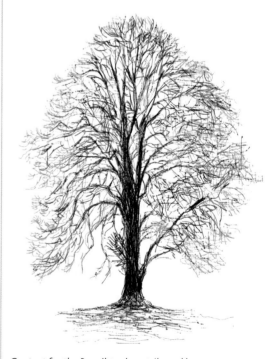

Content for the Pencil tool contributed by MARTIN BEEK.

TOOLS AND SUPPORTS

Graphite pencils

Graphite, a form of carbon, is mixed with clay, water and glue and cooked in a kiln to harden. The resulting 'lead' is usually encased in wood, but pencil casings are also made from paper, plastic and metal. It is variations in the recipe of ingredients and the ratio of graphite to clay that give each pencil its relative hardness (H–6H) or softness (B–6B) and result in slight differences between makes.

Graphite pencils

Propelling pencil

Watercolour pencils

Watercolour pencils

These are slightly softer than normal coloured pencils and can be dissolved in water to give an opaque wash.

Powdered graphite

Powdered graphite

Graphite can be bought in powdered form and sprinkled, rubbed or dusted on the surface of a drawing.

Sharpener

Craft knife

Graphite sticks

These thicker sticks are formed in a mould, and hold together without the support of a wooden structure. They come in a range of thicknesses and softnesses: 6H–12B.

Graphite sticks

Surfaces

It is possible to draw in pencil on any kind of paper, but if permanence is an issue, you should choose an acid-free paper. Pencil can also be used to draw with on primed or unprimed canvas, and into or on top of all types of paint. For large-scale drawings, cartridge paper in different weights can be bought on a roll. For more on surfaces see pp.94–101.

Pencil sharpeners

Pencil sharpeners sharpen quickly, but the point of a pencil cut with a knife will last longer.

Putty eraser *Plastic eraser*

Coloured pencils

Coloured pencils are made from mixtures of waxes, clay/kaolin and pigment. They are not cooked, as this would destroy the colour, and so are generally softer. Because they are used by children, there are limitations put on the types of pigment that can be used. As a result, colourfastness can be an issue and, as with all materials, it is worth buying artist's pencils as these are less likely to fade.

Coloured pencils

Erasers

Plastic erasers are very efficient at erasing graphite cleanly without smudging. They are firm to draw with and can be cut up into smaller sections for erasing detail. Putty erasers are also useful for removing small areas of white as they can be moulded to a point. They should be warmed in the hand and well kneaded or they will smudge the surface.

Techniques
PENCIL BASICS

If you are new to drawing, you may be surprised to find that you experience fear when using such a familiar medium. The main thing to be conscious of is that any material must be used strongly and bravely. The fact that pencil can be rubbed out can make us too quick to erase, and the need to produce the perfect image can make us hesitant. Different types of pencil will make you feel and draw differently. Try to exploit these differences and use a type of pencil and way of working that gives you courage.

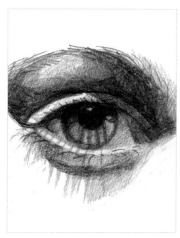

Line drawing using a sharp 6H pencil
The hard pencil means that lines are sharp and pale, with little variation in tone. The need to press hard to make a mark, and the resulting incised lines, mean that the drawing has a certain intensity. It is possible here to indulge a longing for detail and accuracy. If mistakes are made, the whole drawing can be rubbed back with an eraser and redrawn.

Line drawing using a thick 7B graphite stick
A thick graphite stick cannot be held like a pencil – a drawing must be worked with the whole arm, and the hand cannot rest on the paper. A graphite stick is also much blunter and less accurate, so you may find yourself working more broadly, enjoying the exaggeration that the material brings. An eraser was used to rub back between the branches.

Tonal drawing using cross-hatching: 6H pencil
Tone is built in blocks from light to dark using evenly spaced overlaid lines, first one way and then the other. The tone is darkened by increasing the number of layers and drawing the lines closer together. This gives a 'cool', crisp, technical effect, reminiscent of an engraving or etching.

Tonal drawing using shading: 6B pencil
Tone here has been built in blocks from light to dark. There is little or no texture. The 6B pencil gives a good strong range of tone, from pale grey to intense shiny black.

Artist's tips

- Try building your drawing from pale to dark, drawing lightly and quickly at first, then working into it more firmly as you become more confident. **(A)**

- Aim to create several drawings rather than just the one.

- Try *drawing* with an eraser rather than simply using it to rub out. Cut it up into smaller sections to get a sharp line. **(B)**

- When working with a soft pencil, shield your drawing from smudging by placing a second piece of paper under your hand.

- Try holding your pencil at arm's length, and between thumb and forefinger, rather than against your second finger, as when writing. **(C, D)**

- Experiment with scale. Try working larger on an easel or wall. **(E)**

- If your drawing becomes dull and overworked, rub it back with an eraser using bold, diagonal strokes and then work back over the top.

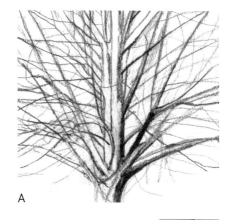

A

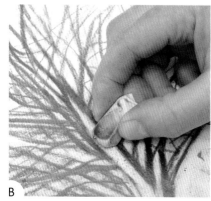

B

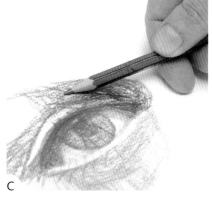

C

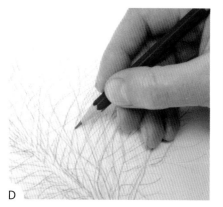

D

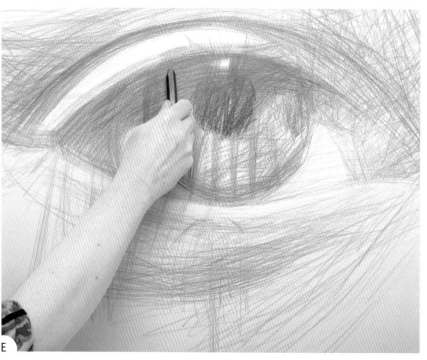

E

Techniques
TRACING AND USING COLOUR

Graphite pencils are great for tracing source material and taking rubbings to transfer textures from one surface to another. Twentieth-century artists such as Max Ernst and Andy Warhol used these simple methods to explore new ways of developing imagery, and tracing is still much used by artists today to extract strong, simplified shapes from photographs.

Coloured pencils provide an easy way to add colour, and their associations with childhood can encourage a sense of play. Different hues and tints can be overlapped to give optical effects, and watercolour pencils can be dissolved to give a simple wash. They can give intense colour contrasts if drawn with strongly.

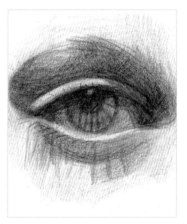

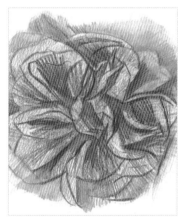

Traced line drawing using a 2B pencil
Tracing results in the sort of clean, accurate line found in advertising and technical drawing, and is a good way of simplifying from photographs and sketches. Here it allowed the addition of all the complicated detail that could not be seen when drawing from observation.

Collaged drawing using rubbings with a 4B pencil
Graphite is perfect for taking rubbings from surfaces. Here, textured papers of different tonal values were made from a plank of wood and a barbeque grill, using a soft pencil. They were then cut up and reassembled. This is a good way of simplifying and moving away from observational drawing.

Tonal drawing made using coloured pencil
A drawing like this begins with the lightest colour – in this case, orange. Once this is established, the drawing is continued in the darker colours – here, green and then purple. Finally some black was added to complete the tonal range.

Watercolour pencil with water washes
Softer and creamier than an ordinary coloured pencil, a watercolour pencil creates a drawing that can be dissolved in water, giving a pleasing softening of the line and a slight wash. Washes tend to be tints – less transparent than pure watercolour – but the ability to combine line and brush easily is useful.

Artist's tips

- Take tracings from photos, magazines and your own drawings as they develop. Trace directly from the computer screen or tablet to save printing out the image. **(A)**

- Transfer the image to new surfaces. Turn the tracing over and draw back over the lines in soft graphite or watercolour pencil. When this is placed right side up on a second sheet of paper and the lines are drawn over again, the image is transferred. Alternatively, use carbon (graphite) paper. **(B)**

- Experiment with taking rubbings from different surfaces on different sorts of paper. You will need thin cartridge paper and a fairly soft pencil (2B–6B) or graphite stick. **(C)**

- Try rubbing graphite powder into different surfaces; drop it into glue or paint. **(D)**

- A watercolour pencil drawing can be dissolved by brushing gently with water. **(E)**

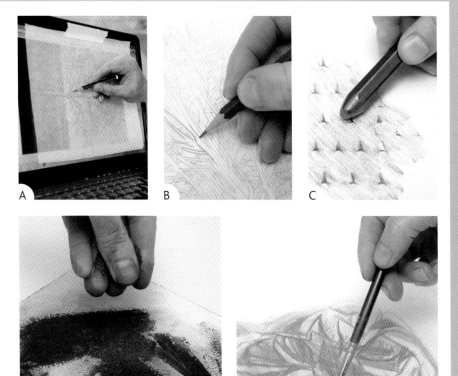

A B C

D E

Digital options:
TRACING

Advantages

- Many apps offer the use of overlapping layers. This is like working on multiple sheets of tracing paper or acetate overlaying one another.
- Drawings and photos can be easily imported into a new composition and used as a template.
- Tools such as the Find Edges tool in Photoshop will quickly convert a photo or tonal drawing or painting into a line drawing, saving time on tracing.
- Drawings can be projected or even printed directly on to larger canvases or paper without the need for complex squaring up or scaling.

Content for digital tracing contributed by MARTIN BEEK.

Left: Photograph converted into line with the Find Edges tool.

Artist profile
DANIEL ZELLER

Born in San Raphael, California, in 1965, Daniel Zeller studied sculpture at the Universities of Connecticut and Massachusetts. His pencil, ink and acrylic drawings can be found in the permanent collections of several museums, including New York's Museum of Modern Art. He has exhibited widely in both the US and Europe.

Zeller's inspiration comes from rivers, roads, veins and cables. 'The ideas grow out of these different stories that I like to look at – aerial photography, satellite imagery, microscopic imagery, anatomy.'

These ideas are then absorbed, abstracted and transformed by a working process that is one of constant invention. Zeller deliberately avoids having a plan. He looks at what is on the page and reacts to it. 'It's very fluid – a stream of consciousness that crawls along at a snail's pace – building with one line.' To preserve this fluidity, he works on several pieces at the same time; if he becomes bored or stuck, he chooses another drawing. He does give himself one important restriction, though – there can be no erasing. 'Always respect what has already been put on the page – it is not to be crossed out or obscured.'

Pencil drawings are worked either flat on the table or, if big, vertically on the wall. Zeller sharpens lots of pencils, then starts in one corner and works his way across to the other. Some drawings take a day, some a month – some several months, depending on the size and density of the marks. But Zeller does not regard the time involved; the effort is not the point.

Zeller enjoys getting lost in the rhythm of repetitive detail, and these marks naturally build into shallow spaces where three-dimensional shapes interlink and weave. 'As much as I try to flatten things, I always end up having some manipulation in the surface.' This

Right: Synaptic Globulosis.
Graphite on paper.

fascination for intricate, undulating detail dates back to his childhood. Zeller recalls looking at maps, with their thousands of little lines, and visiting his father at work, where the computers took up whole rooms, and loving the mass of sinuous cables and the scale of everything.

Although some of his finished pencil drawings have titles that link them to specific places, Zeller considers his work to be abstract. It is the way it is made – the stream of consciousness, the sense of discovery and surprise – that is most important for him. As he says, 'I don't know where it's going, and that's half the fun for me.'

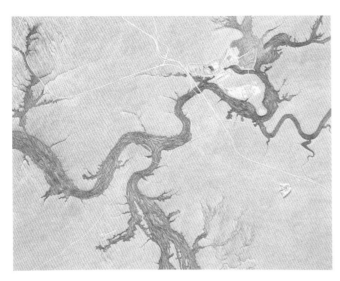

Left: Kingston. *Graphite on paper mounted on panel.*

Below: Operative Relay. *Graphite on paper.*

GALLERY

Left: Untitled #13. *Pencil and coloured pencil on paper, by Tomma Abts.*

Above: Head 1. *Graphite on paper, by Peter White.*

Opposite top left: Amaryllis. *Pencil on paper, by Peter S. Smith.*

Opposite bottom left: Untitled. *Pencil on oiled paper, by Marion Thomson.*

Opposite far right: View from the Model Room Window 2010–13 (02/05/2013). *Pencil on paper, by Liam O'Connor.*

Chapter Two
INK

OVERVIEW

Ink is an immediate and flexible medium, demanding courage because it cannot be erased. Even those whose work is painstakingly detailed will have to embrace uncertainty, and anyone working in ink will have to balance a need for control with risk taking.

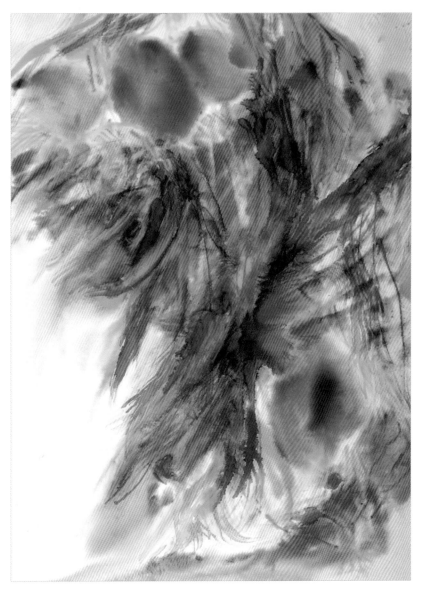

In the West, ink has long been used for its responsive and fluid line, enabling artists such as Rembrandt to sketch out ideas quickly in line, light and shade. But in the twentieth century, artists from Matisse to Ad Reinhardt were much influenced by Oriental painting methods, where much more emphasis is placed on the quality of the line, drawn directly on the paper without guidelines. This approach can be seen in Zheng Chongbin's experiments with gesture, texture and contrast (pp.38–39). Lisa Wright (p.43) and Joy Girvin (left) also exploit the wetness of ink and the happy accident, manipulating the medium, allowing it to run and bleed into the paper to create different types of mark. Emma Stibbon (opposite) adds carbon and volcanic ash to her ink, linking the medium to the place, while Tania Kovats' drawings of water are made through a process of evaporating water, ink and salt (p.41).

If applied with a pen, ink offers the chance to work in fine detail, building up tone and pattern with line – as seen in Laylah Ali's intensely patterned black-ink drawings (p.41) and Daniel Zeller's luminous coloured pieces (p. 41). Film-maker Paul Emmanuel scratches into light-sensitive film, producing images that look like they have been meticulously drawn in ink pen (p.42).

All sorts of felt-tip markers and ball-point pens enable scribbling freely in all directions without fear of blotting; their convenience means that they are being increasingly used by artists. In Jen Stark's *Cosmic Strings* (p.40), felt-tip pens are used to develop a joyous doodle, and Kate Morgan achieves rich contrasts when working in ball-point pen (p.42). Alternatively, you might consider using black marker pen to delete and obliterate, as does Kathy Prendergast in her 'Black Maps' series (see also pp.231 and 238).

Left: Studio painting by Joy Girvin, improvised from a slide by Dr Renne Germack.

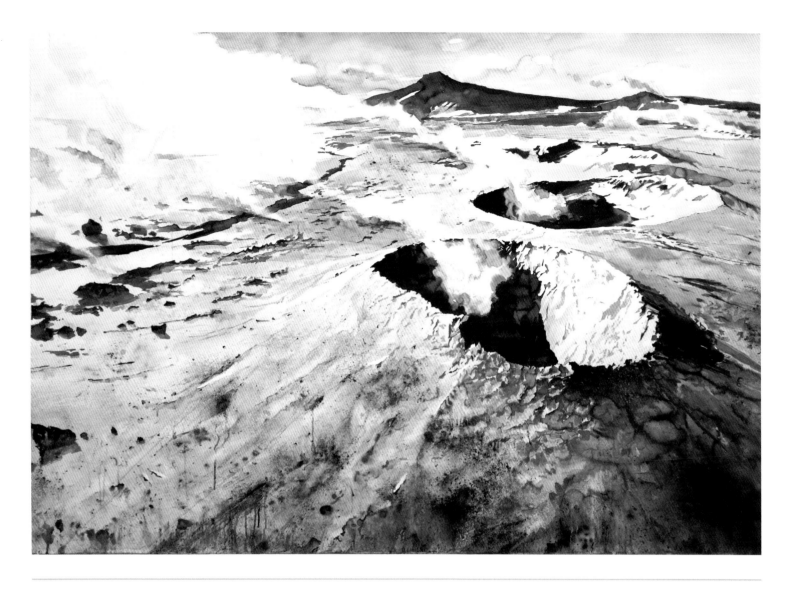

Digital options:
PEN TOOLS

Above: Hverir, Iceland. *Ink, carbon and volcanic ash on paper, by Emma Stibbon* RA.

Advantages

- Some drawing apps for the iPad and other tablets have some very useful Pen tools, which to some extent replicate pen-and-ink drawing.
- Pen tools and sizes are numerous, as are paper types and even simulated ink spread.
- You can easily vary tonal and nib types with a few deft selections.
- Portions of a drawing can be erased or temporarily hidden behind other layers.
- Most monochrome line drawings can be blown up to larger sizes without undue pixellation.
- Use a shade of grey or cream for the underlying paper; it is easier on the eye than the pure white of the screen.

Disadvantages

- The simulated inks may not behave as real ink does on quality paper.
- It lacks the subtlety of the dried ink surface.
- Minute cross-hatching may become confused and indistinct when viewed on a screen.
- Some types of ink brushwork cannot be adequately replicated; even the random scatter brush of blots or dots has some predictability and can look unnatural.

Content for Pen tools contributed by MARTIN BEEK.

TOOLS AND SUPPORTS

Waterproof inks

Waterproof inks are made with a soluble dye or pigment suspended in a shellac or synthetic resin, e.g. Indian or acrylic ink. They dry to a hard, glossy film. This surface can be overpainted or overdrawn without the ink bleeding. Colours can be overlaid one over another in washes.

Black Indian ink

Non-waterproof ink

Lightfastness

Inks based on soluble dyes will fade when exposed to light – those based on pigments are far more lightfast. As a general rule, artist's colours are likely to be less fugitive than those made for students, but always check the manufacturer's label, especially when buying bright colours such as yellows, as these are more prone to fading. The ink in ball-points, roller balls and felt-tip pens are particularly unstable when exposed to light.

Acrylic ink

Acrylic ink

Non-waterproof inks

These are similar to a diluted watercolour and should be used if wishing to redissolve a colour with water, other colours or bleach. They dry to a matt finish and, unlike waterproof ink, sink into the paper rather than sitting on the surface.

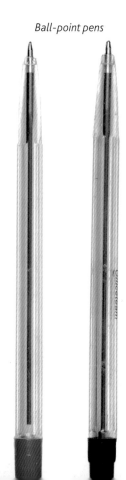

Ball-point pens

Shellac ink

Acrylic ink

Shellac-based ink

Acrylic ink dropper cap

Ink cartridges

Pen ink

Reservoir and cartridge pens
These are pens that take ink cartridges, or have a chamber that you can fill with ink. Buying one with a reservoir means you can mix the colour of ink you put in it yourself. They come with two sorts of nib. The first is similar to a dip or writing pen. The second is tube-like. Designed for graphic artists before the invention of computers, a tube nib is still worth using if you want a very even line. However, it must be held almost upright to keep the ink flowing at a constant rate, is prone to clogging, and must be cleaned regularly.

Reservoir pen *Cartridge drawing pen*

Roller-ball pen *Stylo tip marker pen*

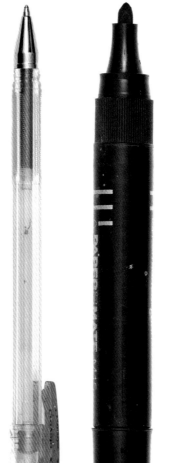

Self-inking pens
Ball-point, roller-ball and felt-tip pens are easy to use and encourage a relaxed approach to drawing. Experiment with different makes and nibs – the feel of the pen and the colour of the ink on the page will vary, even with blacks.

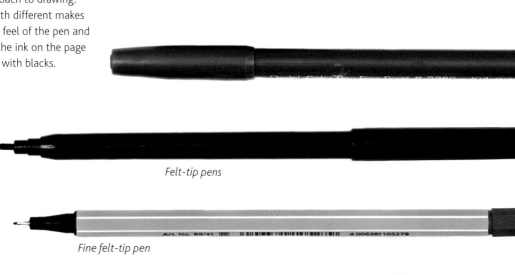

Felt-tip pens

Fine felt-tip pen

Broad felt-tip pen

TOOLS AND SUPPORTS

Brushes
Any kind of brush can be used for working with ink, from a stiff bristle to a soft sable. Japanese brushes are particularly responsive as they hold ink well. All will give different types of mark.

Oriental ink sticks
These are made from a mixture of lamp black pigment (soot) bound with fish glue and parchment size that has been dried in a mould. To release the ink, the stick is ground on an inkstone with a small amount of water. It takes practice to get this right – too thick and the ink will not flow well; too wet and it will blot and expand.

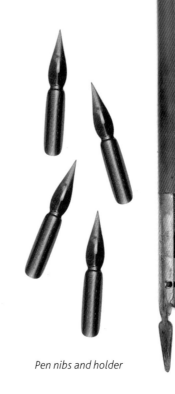

Japanese brush

Dip pens
Dip pens are dipped into ink to make a mark.

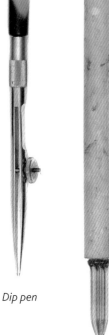

Dip pen

Pen nibs and holder

Glass dip pen

Oriental ink stick

Watercolour brush

Japanese-style brush

Papers
Generally, a thick (300–600gsm), smooth hot-pressed paper is used for ink drawings – this will withstand some dampness and the ink will glide easily across the surface (see p.94). If you want to work very wetly, the paper should be stretched (see p.95). Rough papers can be used if you wish to encourage a drier, textured mark. Japanese papers are thin and absorbent – perfect for one-stroke action painting, as in the work of Zheng Chongbin (pp.38–39).

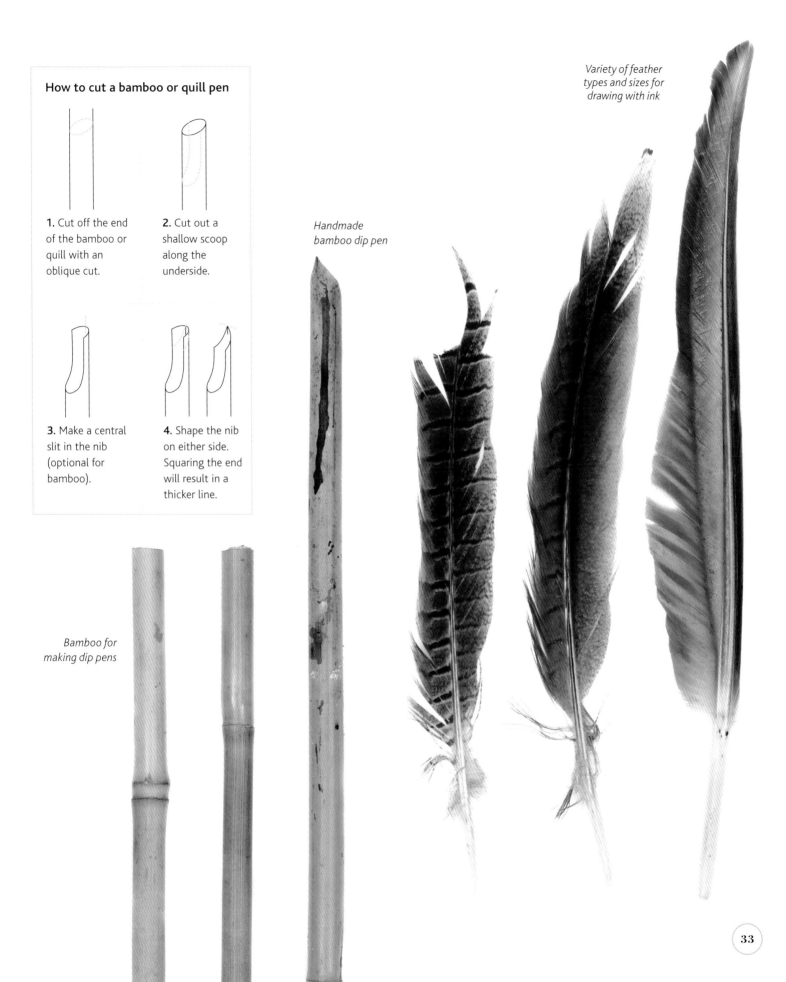

How to cut a bamboo or quill pen

1. Cut off the end of the bamboo or quill with an oblique cut.

2. Cut out a shallow scoop along the underside.

3. Make a central slit in the nib (optional for bamboo).

4. Shape the nib on either side. Squaring the end will result in a thicker line.

Bamboo for making dip pens

Handmade bamboo dip pen

Variety of feather types and sizes for drawing with ink

Techniques
EXPERIMENTING WITH INK

Exploiting the fluidity of ink takes some courage. Experimenting with the way you stand and hold the pen or brush, and working on several drawings in series, can all help to increase your confidence. Be prepared to react to the work as it happens. Options include: working into the surface with more ink, cutting and collaging over the top, bleaching back the surface, overpainting with other paint media, and scanning in the image so it can be altered on the computer, printed out and then reworked.

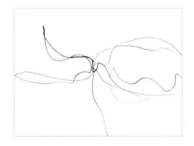
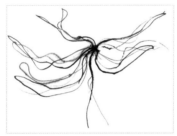
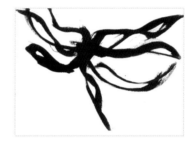
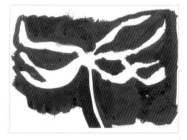

Bamboo stick on dry paper
A bamboo stick is cut to a simple point and dipped into the ink. Drawn across the surface, this homemade pen gives an even, dense black line that gets progressively drier as the ink is used up. With practice, this natural variation in mark and resulting calligraphy can be exploited, and is not to be found in work made with cartridge or reservoir pens. Speed and pressure will also affect the line made.

Bamboo stick on wet paper
Dampening the paper encourages ink to spread out, and gives softer, broader, fuzzier lines. This adds a playful element of chance to a drawing, as it is difficult to predict just how the ink will react. How damp the paper is can be controlled by blotting water from the surface, rewetting parts of the drawing or allowing the surface to dry slightly as the drawing progresses.

Brush with Indian ink
This was made using a pointed, coarse-haired Japanese brush. The marks made in this case are affected by the type of brush, the way it is held in the hand, how much ink is loaded on the bristles, the pressure put upon the brush and how fast it is drawn across the paper. Here, both wet and dry textures can be seen as the outside edges of the brush began to run out of ink.

Brush painting; negative space
Here the white of the paper has been left to give the positive shape of the honeysuckle. Wet ink was used to paint the background shape. It was laid down generously, and the way it flowed and bubbled when wet can clearly be seen in the dry surface texture.

Content for experimenting with ink contributed by MARION THOMSON.

Artist's tips

- Ink is unforgiving of mistakes, so build up momentum by making lots of drawings in succession. You will find that you can refer from one to the other, learning as you go; the drawings should become more automatic and increasingly loose as you work. The best drawings can then be chosen from the set. **(A)**

- Hold the brush loosely in your hand and try standing up to draw so that you can use your arm as well as your hand. This allows for a more gestural movement and sensitive application of ink. **(B)**

- Work flat, or try tipping up your board slightly. Too steep an angle will result in the ink running down the page. **(C)**

- Experiment with different implements dipped in wet ink, such as pens, brushes, sticks or even vegetables. They will all make different marks and will feel different in the hand. The drawing here has been made using pieces of celery, cut into different widths and lengths, then dipped in ink. **(D)**

- Try holding your stick, pen or brush vertically, as the Japanese or Chinese do. This will give you a different sort of control and an alternative way of working. **(E)**

- If working in line, look directly at the object and allow your eye to lead your hand without looking at the paper. With a little practice this will result in a continuous line, and drawings that are abstract, fluid and automatic – confident rather than tentative.

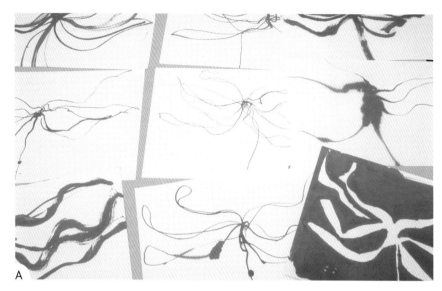

A

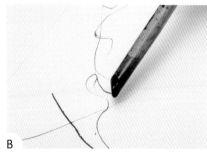

B

C

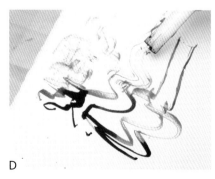

D

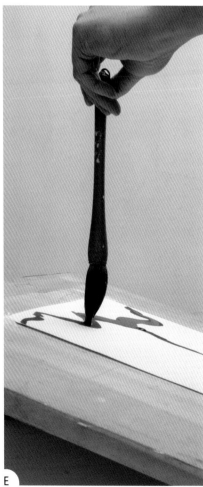

E

Techniques
USING PENS

Working with a cartridge, ball-point or felt-tip pen gives some control, as lines are finer and are generally built up over time. If embarking on a long and detailed work, you may consider drawing out some pencil guidelines first as this can be helpful with the placement of the composition. Even so, it is best if this underdrawing remains sketchy – line rather than tone. Ink reacts very differently to pencil on the page.

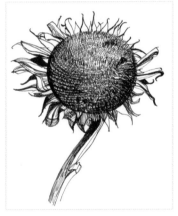

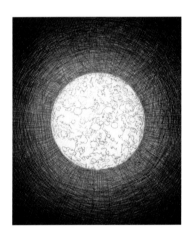

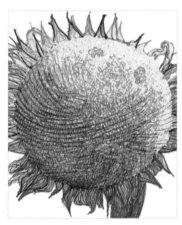

Dip pen
In this drawing of sunflowers by Marion Thomson, the marks are thin and scratchy – typical of a fine metal nib. The line varies according to the ink supply and the pressure put upon the pen.

Cartridge pen
Because the ink supply is continuous with a cartridge pen, the line is more constant, and it is easier to build up areas of tone and texture than with a dip pen. Although there is less variation in the mark, there is also less danger of blotting.

Ball-point pen
A ball-point pen encourages a scribbly line that can be built up to a satisfying intensity. This particular drawing was made on a soft, unsized paper so that the lines could be incised into the surface, rather like an etching.

Felt-tip pen on cartridge paper
A felt-tip pen offers an easy way of adding colour to a line drawing, and will give a graphic rather than a painterly feel. Work on a good thick cartridge paper if you are intending to colour in areas of tone because the pen will tend to make holes in thin paper. The colours produced are bright and vibrant, but likely to fade over time; scanning the drawing and printing it as a professional giclée print would be a commercial option.

Artist's tips

- Try working on different sorts of paper (see p.94) as this will make a difference to the mark. For example, a smooth hot-pressed paper that has no texture will allow ink to run freely, whereas an absorbent, rough paper will encourage ink to bleed slightly and so will accentuate texture.

- As can be seen in this drawing, *Reacting Heart Proteins* by Joy Girvin and Dr Renne Germack, coloured ink is transparent and vibrant. Experiment with mixing new colours from primaries (see Colour mixing, pp.86–87) and dilute your ink with water to achieve paler coloured washes. **(A)**

- Experiment with different sorts of mark to build up pattern and texture: scribbles, dots, dashes and splatters. Try working these into wet paper, or overlaying them with a wash when dry. Look too at the variety of marks and patterns in the work of Jen Stark, Laylah Ali and Paul Emmanuel. **(B)**

- Try drawing into dry, water-soluble ink with a dip pen dipped in bleach. This reacts with ink, resulting in a negative line and a very particular texture. **(C)**

- Many of the techniques employed by watercolourists can be used with ink. Try masking fluid or tape to preserve the white of the paper, or splattering with a toothbrush to create texture. You can also try mixing with other media, such as wax crayon and oil pastel, for resist effects. **(D)**

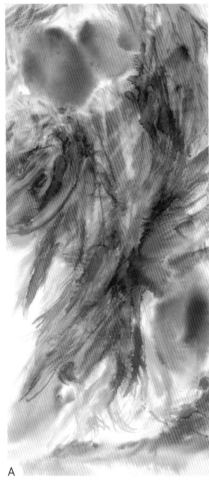

A

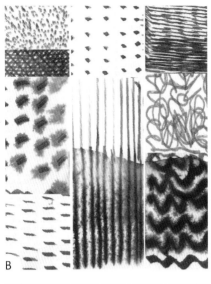

B

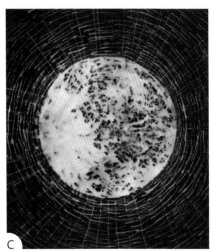

C

D

Artist profile
ZHENG CHONGBIN

Born in Shanghai in 1961, Zheng Chongbin studied traditional Chinese painting at the Zhejiang Academy of Fine Arts (now the China Academy of Art). Having secured an international fellowship he then moved to the US to study contemporary Western art at the San Francisco Art Institute. He now exhibits widely – Hong Kong, Singapore, Germany, Beijing, Canada – and recent exhibitions have been held at London's Saatchi Gallery and Christie's in New York. His work is also held in public collections, such as that of the British Museum.

Bicultural, Zheng divides his time between studios in San Raphael in California and Shanghai. Although he also works in film and installation, ink is central to his practice, since 'the medium itself bears a lot of ideas about philosophy and cosmology'. His paintings are huge, abstract and without colour, and aim to transcend the merely material. His thinking and paintings also demonstrate the influence of both Chinese brush painting, and American and European abstraction. Thus he works within an artistic framework based on the writings of the fifth-century Chinese artist and theorist Xie He, while actively referencing the art and ideas of Western twentieth-century artists such as Ad Reinhardt and Kazimir Malevich.

'I am interested in perceptual experience … in [the] material rather than traditional forms. My work is about physicality … about mass, about weight, about light.'

Zheng's starting point is Xuan paper – a soft, fine-textured paper that is naturally absorbent and gives a blurry edge to ink and paint. Large pieces are laid across the studio floor and their absorbency is increased or decreased by prior soaking with water or painting with an acrylic primer. Random textures are deliberately created. As the paintings develop, more paper is overlaid, as is white acrylic. Ink is used densely or thinned with water, and its transparency contrasted with opaque areas of ink thickened with acrylic paint.

'Black, white, liquid on surface, dry, wet, void, texture' are the words Zheng uses to describe his manipulation of the medium, and the contrasts he seeks, while 'action, drip, random, scribble, flat brush, cast, collage, tailoring' describe his use of the brush, and tie in with the writings of Xie He. But, as Zheng straddles his work, painting with large brushes and a generous and liberal action, he also displays the experimentation, intuition and bravado of an Abstract Expressionist. His practice can therefore be seen as a dialogue between East and West.

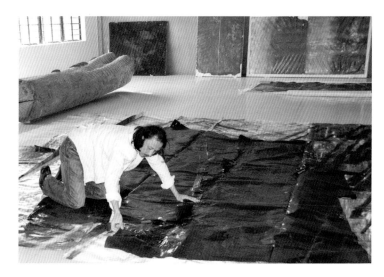

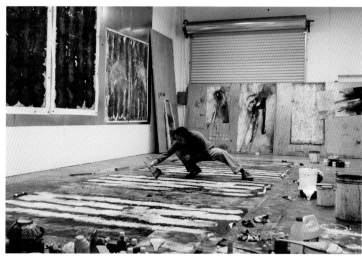

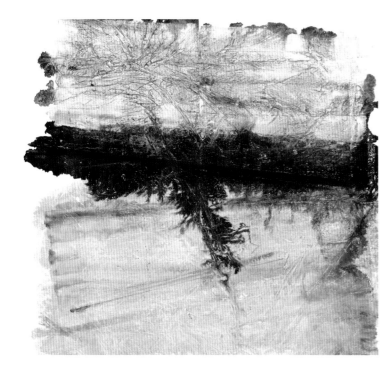

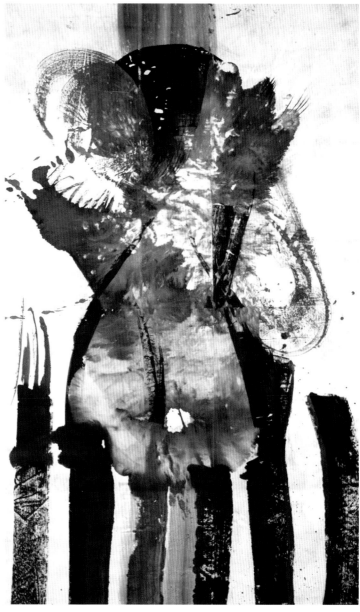

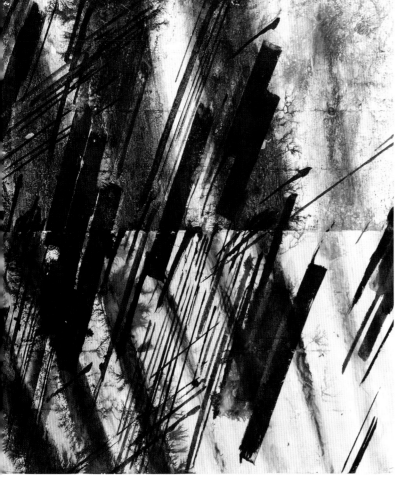

Opposite left and right: Zheng Chongbin at work in the studio.

Above left: Leaning Field. *Ink on collaged Xuan paper.*

Above: Untitled #3. *Ink and acrylic on Xuan paper.*

Left: Passing Lines No. 2. *Ink on collaged Xuan paper.*

GALLERY

Opposite: Cosmic Strings. *Felt-tip pen on paper, by Jen Stark.*

Above left: Evaporation 4 *(detail). Ink, water and salt on paper, by Tania Kovats.*

Above right: External Resolution. *Ink and acrylic on paper, by Daniel Zeller.*

Left: Untitled, *from 'The Kiss and Other Warriors' series. Ink and pencil on paper, by Laylah Ali.*

Above: After-image. *Hand-incised,
exposed and processed colour
photographic paper,
by Paul Emmanuel.*

Right: Moth. *Ball-point pen
on paper, by Kate Morgan.*

Opposite: *Study for* Tell No One.
Ink on paper, by Lisa Wright.

Chapter Three

CHARCOAL AND CHALK

OVERVIEW

Thicker and blunter than graphite pencils, charcoal and chalk are naturally suited to large-scale work and the grand gesture. Unlike pencil, which is labour intensive, these two media are quick to cover large areas in tone. The user is likely to feel exhilarated rather than exhausted.

Above: Studio. *Charcoal on paper, by Jane Joseph.*

Willow charcoal gives a soft, smoky line that can be modified easily by brushing, wiping or rubbing. Black chalk too, although more dense, can be wiped back and overworked with more chalk, or drawn into with an eraser. This flexibility makes these responsive and expressive media. Because changes can be made so easily, even an enormous drawing can respond well to changing thoughts, enabling artists such as Jane Joseph (left) and Annie Attridge to develop ideas on a large scale (pp. 54–55). Jonathan Delafield Cook's imposing images of nests and animals demonstrate that charcoal is also capable of great subtlety and an almost photographic finish (below).

In the past, charcoal was used to sketch out images on a panel or canvas before painting, but it is now treated as an expressive medium in its own right. Popularised during the twentieth century, charcoal and black chalk continue to be associated with the gestural drawings of the modernists. Simon Burder works in a similar way today, using charcoal to simplify and abstract from what he sees and/or to visualise ideas. These drawings form part of his working practice (p.56).

As with other media, contemporary artists will choose charcoal or chalk if it is the best way to convey a particular idea. Current work in charcoal and chalk explores surface and meaning. For example, Tacita Dean's blackboard drawings deliberately draw attention to the ephemeral nature of an image that is unframed and unprotected by glass (p.57). Others reference the fact that charcoal is ash. Using a stick of charred gorse, Frances Hatch draws the forest fire before her (pp.198–199). Drawing with smoke from a candle, Diane Victor uses the medium to allude to the fragility of the political situation in her native South Africa and the vulnerability of the people she depicts (p.57).

Digital options: CHARCOAL TOOLS

Advantages

- Simulated charcoal drawing can be achieved on the iPad and other tablets with a number of apps and tools. Some have become quite sophisticated, allowing for smudging and blending.
- The tooth of papers can be visually replicated.
- The drawing surface will never become dusty or overworked.

Disadvantages

- Due to the size of a tablet, the type of mark that can be used is limited to those that can be made with a hand or wrist movement rather than an arm movement.
- Drawing with a stylus on the glassy surface of a tablet does not have the feel or resistance of paper, and this inevitably leads to very different types of marks. As a result, a drawing will inevitably only be superficially like charcoal.

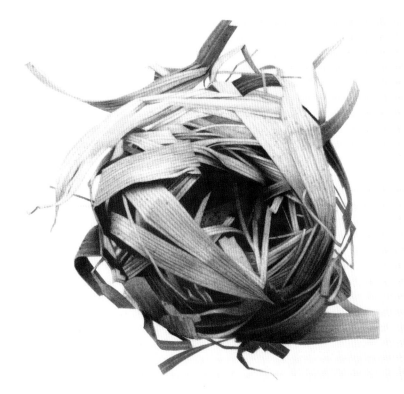

Above: Golden Babbler Nest. *Charcoal on paper, by Jonathan Delafield Cook.*

Content for Charcoal tools contributed by MARTIN BEEK.

TOOLS AND SUPPORTS

Also called vine charcoal, willow charcoal is burnt wood – probably the world's oldest drawing medium. Today it is made commercially from willow sticks or vine, and comes in several different sizes. Scene painter's charcoal is the thickest and is good for large-scale work, while a charcoal pencil is useful for small-scale detail and mark making.

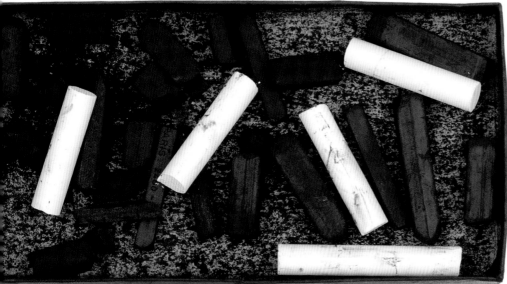

Chalk
Black or white chalk is made from carbon or chalk, bound with oil or resin and formed into sticks. (See p.62 for the composition and use of coloured chalks and pastels.)

Chalk

Compressed charcoal and white chalk

Compressed charcoal
This is willow charcoal that has been ground into a powder, then bound with a binding medium such as oil and compressed into a stick shape. It is a form of black chalk or pastel.

Willow charcoal sticks

Fixative

Modern aerosol-can fixatives are generally a solution of PVA (polyvinyl acetate resin) in methylated spirits, which quickly evaporates as the surface dries. For a more permanent sealed surface, two or three coats of a dilute acrylic emulsion can be applied by spray gun.

Plastic eraser

Putty eraser

Fixative

Erasers

As with graphite, plastic erasers are an effective way of removing charcoal without leaving smudge marks. Cutting them into smaller pieces makes them easier to use on detailed areas. Alternatively, use a putty eraser, moulded to a point. Remember to warm it in your hand first, and knead it well, or it will smudge the surface.

Charcoal pencils

Surfaces

Any surface with a slight texture is good for charcoal or chalk as this helps the pigment to stick. Cartridge paper or textured watercolour papers are good, as are the textured, tinted papers produced specifically for pastel drawing. For large-scale drawings, cartridge papers of different weights and textures can be bought on a roll.

Charcoal pencils

Chalk and charcoal pencils can be easily sharpened to a point and are good for detailed work. As with graphite pencils, they come in varying degress of hardness, and different makes have slightly different characteristics.

Techniques
USING THE MATERIALS

Although they can be used together, charcoal and chalk do have quite distinct characteristics. Willow is softer and more transparent; it will give a beautiful range of subtle greys, and, if fixed, it can be overdrawn to give richer blacks. Black chalk is opaque, much blacker and has more of a texture. When mixed with white, it will give a range of robust, opaque greys that are very different in character from the transparent greys of willow. White chalk gives an opaque alternative to white paper highlights and is particularly effective when used on a toned or coloured paper.

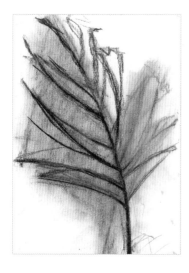

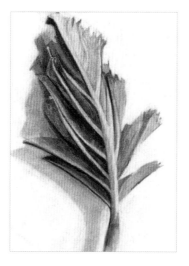

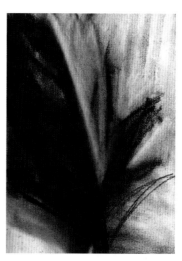

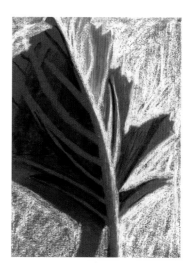

Willow charcoal
A drawing showing the 'ghosting' that is typical of willow charcoal. Marks can be easily wiped back with a tissue or hand, allowing changes to be made over the top of the smudged image.

Willow charcoal (continued)
The previous image has been drawn into here, showing how willow charcoal can provide a wide and subtle range of tones.

Black chalk
More opaque than willow charcoal, black chalk feels heavier and more dense. The exact drawing quality will vary according to the make, but chalks will usually yield rich, dark tones quickly and easily. Hard to rub out, chalk will give strong contrasts if worked into firmly with an eraser.

White chalk on coloured paper
Working from light to dark and building up the texture in the light areas as well as the dark can make for an interesting drawn surface. White chalk can also be mixed with black chalk or charcoal to give a rich opaque grey.

Artist's tips

- Try wiping back with a hand or tissue when things are not working. You can then draw back more strongly over the top. Chalk and charcoal are ideal materials for working out ideas and compositions because they allow you to change your mind easily. **(A)**

- Use an eraser to draw in areas of white into the drawing. **(B)**

- Brush the pigment softly from the surface to gain a greater tonal range. **(C)**

- When scaling up a drawing or working on a large scale, try drawing with your charcoal attached to a bamboo cane or stick. This forces you to stand right back from the image and enables you to see the whole composition as you work. You will find that you can draw in long, sweeping lines. **(D)**

Attaching charcoal to a bamboo cane

Fix your charcoal to the cane using masking tape, or make cuts in the bamboo and insert the charcoal inside.

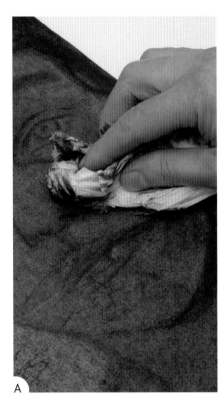

A

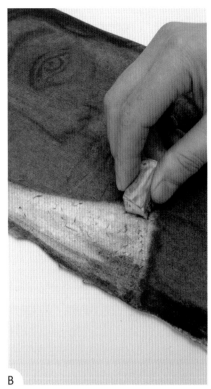

B

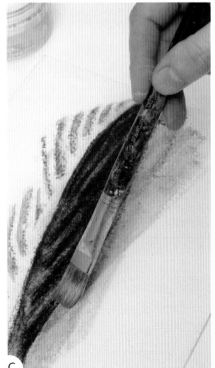

C

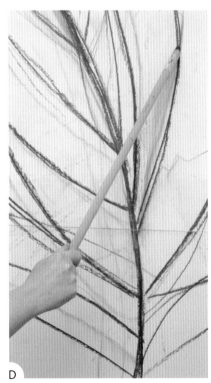

D

Techniques
FURTHER EFFECTS

Adopting different ways of working with charcoal can result in different ways of thinking and seeing. For example, working on black paper with white chalk, or drawing with an eraser into a black chalk ground, will encourage you to see and think of areas of light rather than dark and shadow. Varying the materials and the ways you use them will give you a range of marks. Try using a thinner, harder charcoal pencil to contrast with the smokier line of willow charcoal, brush chalk softly into the surface of the paper or add water for more painterly effects.

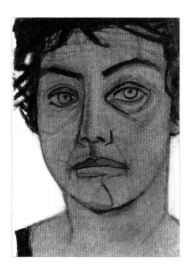

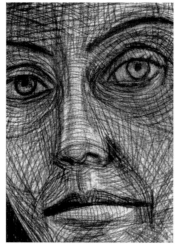

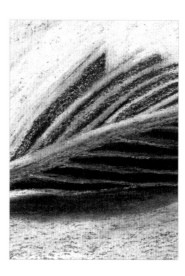

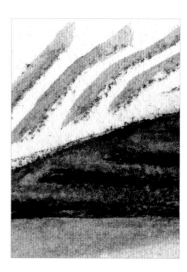

Black chalk ground
Here, white paper was covered all over with a black chalk that was then rubbed back with a tissue to give a grey ground. This provides a good drawing surface that can then be worked into with black and white chalk and an eraser.

Charcoal pencils
These give the option of working in a thinner line than is generally possible with willow charcoal or chalk, and encourage the building of tone with line.

White and black chalk
These can be mixed together to give greys and to build up an opaque and textured surface. Here, white has been grazed across the black to give highlights rather than rubbing back with the eraser, and the materials have begun to sit up on the surface.

Water
Water can be used to paint into the surface of a charcoal drawing, allowing the creation of washes and a painterly way of working. When dry, more charcoal can then be drawn over the top. If combined with a textured watercolour paper, this can give good textural contrasts as the charcoal takes on the tooth of the paper.

Artist's tips

- Try working into a charcoal drawing with water. Use a thicker textured paper for this, such as watercolour paper. When dry, more charcoal can be drawn over the top. **(A)**

- Fix the surface with fixative as you go along. If you work into a drawing for a long time, you may find the charcoal or chalk refuses to stick. Fixing restores a solid surface and tooth to which the pigment can adhere. **(B)**

- Try varying the paper you use. The tooth or surface texture and the colour of the paper will change the feel of a drawing. **(C)**

- If you react badly to a dusty environment, you can make willow charcoal less dusty to draw with by immersing it in linseed oil for 24 hours. The sticks should then be wiped dry and kept in an airtight container to stop them drying out. This process slightly changes the way the charcoal adheres to paper – it retains its characteristic smoky line, but it is harder to erase. **(D)**

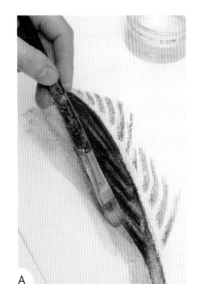

A

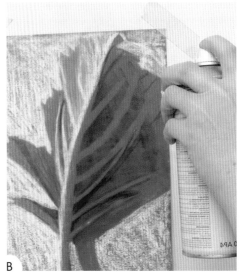

B

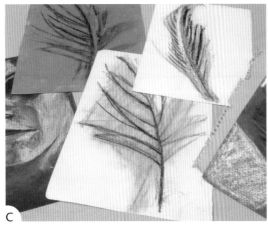

C

D

Digital options:
LASER CUTTING

For installations, consider having digital drawings laser-cut out of vinyl. Vinyl and acrylic signs come with a sticky back and can be placed directly on a gallery wall. This makes large wall pieces less vulnerable to damage than a charcoal drawing would be during an exhibition.

Right: Paries Pictus – Connect the Dots. *Car, vinyl and crayon, by Robin Rhode.*

Artist profile
ANNIE ATTRIDGE

Born in Wigan, in the north of England, in 1975, Annie Attridge studied at Brighton University and the Royal Academy Schools. She now lives and works in London. Solo exhibitions of her work have been staged by various galleries, including Asya Geisburg in New York, Galerie 13 in Paris, and both the Nettie Horn Gallery and the Prowler Project Space in London. Attridge has also participated in group shows at the Galerie Maurer in Frankfurt, as well as the Saatchi Gallery, the Contemporary Art Society and the Danielle Arnaud Gallery, all in London.

Like many contemporary artists, Attridge works with a range of materials, and her charcoal drawings are displayed alongside sculptural pieces made from porcelain, stained and carved wood, jade, gold gilt, pewter and hand-printed wallpaper. 'I really love the idea of finding new materials, and once I do, I become obsessed with getting every detail just so.'

However, Attridge particularly likes the physicality of charcoal: 'You can get it on your hands, and I love the way you can get your fingerprint marks in it. In the same way as working with clay, I'm in the drawing, really pushing it; it's like my hands have their own mind.'

Attridge crushes up willow charcoal and paints it on softly, like smoke, using a paintbrush. She then draws into the darker areas with compressed charcoal, building up tones in layers like an oil painting. She also enjoys creating texture, rolling a moulded putty eraser across an unfixed surface and applying sandpaper or a knife to take out highlights.

Attridge's various works explore love in all its manifestations. Many of her works are naughty, and some are deliberately and explicitly sexual. For example, the cheeky *Chocolate Chip Flirt* addresses the idea of food as sexual temptation. Others are deeply romantic. Romantic longing, desire, friendship, lust, the parting of lovers – all are explored through motifs inspired by her life experience.

Right: Boobie Love. *Charcoal on paper.*

Opposite left: Love is an Anchor. *Charcoal on paper.*

Opposite top right: Chocolate Chip Flirt. *Charcoal on paper.*

Opposite bottom right: You Mark Me the Deepest. *Charcoal on paper.*

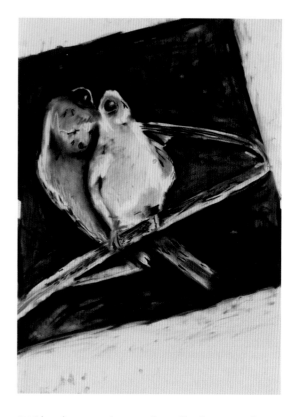

Attridge also notes the recurring sailing imagery in her work, and how growing up in a shipping village and crewing on the tall ships as a young girl inspired the symbolism in *Love is an Anchor*. 'When it's 12 o'clock at night and there's no wind, it's really magical.' These memories are used to evoke the bittersweet ending of an affair. The boats are held only until the tide turns; the anchor in the foreground begins to float on the water.

Drawing is an important part of Attridge's practice as an artist. 'It's a different spirit to making sculpture – it's more immediate, and a way of getting ideas out of your head.' Her choice of charcoal is an emotional response to the material itself. She likens it to falling in love: 'It's really important to have a relationship with your materials – a loving relationship.'

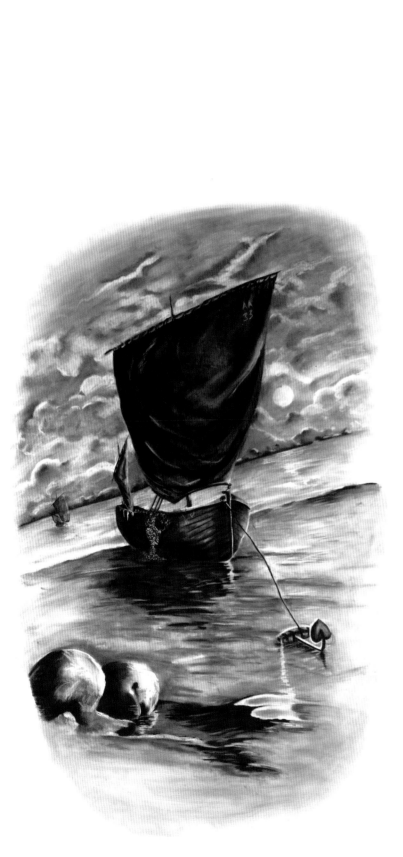

GALLERY

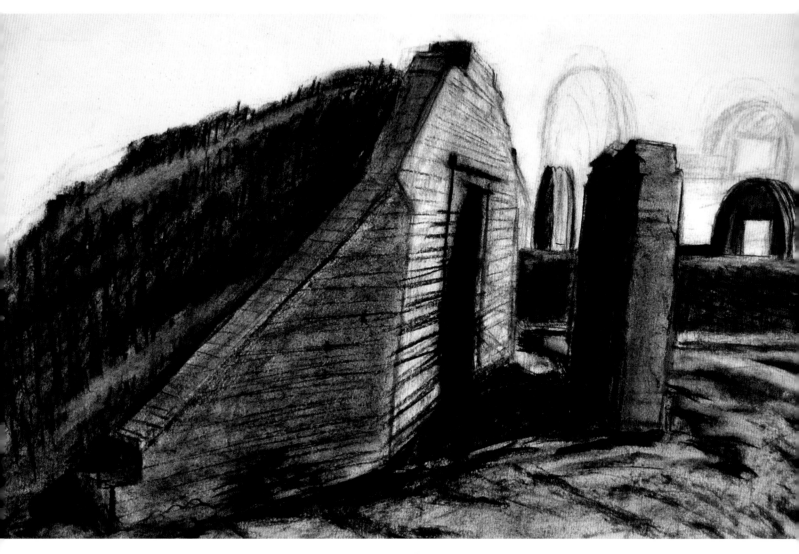

Above: Air-Raid Shelter. *Charcoal on paper, by Simon Burder.*

Opposite top left: Woman with Birds. *Charcoal on paper, by Eileen Cooper RA.*

Opposite top right: Bone Girl. *Smoke on paper, by Diane Victor.*

Opposite below: Fatigues *(installation view). Chalk on blackboard, by Tacita Dean.*

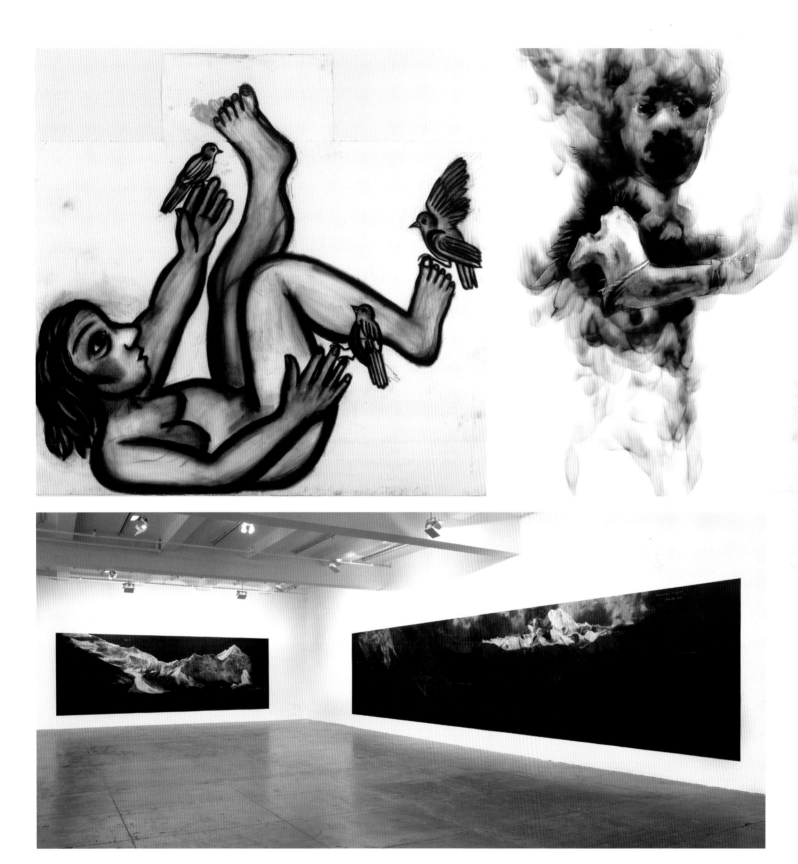

Left: Fatigues *(detail). Chalk on blackboard, by Tacita Dean.*

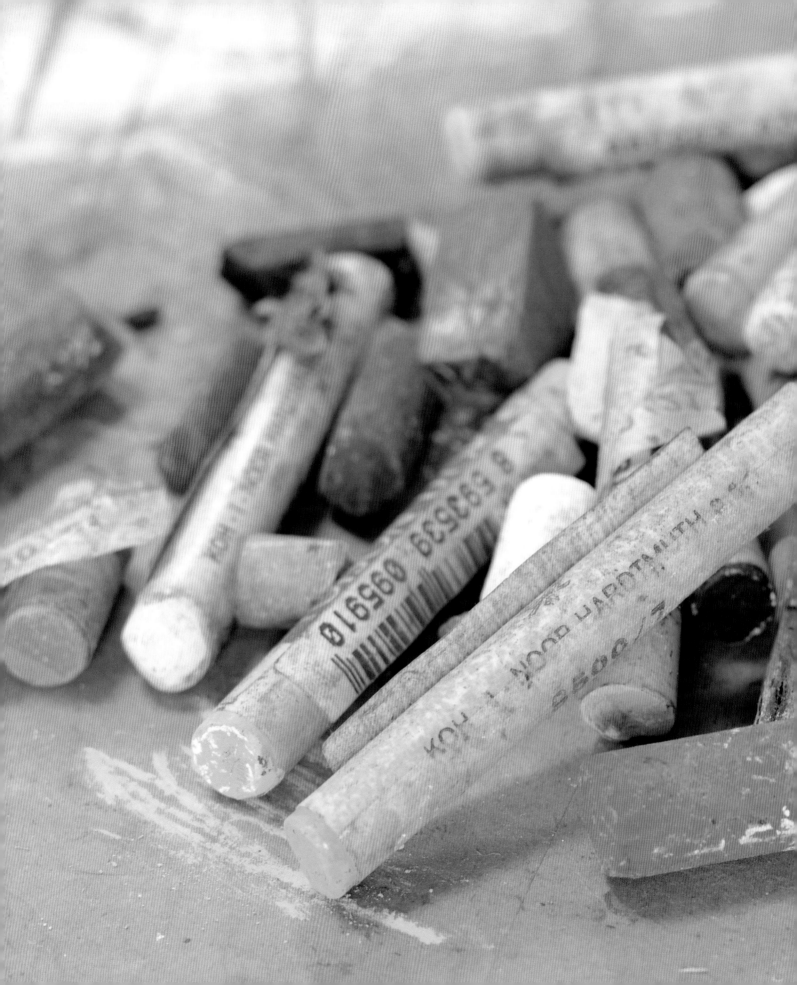

Chapter Four

PASTEL AND CRAYON

OVERVIEW

Pastels, chalks and wax crayons are made from powdered pigment mixed with gum, resin, oil or wax. It is the variation in the binding agent(s) and the purity and amount of pigment that characterises each type and make.

Soft pastels were first widely used in the nineteenth century. Soft and creamy, the best soft pastels have a luminosity and purity of colour that is very satisfying to work with. Like charcoal, they can be rubbed on as well as drawn with in a line. Melodie Cook's coolly observed self-portrait *Red Monocle* (left) and Huma Bhabha's intensely expressive layered skull-like head (p.75) both exploit the contrast between this luminous smeared pigment and drawn line. See also David Tremlett's huge hand-smeared wall drawings (p.276). Working over toned/coloured paper can give an extra intensity to the colour too, as in Oliver Bevan's or Mark Cazalet's work (pp.76 and 77).

Oil pastels are a twentieth-century Japanese invention intended to encourage children to draw. They were developed into a fine-art medium in the late 1940s by the French firm Sennelier, at the request of Picasso. They are oily rather than dusty in feel, and can be melted or dissolved in thinners to give marks from the drawn to the painterly. In *Untitled* (p.75), Laylah Ali chooses to draw simply and strongly over watercolour for a childlike, crayon-like feel. Thomas Gosebruch (p.75) exploits the three-dimensional oiliness of the line, while Philip Archer builds up rich surfaces in the medium (opposite).

Cheaper versions of the above, chalk and wax crayon have associations with childhood, colouring books, chalk boards and even graffiti. They are harder, and generally more difficult to blend than pastels, but can be a good way to add colour to a sketchbook. They may help you to play creatively with ideas, evoking certain memories as you work. You may choose them over other mediums for their associations, as in Robin Rhode's community project, *Paries Pictus* (see p.53).

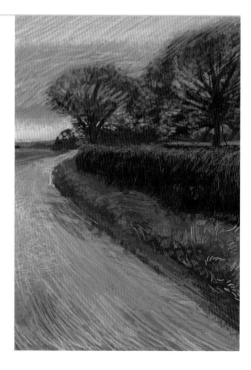

Content for oil pastels throughout this chapter contributed by *PHILIP ARCHER.*

Opposite: Red Monocle. *Pastel and Conté on paper, by Melodie Cook.*

Left: On the Terrace. *Oil pastel on paper, by Philip Archer.*

Below: Hinton Waldrist, April Shower, *showing use of Pastel tool, by Martin Beek.*

Digital options:
PASTEL TOOLS

Advantages

- Simulated pastel drawing can be achieved on the iPad and other tablets with a number of apps. Some have become quite sophisticated, allowing for smudging and blending.
- The tooth of papers can be visually replicated.
- The drawing surface never becomes dusty and overworked.
- As with other tablet techniques, the drawing can be overlaid ad infinitum.
- You can experiment with changing the colour of background paper layers until the absolute best colour is found.

Disadvantages

- As mentioned for Charcoal tools (p.47), the size of the tablet means that the type of mark that can be used is limited to those made with a hand or wrist movement rather than an arm movement.
- Drawing with a stylus on the glassy surface of a tablet does not have the feel or resistance of paper, and this inevitably leads to very different types of marks. As a result, a drawing will inevitably only be superficially like pastel.

Content for Pastel tools contributed by MARTIN BEEK.

Jumbo wax crayons

TOOLS AND SUPPORTS

Drawing successfully with a coloured pastel or crayon depends a lot on how many colours you have. Exact colours cannot be mixed, as paint can, from a few primaries, so even when starting out, it is advisable to buy the largest set you can afford – around 50 to 100 sticks.

Wax crayons

Wax crayons are made with powdered pigment that is mixed with melted paraffin wax, poured into moulds and set. If buying chalks or crayons intended for the children's market, be prepared for the pigments to fade over time.

Colour range

Chalk and wax crayons are created for the children's market and are limited in range, although it is still possible to buy variations on the basic colours – different shades of green, for example. With soft and oil pastels, where the manufacturer provides the names of the pigments used, you should acquire a range of primary and secondary colours, together with a range of tints and greys, plus black and white (see Colour mixing, pp.86–87). Compare make with make and try before you buy. Be prepared to buy the artist's quality because the colours and texture are likely to be so much better. You can then extend the range of this set with individual sticks as you progress. Extra sticks of white are always useful – you will find that you use these the most.

Wax crayons

Chalk sticks

Conté

Conté

Conté is the brand name for a crayon made from a mixture of graphite, charcoal or pigment and wax or clay. It comes in different grades of hardness and is slightly more robust, similar in feel to a wax crayon. Developed for the artists' market, the pigments should be reliable. Conté crayons come in a range of colours, including earth colours and black and white.

Coloured chalks

Chalks are a mixture of chalk, powdered pigment and water, formed into sticks and then baked. Developed for use on school blackboards, the pigments are guaranteed to be non-toxic, although they may be fugitive if exposed to light over a period of time.

Soft pastels

Soft pastels are made with powdered pigment and chalk, mixed with gum or resin. The resulting mixture is formed into sticks and air dried. They are soft, medium or hard, depending on the ratio of pigment to gum, and how much chalk is mixed in with the pigment. For this reason, pastel pencils tend to be harder than the sticks, and student-quality sticks tend to be harder than artist's pastels. Artist's pastels are the creamiest and most vividly coloured because they contain the most and purest pigment. Since pastel is a dusty medium that will stay in the air and coat the skin, it is a good idea to check exactly what these pigments are to avoid any toxic colours.

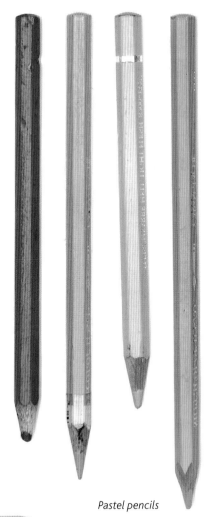

Pastel pencils

Soft pastels in storage box

Soft pastel sticks

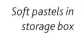

TOOLS AND SUPPORTS

Oil pastels

Oil pastels are made from a mixture of pigment, wax and animal fat. Student-quality pastels tend to be hard like wax crayons, and some of the colours are fugitive, with limited richness, density and range. They are also often difficult to blend. However, they are cheap and can be used for drawing with line, for quick sketches and with mixed media that are not intended to last forever. Oil bars are a larger version of oil pastels and are often used in conjunction with oil painting.

Starter oil pastel sticks

Professional-quality oil pastels are made with the best pigments, which are combined with beeswax and inert oils. They are softer in feel, acid-free and provide both excellent adhesion and permanent colour, with a richness and depth that does not yellow with age. They do not harden completely and so are not subject to cracking.

Surfaces

Any surface with a texture is good for soft pastel or chalk as this helps the pigment to stick. Medium-grade rough and cold-pressed (NOT) watercolour papers are good, as are sandpaper, canvas and the textured, tinted papers produced specifically for pastel drawings. Alternatively, a really textured surface can be created by coating paper with starch paste or size and sprinkling it with pumice powder (see p.95).

Oil pastel or wax crayon will adhere to most dust-free surfaces. Thin paper is prone to scrunching up when drawn on, due to the stickiness of the pastel – therefore heavier cartridge paper or water-colour paper provides a better surface to work on. Very heavy watercolour paper can absorb the pastel, though, deadening the colour and making it difficult to spread across the surface. A medium-grade watercolour board provides an excellent surface, as do purpose-made oil pastel papers.

Cartridge and watercolour papers can be primed like canvas to keep the pastel from being sucked into the surface, and to prevent the oil seeping through the back of the paper (see p.105). However, if permanence is not an issue you may like to exploit this effect of the oil leaching into the paper.

Thinners

Turpentine and white spirit, Sansodor or Zest-it can be used to dissolve oil pastel so that it can be painted with. (See also p.155.)

Turpentine

Low-odour white spirit

Fixative

Chalk, soft pastels and oil pastels all have surfaces that are vulnerable to damage, so fixing each drawing with an even spray of fixative or unperfumed hairspray is beneficial. They should also be framed behind glass for protection.

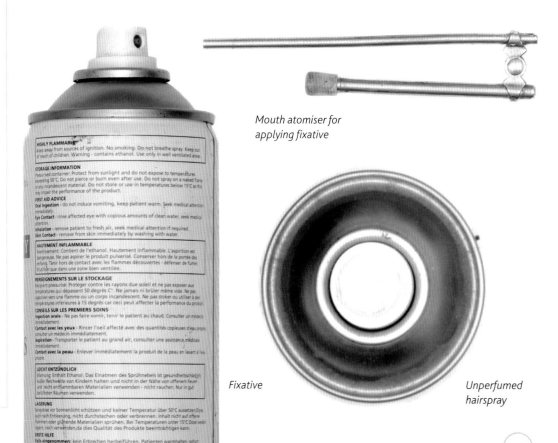

Mouth atomiser for applying fixative

Fixative

Unperfumed hairspray

Techniques
SOFT PASTELS

The best soft pastels are soft and creamy in texture, with pure and vibrant colours – even the tints – and they have a freshness, attack and immediacy that are extremely satisfying. Because they are soft, they take to paper more easily than a harder chalk and are, I think, easier to use. They can be rubbed or scraped back if mistakes are made, and redrawn over the top. Learning to strike colours strongly into the surface is a must as the pigment adheres by pressure. Learning to place strokes of different colour, both overlaid and side by side, is useful too, as this enlivens a drawing.

Health and safety
You should always be aware of the health and safety implications of working in a dusty environment. Consider wearing a mask when drawing with pastels.

Soft pastel on brown paper
This image was sketched out in pencil and the negative shape or background was added in strokes that allow the brown paper to show through. The use of two contrasting colours and this particular slanting stroke are strategies that work well in pastel.

Soft pastel on brown paper (continued)
The previous drawing has been developed further. The middle has been drawn in with a darker brown against the paper. Strokes of similar and contrasting colour were then struck in firmly beside and over one another – light over dark, and dark over light.

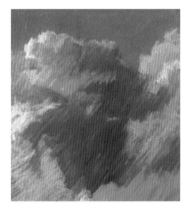

Soft pastel on fine black sandpaper
This makes use of smudging and blending, as well as the strokes described previously. Strokes of blue pastel in different tones were smudged with a rag for a smooth finish, then worked into with two types of mark – the side of the pastel and the slanting stroke. These were then blended and drawn into with a piece of rolled-up paper.

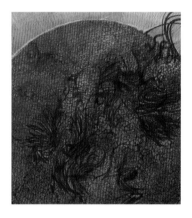

Soft pastel drawn back into with ball-point
Good soft pastel has a purity and luminosity of colour that is a pleasure to work with. This can be smeared in as a base and then drawn into with other media, such as a pencil, pastel pencil or a ball-point pen.

Artist's tips

- Working on a white textured paper will result in white speckles all over the drawing, so rub charcoal or coloured chalk/pastel into your paper first – or draw on fine sandpaper or a toned paper instead. Painting watercolour paper with an acrylic or watercolour wash also works well.

- There are three ways to draw with the pastel – with the tip **(A)**, with the side **(B)** and manipulating or smudging with a rag **(C)** or torchon **(D)**.

- A torchon is simply a strip of paper rolled up to make a soft stick. It is used to manipulate and smudge the pastel on the surface. This can be done with a finger, but the paper stick is surprisingly useful, particularly on sandpaper, where the finger can get sore. **(E)**

- If there is so much pigment on the surface that the paper will not take any more drawing, scrape back the part that needs reworking with a palette knife. If the whole drawing is overworked, bang it against a surface to release the pigment. Do this outside because of the dust.

- To fix the surface, place your drawing upright on a board and spray it from a distance of about an arm's length. Spray systematically from left to right across the surface, repeating until the whole drawing is covered and slightly damp. You will find that this darkens and dulls the colours slightly. Because of this, some artists will draw in a final layer that remains unfixed.

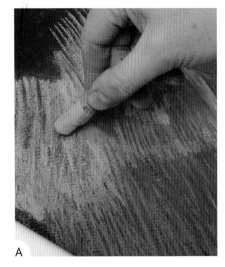

A

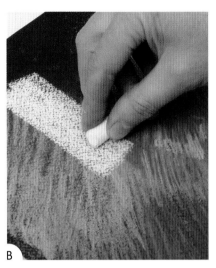

B

C

D

E

Techniques
OIL PASTELS

Oil pastel is a very versatile medium; it can be used to draw in line or layered to make textured surfaces like oil paintings. The pastels can also be melted with heat to employ an encaustic method, or melted with thinners to produce washes that can be brushed in. It will combine with most media and collage, and can be scored or scratched in sgraffito fashion (see opposite). It is also ideal for working outside, as it is easy to transport and use.

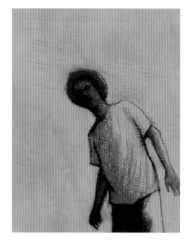

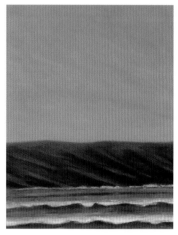

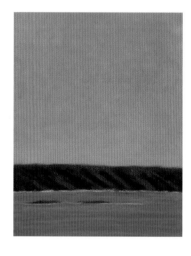

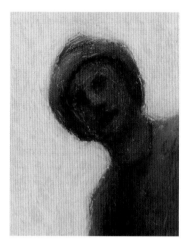

Oil pastel line drawing over turpentine wash
Here a figure was drawn in line and limited tone using student-quality oil pastels over a washed coloured ground (see also Artist's tips, opposite). The cartridge paper was primed first with white emulsion, so that the wash would sit on the painted surface.

Oil pastel washes
Oil pastel melted with turpentine was painted on to unprimed cartridge paper so that the turpsy washes would sink into the surface. In some parts, such as the hills, layers have been built up by fixing and drawing thickly over the top.

Encaustic washes
Here the pastel was melted in a spoon held over a tealight and then applied with a brush on to card primed with white emulsion. Melted wax dries quickly, so layers can be built up without fixing. When using this method it is essential that no fixative, turpentine or other highly flammable substances are applied.

Layered oil pastel drawing
The watercolour paper substrate was primed with shellac and the warm ochre tone, maintained as an essential part of the drawing, can be seen showing through in the white wall.

The figure and wall were built quite densely with fixing and then overdrawing. The final layer has been smudged with an eraser to give soft edges and an additional change in texture.

Artist's tips

- To create a coloured background to draw over, take a light ochre oil pastel and scribble evenly and lightly over the surface. Then make a wash by painting over the pastel with a large brush loaded with turpentine. **(A)**

- Turpentine can be applied at any point in the drawing to melt the oil pastel and create a wash over the surface. **(B)**

- Sgraffito is the effect achieved by scratching through one surface of oil pastel with a knife or palette knife to reveal another. **(C)**

- Oil pastel can be melted on a spoon over a tealight. Ensure there are no flammable liquids anywhere near the naked flame. Apply the melted oil pastel 'encaustic' with a brush. **(D)**

- An eraser can be used to smudge the surface and to change the texture. **(E)**

- Clean and sharpen pastels with a small knife and a rag or paper towel.

- Barrier cream or protective gloves are helpful for protecting hands and fingernails.

- Prime your paper with white emulsion or gesso to keep the pastel from being sucked into the surface, and thus losing the beautiful sheen the oil and beeswax create in artist-quality pastels.

- Shellac or button polish, with its warm ochre colouring, is also worth considering.

A

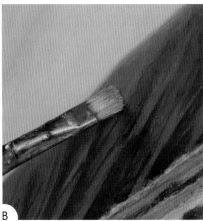

B

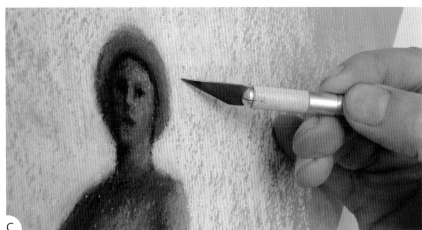

C

D

E

Artist profile
ANGELA A'COURT

Originally from London, Angela A'Court now lives and works in New York. She studied at Goldsmiths in London, and Parsons, The New School for Design in New York, gaining a degree in fine art textiles. After 15 years as a successful interior designer, with work featured in magazines such as *Homes and Gardens* and the *Sunday Times*, she made a return to fine art. Elected to the UK's Pastel Society in 2009, she now exhibits in both the US and the UK.

A'Court's subject matter is the still life. She draws first from observation, choosing simple domestic objects – a mug, a chair or flowers in a vase. Once observed, these elements are abstracted, reworked, rearranged and refined. Colours are heightened, juxtaposed and overlaid until they vibrate.

Objects are also chosen for their meaning. A'Court explains, 'It is the overlooked aspects of everyday life that interest me – the beauty of everyday ordinariness, private worlds, the unsaid; the precarious nature of what happens day to day.' For her, these still lives are 'the remnants of human presence' and through these objects we are invited to reflect upon the people who have touched and placed them.

A'Court's working process is an explorative, intuitive mix of several disciplines: pastel, print and collage. For example, she will try out ideas from her sketchbook by drawing directly on to a silk screen in pastel and then printing from it. 'I love it as a process and it's a good way to get into the flow of experimenting with new ideas. There's an alchemy of an accident.'

Pastel is chosen because of its directness, but also because its softness allows creativity – A'Court finds that the physical hard work required energises her. And because there is no waiting for it to dry, there is a direct connection; she can make a mark and work into it straight away, adding, layering and scratching back into the surface.

Above all, A'Court values being able to work with intense, vibrant colour. It is this that makes her a real advocate for the medium, encouraging others to experiment and use it in new ways. 'With pastel, I am holding a stick of pure pigment in my hand. There is no intermediating catalyst of a paintbrush or pen – just colour that is applied directly to the work surface.'

Right: Pastel offers a range of vibrant colours for the artist to work with. Photograph by Ty Cole.

Opposite top left: What I Love About You. *Soft pastel on paper.*

Opposite top right: Yellow Cup. *Soft pastel on paper.*

Opposite bottom: Deep Red Roses. *Soft pastel on paper.*

GALLERY

Above: Red Sky at Night. *Soft pastel on paper, by Robin Warnes.*

Opposite top left: Untitled. *Ink and pastel on paper, by Huma Bhabha.*

Opposite top right: 17. *Oil pastel on paper, by Thomas Gosebruch.*

Opposite bottom left: New York Skaters IV. *Pastel on monoprint, by Bill Jacklin* RA.

Opposite bottom right: Untitled, *from the 'Types' series. Oil pastel, watercolour and pencil on paper, by Laylah Ali.*

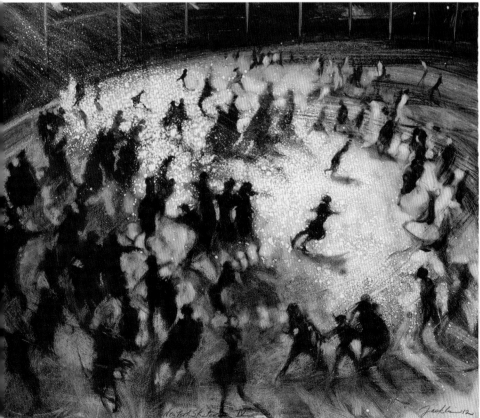

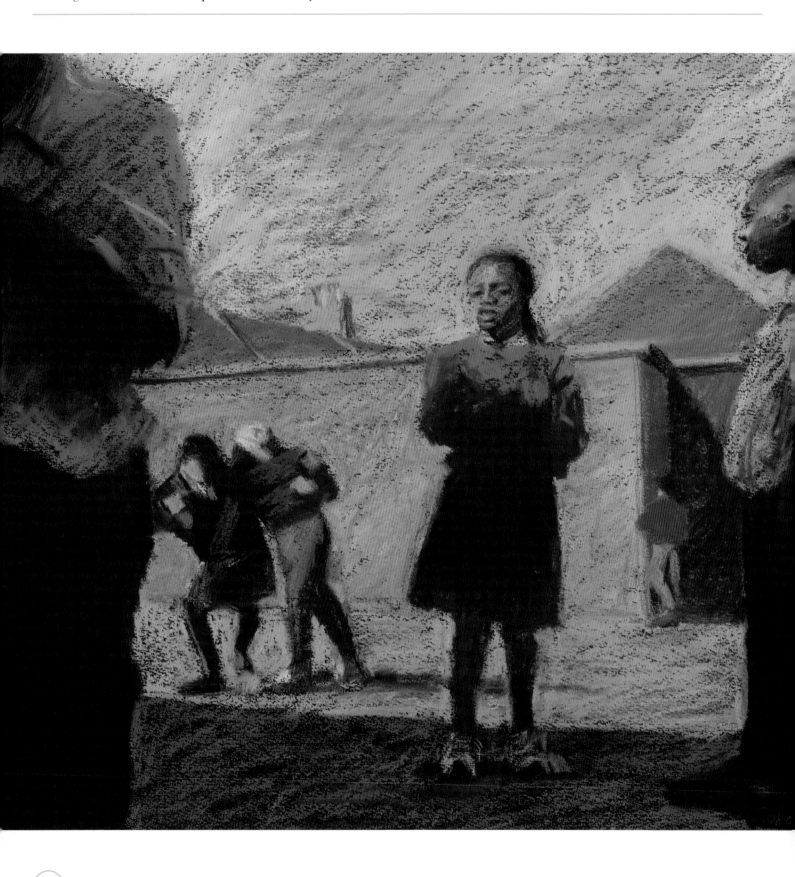

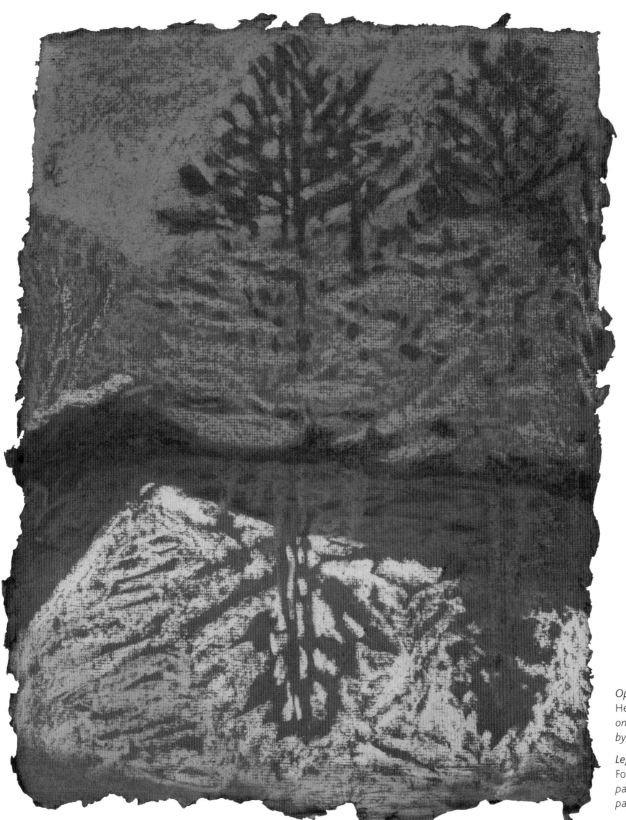

Opposite: Standing
Her Ground. *Soft pastel
on black paper,
by Oliver Bevan.*

Left: The Hours: Albers
Foundation Estate. *Chalk
pastel on Khadi coloured
paper, by Mark Cazalet.*

2

PAINTING MATERIALS AND TECHNIQUES

Stevie Smith
and the Willow.
*Oil and acrylic on
aluminium, by
Sarah Pickstone.*

Chapter Five

COLOUR

OVERVIEW

While some people have a natural flair for colour and can 'feel' their way when choosing combinations, others get into a mess when starting to work in paint because they are uncertain of which pigments to buy and, when they have them, how to mix them. If you are having difficulties, colour theory can be helpful.

Paint and colour

You will learn a lot by mixing and experimenting with paint. Paint is physical. Pigments react in different ways, according to how finely they can be ground and how easily they mix with the binder. Binders affect the way colour can be laid down: transparent, opaque, overlaid or chunky. Playing with various types of paint and with colours of different consistencies will help you understand and exploit these qualities.

Subtractive colour theory

This describes the mixing of pigments. Two primary colours make a secondary colour, but this secondary colour is always less vibrant than the two primaries. The more colours are added, the duller the mixture gets. When pigments of all colours are mixed together, they make a sludgy brown/grey colour. This does not mean that greys and browns have to deaden your painting. The challenge is to recognise them as specific colours and use them to offset the more vibrant colours.

A

This subtractive colour wheel is based on primaries of cyan, magenta and yellow, plus black. It is used for commercial and desktop printing. **(A)**

Systematic application

Biggs and Collings explore the systematic application of colour theory when mixing and applying paint (see left). Subtle shifts in tone and colour intensity are a feature of their work. Notice how the greys offset the brighter colours.

Left: 807 Years *(detail). Oil on canvas, by Biggs and Collings. See also p.150 for full work.*

B

This subtractive colour wheel is based on primaries of warm red, warm blue and cool yellow, and may well be the colour wheel you were introduced to at school. **(B)**

Additive colour theory

Additive colour theory describes the mixing of light and is the type of colour you see on a computer screen. Two overlaid primary colours make a vibrant secondary, and colours become purer the more are added. Added together, all colours make white. **(C)**

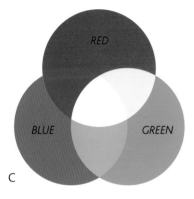

C

Content for digital colour options contributed by MARTIN BEEK.

Below: Chiltern, Oxfordshire. *iPad painting using a digital Brush tool, by Martin Beek.*

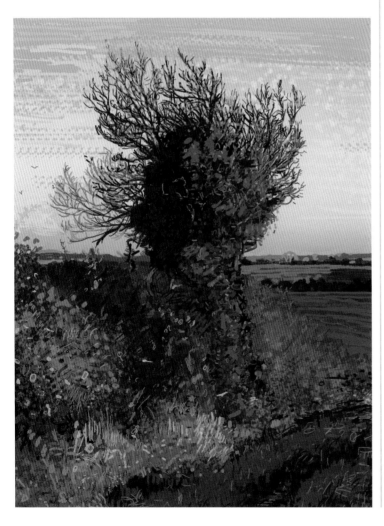

Advantages

- Colours onscreen are made with light (additive colour) and so look very pure and vibrant.
- There is no waiting for paint to dry, and no contamination from one colour to another. Brushstrokes can therefore be overlaid cleanly.
- Some programs have layers that allow colours to be overlaid over drawings and photographs. Multiple layers can be created, turned on or off, and hidden or deleted, enabling you to try out different colour combinations. The transparency or opacity of overlaid colours can also be manipulated. **(D)**
- Existing images can be scanned in and the colour balance, hue, saturation and tone altered to give immediate alternatives. **(E, F)**

Disadvantages

- Colours are likely to look less vibrant when they are printed (subtractive colour). To overcome this, some artists display their digital works on a wall-mounted monitor.
- Because the feel is more like drawing on glass, you may miss the physicality of working with the actual stuff of paint.

D

E

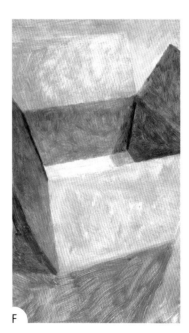

F

Techniques
CHOOSING A PALETTE

You may have learnt at school that you only need the three primaries – red, yellow and blue – plus white. This is not strictly true. Not even the modern CMYK pigments used in commercial printing will provide every colour you might need.

Titanium white

One solution is to use two of each primary plus white, choosing a warm and a cool from the equivalent pigments and brand names listed below. You may also wish to add earth colours, black, violet and magenta.

Yellow ochre

Warm and cool

Warm is used to describe colours that have red in them, and cool to describe those with more blue. In practice they are applied when making comparisons between two similar colours. For example, alizarin crimson is more purple than cadmium red and is therefore described as 'cool'.

Primary colours

Cool yellows: chrome yellow (hue)/primary yellow/ CMYK yellow/azo yellow/lemon yellow
Warm yellows: cadmium yellow(hue)/permanent yellow deep
Cool blues: cerulean/primary blue/cyan (CMYK blue)/ phthalocyanine blue
Warm blues: French ultramarine/ultramarine blue
Cool reds: alizarin crimson/permanent alizarin/primary red/quinacridone rose
Warm reds: cadmium red(hue)/spectrum red

Burnt sienna

Earth colours

Yellow ochre, raw sienna, burnt sienna, raw umber, burnt umber: these are a good shortcut to making brown, and cheaper than the primaries to buy.

Whites

Titanium white: a modern pigment that gives a good opaque white.
Zinc white: a cool, transparent white that is good for semi-transparent glazes.
Lead white/flake white: more transparent, faster drying and warmer in colour than titanium white. Very toxic.

Blacks

Lamp black, ivory black: while it is possible to create a black with the complementaries violet and yellow, tube black is a shortcut to making deep tones and cooling down colours. When mixing, note that blacks have a blue bias.

Lamp black

Lemon yellow

Cadmium yellow

Cerulean blue

French ultramarine blue

Alizarin

Cadmium red

Artist's tips

There are a few things to bear in mind when buying paints.

- Some colours fade in light while others darken. Manufacturers will rate the stability of the colour with a number. This varies with country. For example, using the American Standard Test Measure (ASTM), I is excellent, II is very good, III is fair or non-permanent. IV and V pigments are rated poor and very poor and are not used in artist's-quality paint.

- Paint manufacturers have improved paint stability by substituting older pigments with synthetic equivalents. Sometimes the older name is given, but the word 'permanent' appears alongside, as in 'permanent alizarin'. Alternatively, synthetic pigments are labelled as primary, spectrum or CMYK colours.

- Some pigments are toxic, and the label will tell you this. They can be absorbed through the skin and should not be ingested.

- Artist's paint contains more pigment than that made for students. It has more tinting strength and goes further.

- Colours vary according to manufacturer, as do feel and consistency.

The pictogram used as standard across the European Union to indicate a chemical hazard.

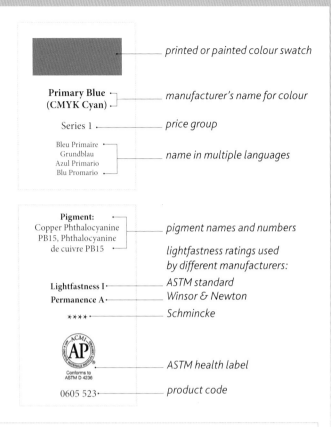

printed or painted colour swatch

Primary Blue (CMYK Cyan) — *manufacturer's name for colour*

Series 1 — *price group*

Bleu Primaire
Grundblau
Azul Primario
Blu Promario — *name in multiple languages*

Pigment:
Copper Phthalocyanine
PB15, Phthalocyanine
de cuivre PB15 — *pigment names and numbers*

lightfastness ratings used by different manufacturers:

Lightfastness I — *ASTM standard*
Permanence A — *Winsor & Newton*
★★★★ — *Schmincke*

— *ASTM health label*

0605 523 — *product code*

AP seal

Products bearing ACMI's AP (Approved Product) seal are certified in a programme of toxilogical evaluation by a medical expert to contain no materials in sufficient quantities to be toxic or injurious to humans, or to cause acute or chronic health problems.

Conforms to
ASTM D 4236

Greens

Mixing your own greens will mean that they are more likely to harmonise with the other colours in a painting.

Violet

A good vibrant violet can be tricky to mix, so can be a good addition to your palette if you wish to work with saturated colour.

Magenta (CMYK)

Like violet, magenta will give good, vibrant purples. Mixed with yellow it gives red, but a duller red than a primary.

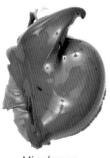

Mixed green

Violet

Mixed red

Magenta

Techniques
COLOUR MIXING

Once you start mixing secondaries and tertiaries, the advantage of having warm and cool primaries will soon become apparent. Simple colour theory will really help when mixing colours from observation, and the addition of a few earth colours will save you time and money when wanting to mix browns.

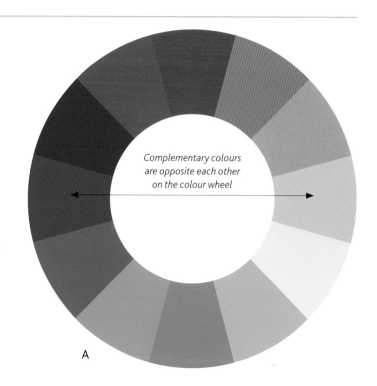

Complementary colours are opposite each other on the colour wheel

A

B

Cool blue mixed with cool yellow

C

Warm blue mixed with cool yellow

D

Cool red mixed with cool green

E

Warm red mixed with warm green

Mixing secondaries and tertiaries

Secondaries and tertiaries are the colours you can mix from your primary reds, yellows and blues. This is illustrated very simply by the colour wheel **(A)** but is more subtle in reality. For example, **(B)** shows the range of vibrant greens gained from mixing a cool cerulean blue with a cool lemon yellow. **(C)** shows how a warm blue mixed with the same yellow will result in a set of darker, browner greens.

Complementary colours

Complementary colours can be found opposite each other on the colour wheel – i.e. green and red, blue and orange, and yellow and purple **(A)**. Mixing two complementaries together will give a subtle range of greens and browns **(D, E)**. If you compare the warm red mixed with green **(E)**, with the shades below, you will see the resulting colours are very different to those given by black added to red **(F)**.

F

Warm red mixed with black to make shades

Shades and tints

Colours can be greyed and made darker by adding black **(F)**. They can be made lighter and duller by adding white **(G)**. Black has a blue bias, which means that, in this case, the tints gained from the shades are purples and violets.

G

Above shades mixed with white to make tints

Matching colours

It is not hard to mix subtle colours, but it can be hard to match them. Thinking in terms of complementaries will give you some control over your colour mixing when working from observation.

1 The cardboard box appears slightly pink, so start with a warm red. **(A)** The red is far too dark so add white to make it lighter and pinker.

2 The resulting tint is now too pink, so dull it with the complementary green.

3 It is now too orange, so dull with the complementary blue.

4 The colour is now much closer but it is still too pink. **(B)**

5 Add a little more green and a little more white. Colour match. **(C)**

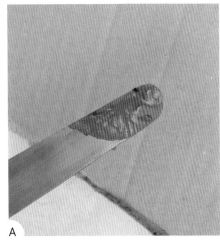

A

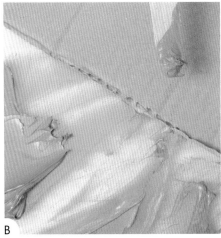

B

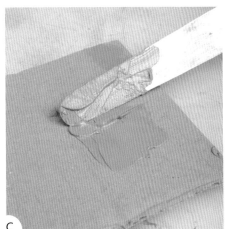

C

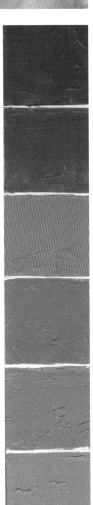

Right: This sequence shows the starting point with cadmium red, through to the colour match with the box.

Mixing with earth colours

Starting with an earth colour can save time when mixing greys.

1 Raw sienna is an orange brown and pretty much the colour reached by point 3 in the exercise above. **(A)**

2 Add the complementary blue to dull. **(B)**

3 It is now too dark and too green, so add white and a little red. Colour match. **(C)**

Right: This sequence shows the starting point with raw sienna, through to the colour match with the box.

A

B

C

Techniques
THE EFFECT OF APPLICATION ON COLOUR

The way that you lay down paint will have a direct effect on its colour. Thinning the saturated colour will make it lighter, while retaining vibrancy. As can be seen from the examples on this page, this is very different to the effect of mixing in white to lighten the paint. So when painting, the thickness and the consistency of a colour can be exploited to change it.

Below left: Red Stone. *Oil, gesso and collage on board, by Marion Thomson.*

Below right: Rain in Durango. *Acrylic on canvas, by Mali Morris* RA.

A

Cadmium red hue and cadmium red tint painted thickly over a white ground. **(A)**

B

...brushed over a black ground. **(B)**

C

...brushed over a yellow ground. **(C)**

Applying a single colour in various ways
In this painting by Marion Thomson, the same orange has been applied in different ways. The paint was first rubbed thinly into a semi-absorbent traditional gesso ground. Then a thicker second layer was applied to give a darker rectangle. Finally, a piece of canvas painted black was collaged on to the surface and an orange tint brushed over it for yet another variation on the colour.

Overlaying colour
It is also possible to change one colour by laying it over another. Here **(A to C)**, cadmium red and tints of cadmium are rubbed over grounds of yellow and black. This effect can be seen in the painting *Rain in Durango*, by Mali Morris, where the same thin, transparent red is washed over the top of rectangles of different vibrant colours.

D

Cadmium red applied thickly with a palette knife. **(D)**

E

Cadmium red thinned with medium and brushed on. **(E)**

F

Cadmium red rubbed thinly into the surface with a rag. **(F)**

G

Cadmium red mixed with white. **(G)**

Artist's tips

Laying a coloured ground/underpainting

- For a plain colour, simply rub the paint into the surface with a rag. It can be spread out more or less thinly, depending on how light or dark you want the ground to be. Alternatively, the paint can be thinned and applied with a rag or brush and allowed to dry. **(A)**

- Paint out a design in thin monochrome paint so you can concentrate on composition and tone. Here a warm brown was used. **(B)**

- The choice of colour for the underpainting will have a direct effect on the colours placed over it. Here the warm brown acts as a complementary colour to the cool blue grey scumbled over it. The grey is modified from below by the tones in the underpainting. **(C)**

- Drawing on coloured paper is just as effective. In *Red Nude* by Alison Harper, the dark red gives vibrancy and contrast to the pastels drawn over the top.

- Try scratching into wet paint to reveal the ground beneath. In *Nelson's River,* a black underpainting allows black lines to be drawn into the green and blue overpainting.

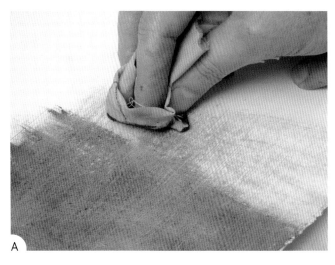

A

Bottom left: Red Nude. *Pastel on paper, by Alison Harper.*

Bottom right: Nelson's River. *Oil on board, by Kate Wilson.*

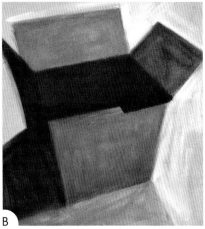

B

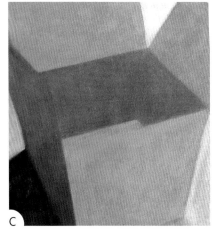

C

Techniques
COLOUR CONTRASTS AND EMOTIONAL COLOUR THEORY

Colours have their own energy. In the world we observe, and in the paintings we make, colours affect each other and appear to be altered by those around them. Mark Cazelet's pastel studies (p.77) and Biggs and Collings's paintings (p.150) give us examples of the many ways that colours can be made to interact, and how changes in tone, saturation, temperature and proportion can be manipulated to give very different results.

A

B

C

D

E

F

G

H

Colour contrasts

- You will see in this first pair that the yellow ochre looks very different, depending on the background colour. This is due both to tonal and colour contrast. Yellow and orange are close in tone and colour (see Harmonious colours, right). Ochre and cyan blue are very different in tone, and opposite in colour (see Complementaries). **(A, B)**

- The proportion of one colour to another also makes a difference to how combinations 'feel'. When the amount of ochre and orange, and ochre and cyan in A and B are reversed, the result looks and feels very different. **(C, D)**

- Saturation also affects how colours relate to one another. Here the cyan and cool primary red appear to resonate together because they are at their most intense. When diluted or mixed with white, they have less impact and are more gentle in feel. **(E, F)**

- The idea of warm and cool can be very useful when choosing colour combinations. In the first square a cool grey is placed against a blue tint of the same tone. It sits quietly. When warmed slightly with the addition of a little yellow ochre, the colours begin to interact, rather as the addition of salt adds flavour to food. **(G, H)**

Vocabulary to describe colour contrasts

Tonal value – how light or dark a colour is. This is easier to see if you look through your eyelashes to cut out the intensity of the colour.

Chroma or saturation – the intensity or strength of a colour. This can be altered or dimmed by thinning the paint, or by adding white or black or the complementary.

Harmonious colours – this term describes colours that are derived from each other, and therefore sit near each other on the colour wheel – yellow and orange, blue and green, red and purple.

Warm and cool – warm colours have more red and cool colours have more blue. This is a simple way to describe colour difference based on visual comparison. For example, these terms can be used to describe the difference between red and blue, two reds or, most usefully, two similar greys. Many paintings are based around warm and cool. A predominantly blue painting is likely to have some touches of warmer colour to give contrast and excitement.

Complementaries – are warm and cool, for example, red with green or orange with blue.

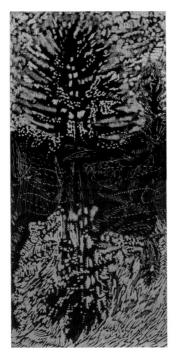

Right: Nocturne on Anni's Pond: Albers Foundation Estate. *Gold and silver pencils, oil pastels, oil marker pens and crayon on paper, by Mark Cazalet.*

Far right: Annunciation. *Oil on canvas, by Alison Harper.*

Below: I Dreamed of Orange. *Oil on canvas, by Alison Harper.*

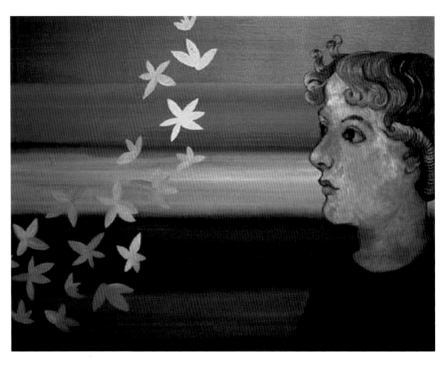

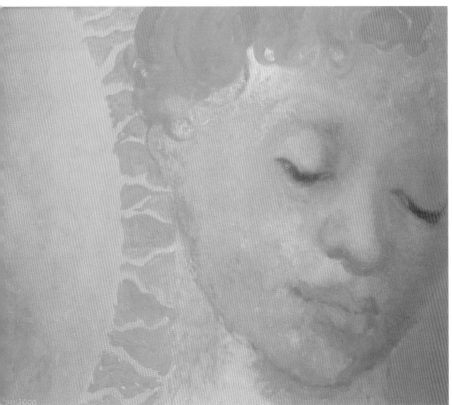

Goethe's colour triangle

Colours affect us emotionally. Our response cannot be accurately predicted, as this is a socially and culturally conditioned reaction, as well as a personal response. However, Goethe's colour triangle, developed at the turn of the eighteenth century to illustrate his theory of colour and emotion, generally corresponds to the use of colours in art and can be used as a starting point. You may like to test the usefulness of this yourself by comparing these two paintings by Alison Harper (left and above right) and the emotions they evoke with the chart below.

Chapter Six

MATERIALS

Supports
PAPER

Paper is made from pulped cellulose fibre taken from a variety of plants, such as cotton, sugar cane or bamboo. When choosing paper, you should think about its pH neutrality, its texture, its absorbency and its weight.

PH neutral papers (also called acid-free papers) are guaranteed not to yellow or grow brittle over time.

Rough and cold-pressed (NOT) papers come in a variety textures that result from the weave of the blanket or mesh that the pulp was laid on. Smooth hot-pressed paper is made by pressing these sheets between hot plates and rollers.

How absorbent a paper is depends on whether size has been added during the papermaking process. All cartridge and watercolour papers are internally sized, and generally watercolour papers are also surface-sealed with gelatin. Soft absorbent papers such as Somerset printmaking paper are less heavily sized.

The thickness of paper is measured in grams per square metre (gsm), ranging from 12gsm for a thin, transparent Japanese paper, to 640gsm for card or watercolour board. (In the US, paper weight is measured in pounds.) Generally, Western papers under 300gsm should be stretched to prevent buckling when painting.

Digital options: PRINTING

Works produced on the computer can be printed on to archival paper produced especially for digital printing. (J)

Paper types

Zerkall, hot-pressed smooth paper (**A**). Wet-and-dry paper (**B**). Sandpaper (**C**). Black card (**D**). Canson pastel paper (**E**). Arches 88 hot-pressed unsized paper (waterleaf) (**F**). Brown wrapping paper (**G**). Japanese gampi (**H**). Khadi bagasse rough (**I**). Hahnemühle German etching inkjet paper (**J**). Saunders Waterford NOT (**K**). Two Rivers handmade watercolour paper rough (**L**).

Preparing paper

Stretching paper

- Place the paper in a bowl of cold water to dampen it. Leave it for a few minutes.
- Shake off the water and place it on a clean wooden board.
- Cut and dampen four strips of thick gummed tape. **(A)**
- Stick the edges of the paper to the board with the gummed tape strips. **(B)**

Adding a texture to a paper surface

- Stretch the paper.
- Paint it with rabbit skin glue.
- Sprinkle the paper with pumice powder or marble dust. **(C)**
- Allow the paper to dry.

Laying paper on board

Sticking paper on to board can give your paper more stability, and the board a different surface.

- Sand the board.
- Cut the paper a little larger all round than the board.
- Size the right side of the board with lukewarm rabbit skin glue or dilute PVA. **(D)**
- Lay the paper on the glue. Place a second, thinner piece of paper over the first to protect it, and smooth from the middle outwards, making sure that any air bubbles are pressed away and the paper is sticking well. **(E,F)**
- Allow to dry.
- Turn the board over, and trim the paper with a knife up to the edges of the board. **(G,H)**

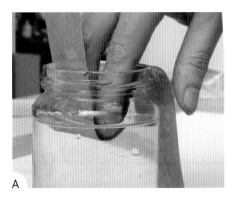

A

B

C

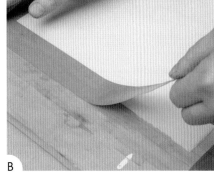

D

E

F

G

H

Supports
BOARDS

The boards featured here can be prepared and primed as a whole sheet, then cut up into sections afterwards. Scraps are often found at timberyards and in skips, making this a cheaper option than canvas. Boards provide the most stable surface for painting, but large, thin boards should be battened or cradled to keep them from warping.

Below: Boards must be sealed front and back to prevent warping – particularly on the cut edge, to prevent moisture from entering.

Archival mountcard
The advantage of using archival mountcard is that it is pH neutral and so, unlike cardboard from a supermarket, will not yellow or grow brittle over time. **(A)**

Particle board (chipboard)
This is lighter and less dense than MDF or hardboard, and more vulnerable to expansion and discolouration due to moisture. It should be sealed well. **(B)**

Medium-density fibreboard (MDF)
MDF is made from sawdust and glue, pressed through rollers to make a solid sheet. Because it is uniform in structure, it provides a very stable surface for painting. MDF comes in different thicknesses and is the most attractive of all the boards on offer, looking like a solid wood panel. However, unlike the other fibre boards mentioned here, it contains carcinogenic ingredients, and a mask should be worn when cutting and sanding. **(C)**

Hardboard (high-density fibreboard)
This is similar to MDF but, since it is manufactured under pressure, it is a stronger product, and does not contain the same carcinogenic ingredients. Usually thinner than MDF, it is available with a smooth front and textured back, or with two smooth sides. **(D)**

Plywood
Plywood is made from thin layers of wood that are glued together. The layers are rotated so that, unlike in a solid piece of wood, the wood grain works in all directions and the danger of warping is reduced. However, because it is under tension, it is less stable over time than hardboard or MDF. **(E)**

Cardboard
Made from pulped wood, cardboard makes a good light surface for small paintings. If longevity is an issue, a pH-neutral product such as archival mountcard should be chosen and the surfaces sealed well. **(F)**

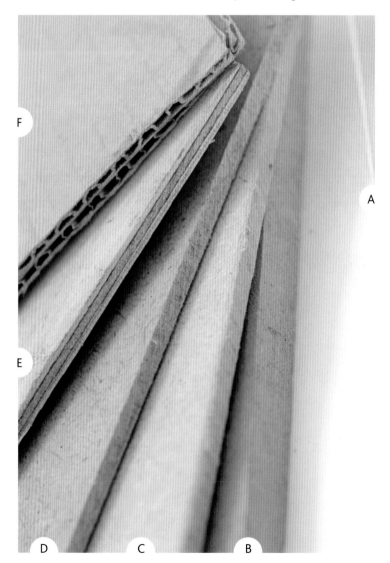

Preparing boards

Covering a board with canvas

- Sand the board.

- Cut a piece of canvas or muslin 5cm (2¹/₂in) larger all round than the board, and another piece 1cm (³/₈in) smaller all round than the board.

- Size the right side of the board with lukewarm rabbit skin glue (for oil paint), dilute PVA or acrylic medium. Smooth the larger piece of canvas over it, keeping the weave parallel to the edge of the board. **(A, B)**

- Brush more glue over the surface, smoothing out from the centre to remove any creases or bubbles. **(C)**

- Turn the board over and trim the canvas across the corners, leaving some margin for shrinkage and the thickness of the board. **(D)**

- Size the back of the board and stick down the canvas edges. Fold in and stick the corners. Do not pull too tight or the board may warp.

- Place the smaller piece of canvas on the back of the board and smooth it into place.

A

B

C

D

E

F

Battening or cradling hardboard

Generally, panels longer than 100cm (40in) in length will need bracing. This can be done after the board has been painted. If this is the case, nails should not be used and the panel must be clamped to the wood until the glue is dry. Battening supports the panel around the edge, while cradling provides bracing at the back in the form of two struts.

Battening

- Cut four lengths of wood and join them with corrugated nails.

- Glue them to the wrong side of the board and clamp or glue and tack them in place with panel pins. **(E)**

- If used, the panel pins should be nailed in at approximately 5cm (2¹/₂in) intervals on the right side of the board.

- Countersink the pins and fill the holes with plastic wood.

- Sand the edges.

Cradling

- Cut two struts shorter than the width of the board. Drill holes if using screws.

- Glue them to the back of the board, placing them so that they divide the surface into thirds. **(F)**

- Clamp until the glue is set, or screw into place.

Supports
METAL AND GLASS

Metals have very smooth, non-absorbent surfaces that allow paint to skid around, but they lack a grain or tooth to help it stick. They usually respond to exposure to air, moisture and heat, so unless you wish to exploit these changes, they must be primed carefully according to metal type. For example, steel rusts easily, while copper is soft, dents easily and expands and contracts with changes in temperature.

As a rule, metals must be degreased thoroughly with white spirit, then abraded with sandpaper or a self-etching primer, before being primed with an oil/alkyd or alkyd primer. Different metals will have different properties, so take advice specific to both the metal and your chosen paint.

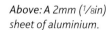

Above: A 2mm (1/8in) sheet of aluminium.

Left: Cumulus. *Graphite powder, resin and oil on coated aluminium, by Christopher Cook.*

Cook moved from working in graphite on paper to working on large sheets of aluminium. Unlike paper, the metal did not need glazing and framing, thus allowing the graphite surface to be displayed in a quasi-industrial manner.

Aluminium panels

Aluminium is often chosen as a support since it is not susceptible to oxidisation and does not react to changes in temperature. Unlike board, it will not warp if stored in damp conditions (though remember that paint – particularly acrylic – is susceptible to changes in temperature and humidity). Aluminium sheet in a variety of thicknesses can be bought cut to size and, if small scale, does not need battening.

• If wishing to work at a large scale, the lightest metal support is a corrugated honeycomb aluminium panel. Developed for the construction industry, these can also be used as supports for paintings. They need degreasing and sanding before priming.

• Alternatively, 2mm (1/8in) aluminium panels can be bought primed and ready-made, mounted on metal frameworks. These can be hung on the wall in a similar way to a canvas or a stretcher.

Glass or acrylic sheet

These are slippery surfaces so the paint will find it difficult to stick. Glass should be sandblasted and at least 4–6mm (1/6–1/4in) thick, as anything thinner is very susceptible to breakage. Acrylic sheet should be sanded to give a slight tooth. Before painting, surfaces should be thoroughly cleaned and degreased with methylated spirits.

Although they can be primed and treated like conventional rigid supports, glass and acrylic sheet can also be used for back-painting. This is when a painting is made in reverse on the back of glass or acrylic sheet and is then viewed through it. The painting is started with what would normally be the top and final layer, and ends with the primer.

Above: Jump. *Oil on glass, by Katherine Englefield.*

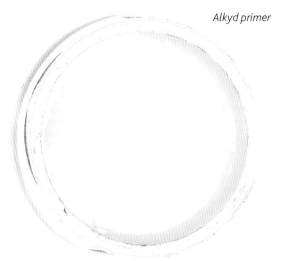

Alkyd primer

Glass sheet

Acrylic sheet

Supports
CANVAS

Although a rigid surface is the most stable support, it can be heavy. Stretched canvas gives you a lightweight, flexible, easily portable surface. It can be taken off the stretcher and rolled up for storage. Linen and cotton are both widely used, in different weights and with various weaves. They come raw or primed by the metre, or primed and ready-made on stretchers.

The surface you choose will depend on how you wish to paint. A smooth application may benefit from a smoother canvas, while a coarse weave will provide a tooth for a bulky use of impasto. Thicker canvas or linen are good for a large-scale painting, while thin butter muslin is a good for mounting on board. I always ask to feel the different surfaces before I buy.

Above: A wooden stretcher.

Below: Lightweight canvas (A), fine linen (B), heavy linen (C), butter muslin (D), heavy-weight canvas (E), scrim (F).

Stretchers

Stretcher pieces can be bought in different lengths, ready to assemble. The better ones have a built-in bevelled edge at the front to hold the canvas away from the stretcher when painting. This is quite important as the paint will look different if painted against wood, and a line can form where the stretcher starts. Alternatively, you can make your own from lengths of 5 x 2.5cm (2 x 1in) wood, with simple halving joints and a bevelled edge made from quadrant. The bigger the canvas, the stronger the stretcher will need to be; larger stretchers – over 1m (3ft) – will need a crossbar or double crossbar. Triangles made from hardboard nailed on to the back of the corners make the structure more stable and less susceptible to warping.

Canvas pliers

Ready-primed canvas is much harder to stretch as it has no give. Canvas pliers are therefore needed to get a good grip on the fabric in order to pull it taut.

Although pliers are recommended for primed canvas, stretching a large unprimed canvas is hard work and can take the skin off your knuckles. Pliers will grip the cloth for you – although you have to be careful not to pull it too taut as it may split when sized.

Canvas pliers

Preparing canvas

Assembling a stretcher

- Make sure that all the pieces are facing in the right direction, with the bevelled edge at the front.

- Push each mitred joint together. Tap them with a wooden mallet so they fit together properly. **(A)**

- Make sure that the rectangle is square by checking the corners against a set square or placing it on the corner of a table.

- If the stretcher does not have a bevelled edge, cut lengths of quadrant with 45-degree angles at each end to make a neat corner, then glue and nail into place. **(B)**

- On large canvases, a triangle of hardboard nailed on to the back of the corners will make the structure more stable.

A

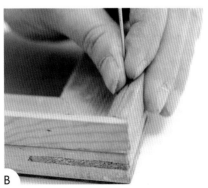

B

Stretching canvas

It takes practice to know how tightly to pull a canvas to stretch it. Firstly, you will find it is easier to pull the canvas in the middle and harder at the corners. The trick, therefore, is not to pull the canvas too taut at the beginning of the process. Secondly, a canvas to be painted on with acrylic will require stretching more tautly than one to be sealed with rabbit skin glue, which will shrink the canvas as it dries.

- Place the stretcher bevelled side down on the canvas, making sure it is aligned with the grain of the fabric.

- Cut the cloth so that it is roughly 6cm (2½in) larger than the stretcher on all four sides.

- Put the first staple in and then follow the diagram, moving from side to side and out from the centre. Pull one side against the other until the weave looks even. **(C, D)**

- Fold in the corners neatly as shown. **(E)**

Repairing tears in canvas

- Cut a small piece of raw canvas that will just cover the tear. It should be of exactly the same sort and thickness.

- Size the patch and the tear on the back of the canvas.

- Lay the patch over the tear on the back, making sure the grain of the canvas lies in the same direction. Smooth it into place.

- Size again over the top, then let dry.

- Re-prime over the tear on the front of the canvas.

Removing bulges in canvas

Simply wet the back of the canvas with water and allow it to dry.

C

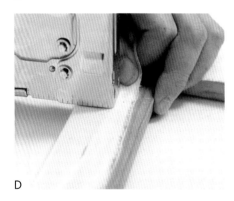

D

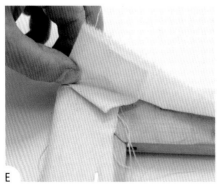

E

Tools and media
BRUSHES

There are two sorts of brush: soft or bristle. Soft-haired brushes are made from red sable, squirrel, ox or synthetic hair. (Japanese varieties are made from deer, goat, rabbit or wolf hair.) Stiff-bristle brushes are made from hog hair or synthetic bristles.

Japanese brushes

Round soft-haired brushes

Pointed round

Fan

Mop

Soft-haired brushes

Soft-haired brushes can hold a lot of thin, fluid paint, and because of their fine hairs, they make a smooth mark. They are therefore the type of brush used for thin washes in watercolour and gouache, for painting in ink, and for glazes in oil and acrylic. Unlike bristle brushes, round soft brushes come to a fine point and retain it while applying paint. They are used for detailed work in all paint media. The longer the hairs, the more paint they hold.

Bristle brushes

These are more robust than soft-haired brushes and are good for brushing on thick impasto paint, for scrubbing paint into a surface and for spreading paint out. They are therefore well suited to painting in oil and acrylic. With thinned paint, they give a coarser mark than a soft-haired brush, and for this reason they are seldom used in watercolour painting, although you may choose them for textural effects.

Shapes of brush

Soft and bristle brushes come in two shapes: round or flat. All these types of brush are made in sizes ranging from tiny to very large.

Round soft-haired brushes

• Pointed round or Japanese brush. These are good for fine detail and come in different hair lengths. The longer the hair, the more paint the brush will hold.
• Rigger, striper. These have extra-long hairs to help you to paint long lines of uniform thickness.
• Mop. This is used to lay out large areas of wash, to soak up paint and to manipulate glazes.

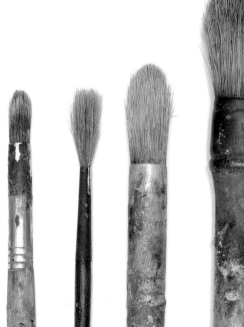

Round bristle brushes

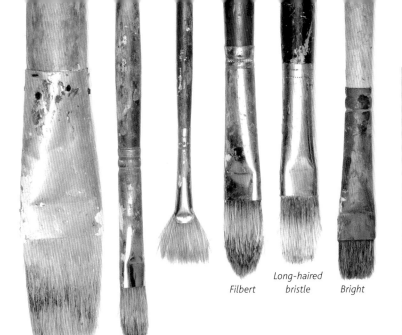

Flat bristle brushes

Filbert

Long-haired bristle

Bright

Flat soft-haired brushes
• Long-haired flat. Also called a one-stroke brush, these carry enough colour to make a single clean-edged stroke across a painting. The thin edge can be used to make sharp lines.
• Pointed flat. This tapers to a point when wet and forms a chisel edge when loaded with colour. It is good for softening edges.

Flat bristle brushes
• Bright. A short-haired flat, used for applying short dabs of colour.
• Long-haired bristle. This gives a longer, smoother stroke than the bright and holds more paint.
• Filbert. A flat brush with a rounded end. It combines some of the best features of a round and flat brush, and is good for painting up to irregular edges.
• Fan brush. Used to smooth out, blend and manipulate wet paint, this brush can also be used for textural effects with dry paint.
• Varnishing brush. A flat, wide, long-haired bristle brush for applying varnish to paintings in long strokes.

Artist's tips

• Soft-haired brushes are made with short handles for use with watercolour, and with long handles or use with oil and acrylic. You can save money if you buy short-handled brushes for both.

• Cheap brushes will not last long, but neither will badly treated expensive ones. With watercolour it is worth buying expensive brushes as the painting process does not destroy them and they will last for years. However the thinners used with oil paint are not kind to soft-haired brushes and it can be a good strategy to buy the cheaper synthetic version. Use them for a time and then throw them away.

• Flat decorator's brushes are very useful, both for priming and for painting with.

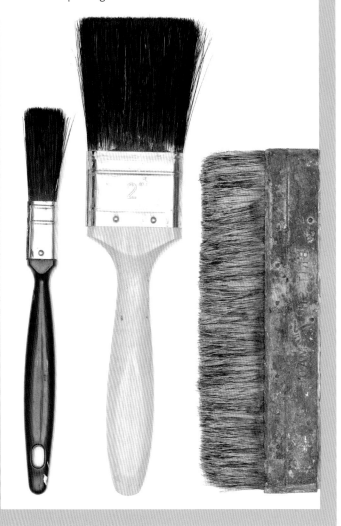

Flat soft-haired brushes

Pointed flat

Long-haired flat

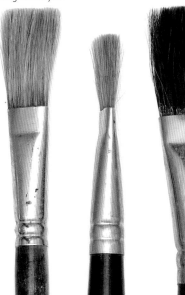
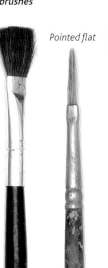

103

Tools and media
PRIMERS

Painting is a lot about feel, and primer contributes to this. Some people like a smooth surface, where the paint sits on top and skids around; others want some tooth or texture and more absorbency so that there is more pull on the paint. Some simply want to seal the support and to paint on the natural colour and texture of the board, canvas or metal. It is worth experimenting, as it is surprising how annoying an unsympathetic surface can be.

Below: The sealed or primed surface often influences the feel of the finished work. In this oil painting, the smooth primed surface shows through layers of thinned and dripped paint. Hull applies three layers of oil-based primer over glue size so that there is very little tooth to the canvas.

Priming is also about preservation. To remain stable, wood and most metals need protection from moisture in the air and should really be painted with a protective layer all over. Smooth surfaces, such as metal and plastic, need careful preparation because the paint finds it hard to stick and the primer chosen will help this.

Although acrylic can be painted directly on most supports and can be used to seal them, oil paint should almost always be painted on to a pre-sealed surface. If the support is porous, such as raw canvas or wood, oil can be sucked from the paint and the pigment left with nothing to stick it together. Also, the linoleic acid content of the linseed oil in the paint will rot canvas, so a sealant, such as rabbit skin glue or an acrylic primer, is needed to form a long-lasting barrier between the first layer of paint and the support.

Finally, a primer should be compatible with its support and the paint that will go on top. Although oil can be painted over acrylic sealants and primers, acrylic cannot be painted over those suitable for oil, such as rabbit skin glue – it will crack badly.

You will find disagreement on what is best practice. For example, for oil on canvas, some recommend one of the more flexible acrylic primers. Others suggest a more rigid glue or primer to help support the oil layer as it grows more brittle over time. Still another recommendation is to avoid canvas altogether and paint only on rigid surfaces – the type of primer then ceases to be an issue.

Right: Friend. *Oil on canvas, by Tony Hull.*

Artist's tips

- Paper or unstretched canvas can be taped or stapled to a board or wall.

- Canvases or boards are best laid on the floor as this helps prevent warping as they dry.

- A stretched canvas should be sealed and primed on the front and along the edges. Boards should be sealed or primed both front and back and along the edges to prevent them from warping and getting damp. **(A)**

- To save time, prime large boards of MDF or hardboard and then cut them up for individual paintings. Once cut, the edges can be sealed. **(B)**

Applying primer

- How you apply any primer will depend on the type of surface you wish to paint on. For a smooth, even coat, choose an area free from dust. Paint smoothly and evenly all in one direction. Sand when dry, then apply a second coat in the opposite direction. Again, you can rub this back with sandpaper when dry. **(C)**

- For a more uneven surface, primer can be brushed in all directions and, if wished, texture added into the second coat – sand, pumice powder, paper, etc.

- A small amount of colour can also be added to the final primer coat for a coloured ground.

A

B

C

Tools and media
PRIMERS

Sealants and primers
for acrylic and oil paint

Acrylic 'gesso' primer

Not to be confused with traditional gesso, there are various fast-drying acrylic primers available for use on board, canvas, metal, acrylic and even glass. These are the simplest of all primers to apply. Surfaces should be sanded, although they do not need sealing beforehand. It is advisable on porous surfaces such as board or canvas to dilute the first coat so that the primer can penetrate properly, and one or two coats should be applied. Generally, a canvas primed with acrylic will lack the tautness and 'ping' of a surface sized with rabbit skin glue, but the manufacturer Golden has developed primers that stiffen the canvas to mimic this. Different makes vary, but I have found acrylic 'gesso' to be a semi-absorbent ground. It should be sanded between coats if you want a smooth surface.

Recent tests indicate that acrylic primer retains very good flexibility over time – better than a traditional ground of size and oil primer. Therefore many manufacturers recommend it as a good option for canvas when painting in oil or acrylic. Golden is more circumspect, explaining that once oil paint has dried out and become more brittle, this flexibility may cause the oil above to crack; it recommends it only as a primer for oil on board.

Household emulsion

Most paints for home interior walls are based on polyvinyl acetate. PVA is less expensive than acrylic but, like oil, it has been found to become brittle over time and therefore less durable than acrylic. Household glues and paints are generally manufactured to last for up to 15 years. So although household emulsion will act as a sealant and primer, you may wish to use it only on short-term projects.

Acrylic 'gesso' primer

PVA glue

Like household emulsion, PVA glue is based on polyvinyl acetate. It can be used as a sealant, but it is more brittle than acrylic and is generally not used on canvas. However, the manufacturer Gamblin claims that PVA is a better sealant for oil paintings on canvas than rabbit skin glue or acrylic, because it forms a rigid support that will not absorb moisture from the air.

PVA glue

Acrylic media

Acrylic media can be used as a clear size to seal board or canvas before painting in oil and as a glue to collage with, and they will remain more flexible than PVA glue. However, not all makes of acrylic paints and media are chemically the same, and different makes should not be mixed. Always follow the manufacturer's advice on suitability and application.

Acrylic medium

Milk

Shellac

Sealants and primers for oil paint

Milk
The casein contained in whole milk can be used to seal paper. Simply paint it on and leave it to dry. This is an easy way to prepare sketchbook pages.

Shellac
Shellac is a resin made from the excretions of the lac bug, found in Asia, and is usually dissolved in alcohol. It can be used to seal paper, board or walls. It is very strong, but brittle, so not recommended for canvas.

Rabbit skin glue
Made from animal hides, this is the traditional sealant applied to surfaces before overpainting with oil primer, and an ingredient in traditional gesso, egg–oil emulsion primer and distemper (see recipe, p.192).

When used as a sealant, two coats should be applied so that the glue soaks in properly. When applied to canvas, the glue tightens it, giving the stretched cloth a satisfying tautness. Rabbit skin glue should only be overpainted with oil primer and never with an acrylic ground as the paint will crack.

Tests show that rabbit skin glue on canvas moves slightly and can cause aged and brittle oil films to crack. This swelling and contraction is caused by the glue absorbing moisture in the air through the back of the canvas. Despite this, a layer of rabbit skin glue is still a popular method of preparing canvas. As with acrylic 'gesso' primer, one solution is to avoid painting in oil on stretched canvas. You can mount canvas on board to provide a rigid surface with the same texture, although this will not have the same feel.

Traditional gesso primer
This is a brittle, chalky, white absorbent ground made from chalk and rabbit skin glue. It should be painted only on board, and preferably on board covered with muslin. The cloth helps the ground to stay on the edges and prevents it chipping off. Gesso is time consuming to prepare but the surface is unlike anything else to paint on – very different from acrylic or alkyd 'gesso' grounds. It is worth trying at least once (see recipe, p.196).

Traditional egg–oil emulsion primer
Oil and egg are added to the ingredients of traditional gesso primer to make a more flexible ground that can be painted on canvas (see recipe, p.197). In feel, it is quite like acrylic gesso, but more susceptible to yellowing and brittleness over time.

Alkyd primers
Artist's alkyd paints are mainly formulated for use on wood and canvas, and should be applied over rabbit skin glue. Some can also be used to prime metal. They are susceptible to yellowing and brittleness.

My favourite primer – thixotropic alkyd primer – is a superior version of a household non-drip gloss. In this context, thixotropic simply means a paint that is gel-like in the tin, fluid when painted, then gel-like again when left. This gives it a self-levelling quality and results in a smooth, shiny, non-absorbent surface.

Oil-based household primers
A wide variety of oil-based primers formulated for use on wood, metal and concrete are available in DIY shops. They are all alkyd based, so susceptible to yellowing and brittleness. Since they are made for household use, they will only last around 20 years.

Alkyd primer

Oil-based household primer

Rabbit skin glue

Tools and media
VARNISHES

Varnish is a clear or semi-clear medium that provides a protective finish. It is applied as a final layer that can be removed when a painting gets dirty. Some proprietary varnishes also come with ultraviolet light filters to protect the paint below from fading and yellowing. The most important thing is that, once dry, the varnish is soluble in something that will not also dissolve the painting beneath.

Varnishes come in a range of surface finishes – shiny, semi-matt and matt – and are also used to enhance the colour of a painting, or to tone it down.

Retouching varnish

Varnishes for oil

Oil paintings should be allowed to dry for between 6 and 12 months before varnishing, depending on the thickness of the paint. This allows time for the top layer of paint to oxidise, solidifying and forming a plastic surface that is no longer soluble in turpentine (turps) or white spirit. Although this process never really stops – and is why finished oil paintings continue to shift about for decades, and even centuries – these months allow the paint to settle. If the varnish is applied too soon, the varnish may develop a cloudy 'bloom' and crack as the oil paint shifts and contracts below it. It may also make the varnish more difficult to remove. Retouching varnish can be used as a temporary measure while waiting for the paint to harden.

Dammar

This is the least yellowing and most stable of the natural resins, and gives a shiny surface. It comes in crystal form and should be dissolved in turpentine to make a liquid: 1 part dammar to 3 parts turps (see recipe, p.110). It can also be bought ready-made. If you wish the painting to remain intact when the varnish is removed, you should not also use dammar as a painting medium as it does not oxidise with the oil in the paint and so remains soluble in turpentine.

Retouching varnish

This is a very dilute varnish that can be painted on to bring an overall temporary sheen to a surface before a painting is thoroughly dry. It is useful for bringing up any sunken patches of paint, or when a temporary varnish is needed. It can be overpainted.

Beeswax varnish

Dammar

Beeswax varnish

This is made from beeswax dissolved in turpentine, and can be applied as a second layer over a shiny varnish to give a matt surface. It is rubbed gently into the surface like a furniture polish and polished off with a soft cloth or a piece of silk. Beeswax is also added to commercially prepared varnishes to give a matt appearance (see recipe, p.110).

Waterborne acrylic varnish

Epoxy resin

Varnishing brush

Acrylic varnish soluble in white spirit (aerosol)

Varnishes for acrylic

Acrylic paintings have a soft, flexible surface that readily attracts dirt, so it is important to protect them. In the past, this slightly tacky surface made it difficult to find an acrylic varnish that was easily removable without harming the paint layer underneath. The best advice was to frame them behind glass. However, in the last few decades, more effective acrylic varnishes have been developed. Since different makes of acrylic are formulated in different ways, it is important to use a varnish made by the same manufacturer as your paint and to follow their instructions for application and removal. Acrylic paintings should be allowed to dry for at least 72 hours beforehand.

Waterborne acrylic varnish

Developed to have a harder film than acrylic paint, waterborne acrylic varnishes offer good protection and are easily removable. Golden polymer varnish is an example – it contains UV light filters to prevent the paint underneath from fading, and is removable with ammonia.

Acylic varnish soluble in white spirit

Epoxy resins

It has become popular to pour epoxy resin over the surface of acrylic paintings to give them a beautiful thick sheen and the appearance of being viewed through glass. Unfortunately, these resins are very hard, and grow brittle and discolour with age. More importantly, they are difficult to remove, so are not really suitable as a protective layer. It is important to remember, too, that any resin or medium used in such large quantities for a shiny effect is unlikely to be stable. An alternative might be to paint on glass in reverse (p.99).

Acrylic varnish soluble in white spirit

Acrylic varnishes soluble in white spirit or turpentine are tougher than waterborne varnish and are suitable for use with oil, gouache and watercolour, as well as acrylic. Soluvar by Liquitex and Golden MSA varnish are two examples. They are said to be very easy to remove, non-yellowing and come in both gloss and matt. MSA varnish comes with UV light filters. This type of varnish is also available as an aerosol, which means that it can be applied very thinly and evenly.

Tools and media
VARNISHES

Making your own varnish

Dammar varnish
Ingredients
- 1 part dammar
- 3 parts turps

1 Pour the turps into a jar. **(A)**

2 Tie the resin in a muslin bag and suspend it in the turps. Allow it to stand for two days. **(B)**

3 Strain through another piece of muslin to remove any debris. Store in an airtight jar.

Beeswax varnish
Ingredients
- 1 part beeswax
- 1 part turps

1 First make sure the room is well ventilated. Pour the turps into a jar and place in a pan of hot water to warm on the stovetop. **(C)**

2 Break up the beeswax and add it to the turps, stirring until dissolved. When cool, it will solidify. Store in an airtight jar. **(D)**

(Both dammar and wax can be mixed with turps in other proportions, and used as a painting medium, see p.157.)

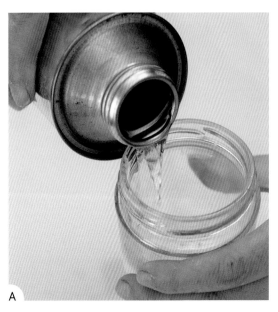

A

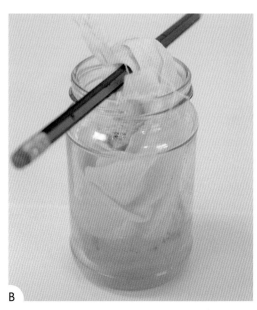

B

C

D

Artist's tips

- You can tell if your oil painting is ready to be varnished by rubbing gently with a cotton bud dipped in white spirit. If any paint comes away, it should be left for longer.

- Retouching varnish can be used as a temporary varnish if your painting is still drying.

- Most commercially prepared varnishes come in liquid or spray form in aerosols. The advantage of the sprays is that they can be applied very thinly and evenly.

How to varnish

Varnish should always be applied following the manufacturer's instructions, but here are some general guidelines.

- Make sure the painting to be varnished is dry and clean (dust and grease free). Dust the back as well as the front of the canvas. If necessary, clean the front of the painting using a cotton bud or cotton wool moistened with saliva.

- Pour the varnish into a shallow container and leave it in a warm place for half an hour to drive off any moisture and air bubbles.

- Lay the painting flat. Apply the first coat with a varnishing brush. Brushstrokes should all be made in one direction, parallel with the picture edge. **(A)**

- Allow it to dry overnight. Another coat will give more sheen and should be applied at right angles to the first, or as a spray to give a fine, even film.

- A matt effect can be made by dabbing the tacky picture varnish with a mop brush or by rubbing it gently with beeswax varnish.

Varnishing brush

Beeswax varnish

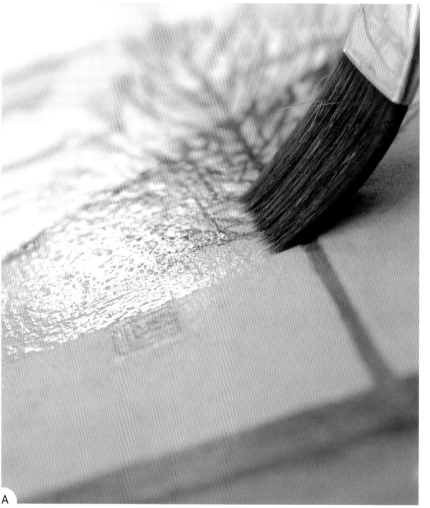

A

OVERVIEW

Watercolour is a fluid, transparent paint used in a variety of ways. Traditionally, in a 'pure' watercolour, the white of the paper is left to provide the light areas and the colour is painted on in washes. Gouache is a fluid, semi-transparent/ opaque paint, very similar to watercolour. It can either be worked in semi-transparent washes like watercolour, or painted on smoothly to give flat, matt, opaque areas of colour.

Watercolour is a challenging yet satisfying discipline. Generally, white pigment is not used, and in this watercolour differs from all other forms of painting, where it is perfectly normal to overpaint in white, and to add white to make tints. If the white of the paper is lost when working in watercolour, the top layer of paper can be cut away with a knife, or areas can just be washed or sponged away.

Watercolour is highly portable and much associated with eighteenth-century landscape painters such as Cotman, Cozens and the Victorian botanists who worked on location. Sally Mole works within this tradition, adding transparent colour washes to drawings made on the spot (opposite). However, it is useful to realise that, back in the studio, watercolour can be mixed up in larger quantities and layered and refined, as in Ellen Gallagher's 'Watery Ecstatic' series (p.128), or Steve Johnson's substantial images of the city (pp.124–125).

Gouache dates back to the work of medieval illuminators. When making a gouache it is common to overpaint in white, and add white to gain tints. Because it is opaque, it can be painted over coloured paper as well as white. Gouache is often used by designers because it lies flat and matt, so is easy to photograph.

A comparison of transparent and opaque painting in watercolour and gouache can be made by looking at the flat areas in two works featured in this chapter – by Ciarán Murphy (p.129) and Laylah Ali (p.126). Murphy's purple

wash is transparent, with some sections overpainted and overlapping. The flow of the paint can be clearly seen. The blue in Ali's painting is a tint and covers more evenly, creating a solid back-drop. However, Marion Thomson's collage, *Blue Gemmi* (below), demonstrates that good-quality gouache can also be worked in a similar way to watercolour, with granulated, transparent washes, while Jemima Brown (p.127) uses her watercolour both transparently and thickly.

In practice, you may find that you work with the two types of paint and painting techniques together. I like to think of them as the same medium and do not consider it helpful to make too much of a distinction. The important thing is to exploit the full range of marks and textures offered by both.

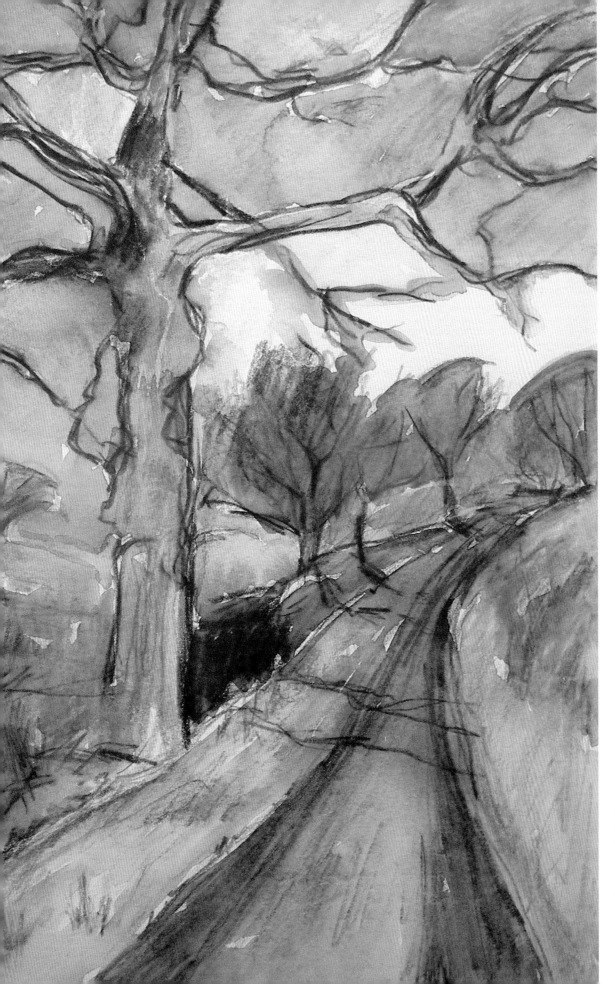

Opposite: Blue Gemmi.
Gouache on paper, collage,
by Marion Thomson.

Left: Oak, Shropshire.
Watercolour wash over pencil,
by Sally Mole.

115

TOOLS, SUPPORTS AND MEDIA

Watercolour and gouache behave in a similar manner because both use the same binder – gum arabic. In watercolour, the pigment is finely ground, making the paint transparent when thinned with water. In gouache (sometimes called body colour) the coloured pigment is coarser and, in some brands, extended with chalk, making the paint more opaque. The differences between makes and quality of paint comes from the purity of the pigment and the proportions of other ingredients such as ox gall, glycerine and starch, added to improve flow and to make the paint thicker. Different pigments require different recipes to make them behave in a similar manner. The most important thing to look for is transparency; any paint can be made more opaque with the addition of white.

Watercolour pans in a box

Watercolour pans

These are little dry cakes of watercolour, made to fit snugly in a watercolour box. They are then rubbed with a watery brush to make the paint. These are useful for taking out on location.

Tubes of watercolour

These are good for large-scale work as it is easier when using moist paint to mix up large amounts of colour for washes. It can be useful to supplement pan colours with tubes when you want to use thicker paint and more saturated colour.

Papers and brushes

Generally a thick, textured, semi-rough (300gsm) cold-pressed paper is used for watercolour or gouache. This is good for smooth washes and fine detail. A rougher paper can be used if you want a drier, textured mark. A smoother hot-pressed paper is best for making a drawing in ink or pencil with colour washes. Gouache can also be worked opaquely on toned and coloured papers. If you want to work very wetly, thinner paper should be stretched (see p.95).

Round, soft-haired brushes are good for these media as they hold lots of dilute paint when laying washes, and come to a point for detail (pp.102–103). A size 6 is a good all-rounder.

Tubes of watercolour

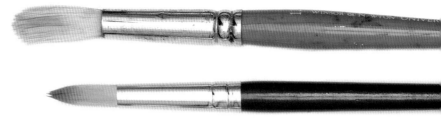

Soft brushes

Tubes of gouache

Ox gall liquid

This is one of the ingredients in watercolour and gouache paint. Adding a little more will improve the flow of watercolour on rough papers where a smoother effect is wanted. It will also help colours to run together. Generally, a few drops are added to a wash before applying.

Texture medium

Tubes of gouache

Gouache comes in tubes of moist paint. It is also possible to buy it diluted in bottles like ink.

Masking fluid

This is a rubber latex solution that can be painted on to mask out areas of white paper while washes are applied over the top. It is then removed by rubbing with an eraser once the paint has dried. It should only be used on dry, sized paper (e.g. watercolour paper) as it can stick and stain.

Masking fluid

Aquapasto

This gel medium by Winsor and Newton thickens paint and makes it behave less like watercolour.

Glycerine

Used as a plasticiser, this ingredient makes paint softer and more pliable. Some artists add a little more to extend the paint and slow the drying time.

Gum arabic

This is the main binder from which watercolour and gouache are made. More can be added to extend the paint and for paint effects such as granulation and wash-out.

Ox gall liquid

Watercolour medium

Texture medium

This medium contains fine particles, which give a subtle granular texture to paint.

Granulation medium

This can be added to watercolour paint instead of water to give a granulated or mottled appearance to the wash. Some pigments, such as manganese blue, granulate naturally, but others – mainly the modern synthetic pigments – are naturally smooth. Commercial media may contain polyethylene glycol, but adding gum arabic to paint will also increase granulation, as will the use of a rough paper.

Watercolour medium

Commercial media are likely to contain gum arabic, and perhaps ox gall and glycerine too.

Gum arabic

Techniques
WORKING WITH WATER

Watercolour and gouache are the most fluid of the water-based paints. The paint dissolves on a wet surface, pools on the paper, spreads and mixes as the colours touch. It is simple decisions made by the artist – how wet, how dry, how long to wait before touching the surface again – that determine how the paint reacts.

Transparent washes as underpainting
Laying on light-coloured washes to establish a composition can be a good way to start. Although you can begin by drawing outlines in pencil first, painting broad, interlocking shapes in pale colours is a good, painterly alternative.

Darker washes overlaid
Initial washes are allowed to dry and are then overlaid with more washes until the painting is complete. Note that in watercolour there is a limit to the number of overlays, as the colour begins to dull. Here, the yellow centre was put on as strongly as possible before overpainting with green and brown. There are two to four layers in this small study.

Watercolour: wet in wet
The paper is painted with water and colours are dropped on to the wet surface and allowed to blend. In this piece, some of the shapes (such as the leaves) were allowed to dry, and then reinforced with more paint.

Gouache: wet in wet
The same technique as for the watercolour exercise was used here, but this time in gouache. The colour blends and flows in a similar way to watercolour, but here the greens and blues have been overpainted with colour mixed with white, demonstrating how opaque paint can be used to cover transparent paint.

Artist's tips

- Work on thick paper – at least 300gsm. You will not have to stretch it, and it will easily withstand multiple washings under the tap. It will also be thick enough to support the cutting away of highlights with a knife. Thinner paper should be stretched (see p.95).

- Work with your board propped up at a slight angle. This helps the paint to flow down the page. **(A)**

- Experiment with sucking up/blotting back the wet paint with tissue to create areas of white. A sponge can be used on larger pieces of work. **(B)**

- Do not be afraid to wash off the whole painting under the tap if things go wrong. The image can then be reworked, either into the wet paper, or once dry. **(C)**

- Work on several paintings in series. There can be a lot of waiting around while watercolours and paper dry. The temptation to touch a surface too soon can be overcome by having other projects on the go.

- If successive overlays of colour wash begin to dull, try overpainting with watercolour or gouache straight from the tube. This will give a more opaque effect but can intensify the colour. **(D)**

A

B

C

D

Techniques
MASKING AND WASHES

Keeping the white of the paper and laying a flat, transparent wash are two of the challenges when painting in watercolour. The paint naturally wants to pool and to spread unevenly, so it can be hard to paint an even wash around a complicated white shape, or to cover a large area with flat, solid colour. Practise first on a small scale; be prepared to take advantage of the happy accident, and change your plans accordingly.

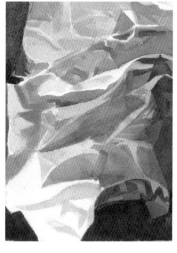

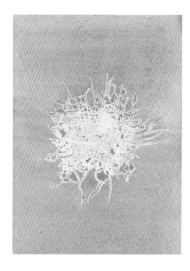

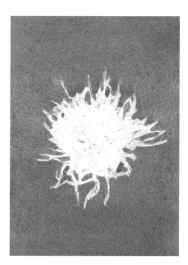

Masking fluid

Masking fluid can be painted on to mask areas that are required to stay white – in this case, the highlights on the paper. This saves you having to paint around them. Yellow masking fluid is good because it allows you to see clearly where you have painted.

Masking fluid (continued)

Here the mask was overlaid with a grey wash. Once this was dry, the masking fluid was removed. More detailed washes were then applied to modify the highlights and to intensify the shadows.

Laying a flat wash

Here the paint was applied in even, horizontal strokes with a fully loaded brush. It would be hard to lay a flat colour around this complicated shape, so it has been masked out and the paint applied over the top. The board was tilted to allow each stroke to merge with the one below.

Laying a flat wash (continued)

Once the paint was dry, a second layer was applied. This strengthens, darkens and intensifies the colour. It also helps to even out any inconsistencies in the wash. Some colours give a more granular wash than others. This is French ultramarine, which gives a slightly mottled texture.

Artist's tips

- Resist using an expensive brush to apply the mask, and wash your brush out in water regularly while working, massaging the fluid out of the hairs. Masking fluid dries quickly and is hard to remove.

- Remove the masking fluid with an eraser. Make sure the paper is completely dry before doing this or you may damage the surface. Make sure, too, that you use a watercolour paper, as this is coated with size – masking fluid will stick to and stain an unsized surface. **(A)**

- Low-tack masking tape can be used as a simple alternative to masking fluid. **(B)**

- Mix up lots of paint – much more than you think you need – so that you can keep the wash going before it dries. **(C)**

- Experiment with the type of paintbrush you use to apply the wash. A flat will give a good even stroke, but I find a large round holds more paint. **(D)**

- Try to refrain from touching the paint once it has gone down. It is best to leave it to settle and dry. If the wash is not to your liking, as mentioned on p.119 (C) you can simply put it under the tap and repaint.

- Wetting the paper before you start will slow drying times and can help washes to lay down more smoothly. Blot the surface of the wet paper before painting to make sure it is evenly damp, or damp the back of the paper only.

- Try adding a little gum arabic or watercolour medium to the paint. This will change the consistency, making it easier to apply a flat wash. However, you should note that this wash will lift if overpainted as more gum arabic makes the paint more soluble.

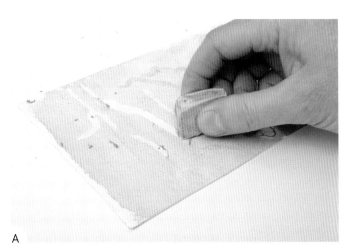

A

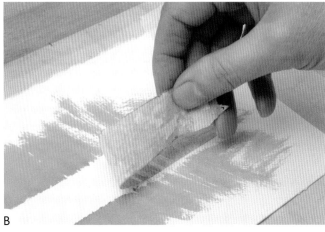

B

C

D

Long-haired flat brush

Large round soft-haired brush

Techniques
ADDING TEXTURE

Watercolour and gouache are naturally liquid and free flowing, but there are techniques that will add texture, some of which are mentioned here. Purchased media can make paint more granular, thicker, less able to stick to the paper and slower to dry. Ingredients are not always specified, but are generally more of what was used to make the paint in the first place, and should be used sparingly.

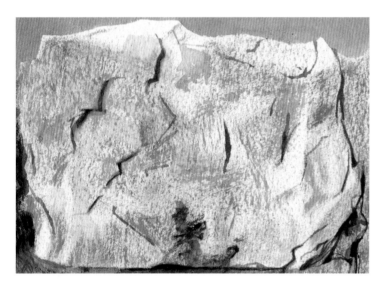

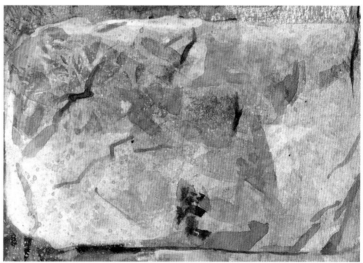

Texture: transparent

Three techniques were used to make the texture shown here: dry brush over rough paper, texture medium added to the washes to make them more granular, and a stiff brush to spatter the paint. The white of the rough paper is important here, and it shows through the transparent paint, adding a sparkle.

Texture: opaque

Here an overall texture was made with paint dragged across the surface with a dry brush. Cling film was dropped into an overlaid wash (see C opposite), which gave an irregular pattern across the whole thing. This was then overpainted and obliterated in places with opaque white, yellow and brown gouache. Finally, spatters were applied – both dark and light – together with stippling using a stiff hog's hair brush.

Artist's tips

- A rough-textured cold-pressed paper is good for granulation and mark making.

- Applying paint to a textured paper with a dry brush gives a speckled effect. Make sure the paintbrush is dry by wiping it on paper, then dip it in the paint and drag it across the surface. Try placing your thumb and fingers over the base of the bristles to spread them out – this will give a wider mark – or use a fan brush. Stippling with a stiff bristle brush will give more controlled areas of dottiness to contrast with smoother brushstrokes.

- Add texture medium to the paint to give a granular texture. Sprinkling a little salt on the surface to suck up some of the wash will have a similar effect, as will adding more gum arabic or granulating medium to the paint. Adding Aquapasto will add body to the paint. **(A)**

- Spatter paint on to the surface with an old toothbrush or bristle brush. Mask out the area you wish to texture with a stencil to protect the rest of the painting. This low-tech method is surprisingly effective with any colour at any point, but you may like to try this with masking fluid to preserve white speckles at the beginning of the painting process, or at the end with white gouache to add light and sparkle to a tired wash. **(B)**

- Place slightly crumpled cling film on top of a wash and allow the wash to dry. When the cling film is lifted, a variegated texture is revealed. **(C)**

- Sanding back gently with coarse sandpaper, scratching out or even cutting out the top layer of the paper with a knife are all ways of bringing back the white of the paper once it has been lost. This is a measure of last resort, though, as it scuffs up the surface of the paper and leaves it difficult to overpaint.

- Underpaint areas in gum arabic or lifting medium. This will then allow the paint to be lifted from the surface after washes have been overpainted. Simply blot away the loosened paint with tissue or cotton buds to reveal the white of the paper below. **(D)**

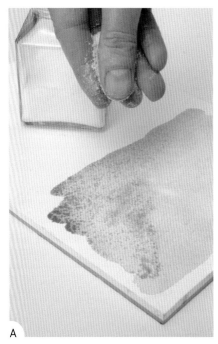

A

B

C

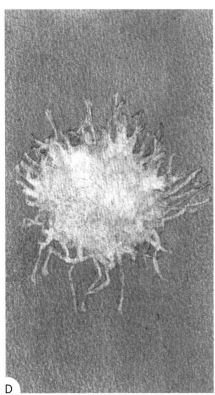

D

Artist profile
STEVE JOHNSON

Born in Whitstable and brought up in Newcastle, British sculptor and painter Steve Johnson first moved to London to study fine art at Goldsmiths. He has received awards from the Arts Council of England, the British Council and the Pollock-Krasner Foundation, New York. His works can be found in several public collections, including those of the Arts Council, the Berlinische Galerie (Berlin) and London's Science Museum.

Johnson was 12 when, on an outdoor-pursuits course in the Lake District, he painted his first watercolour. He responded to the freedom and versatility of the medium, compared with the oil painting he was being taught at school. 'From that moment I really liked it – how the colours bleed into one another; seeing the colours mix in the box.'

The works illustrated here are based on buildings seen in London and Berlin. 'Usually I know what I want to do in the abstract, and then I latch on to something in the real world that I can use as a signifier.'

Johnson alters reality to convey his ideas. Buildings are disconnected from their context like boats afloat in a body of water; perspective is manipulated to distort the chosen object and to place the viewer below ground level; and layers of earth beneath the buildings are made visible, representing history compressed underfoot.

These are large images – A0 (33 x 47in) – painted on stretched 600gsm paper. Steve draws out the composition precisely in pencil. Once finished, he erases these lines so that all edges are left with a tremulous, painterly quality. 'I don't want the paintings to be too perfect or sterile.'

Each piece takes him about three weeks, working across the surface with up to four layers of mark making. He pushes the paint around to get different textures, dropping water into dry paint to get a stain, or working into wet paint with a cotton bud to get the texture of rendered wall. He will also lay a paper towel down over thick, partially dry paint. After being compressed under a piece of marble to prevent the paper going 'completely barmy in terms of buckling', the towel is peeled away to reveal the mottled texture of earth.

Johnson feels that watercolour gives him permission as a sculptor to make paintings, and allows him to pursue ideas that are too difficult or expensive to realise in three dimensions. 'It is closer to drawing [than oil painting], and more sculptural in the way you construct the image.'

When asked what he would like others to feel in front of his work, he responds, 'I think I want them to get the idea via a well-crafted object', and then takes me to look at words written in pencil on his studio door: 'I don't make beautiful things, but I do make things beautifully.'

Below: Eisbude.
Mixed media sculpture.

Opposite top: Hoarding.
Watercolour on paper.

Opposite bottom: Imbiss with Blossom. *Watercolour on paper.*

GALLERY

Above: Untitled, *from the 'Greenheads' series. Gouache and pencil on paper, by Laylah Ali.*

Right: Untitled Profile Pictures (Carla). *Aquarelle on paper, by Jemima Brown.*

Top and bottom: From the 'Watery Ecstatic' series. Ink, watercolour, crushed mica and cut paper, by Ellen Gallagher.

Opposite: Lab Equipment. *Watercolour on paper, by Ciarán Murphy.*

OVERVIEW

Acrylic paint was developed around 60 years ago as a cleaner and healthier alternative to oil paint. Although said to be plastic based, it is in fact a polymer that is mixed with pigment and other synthetic materials to keep the colours true and lightfast. It dries to a permanent and robust finish, which is most evident when the paint is applied thickly.

Acrylic paint can be applied in two different ways. Like oil, it can be used straight from the tube, mixed with different colours with little or no water, and applied with a brush or palette knife, which can give bold and vibrant results. Or it can be mixed with a lot of water, thinning the pigment down, and applied like watercolour to canvas or paper, resulting in a fresh and light style.

Alongside the paint, a wide variety of gels and media can be mixed in to create different effects. Some media are added to make the paint less glossy; others give an extra gloss finish. Retardant medium is used to thin and also prolong the drying time. Gels are used both to thicken and extend paints to certain degrees. When a painting is finished, a varnish can be applied, which can be used both to protect and to change the painting's surface.

Acrylic dries fast and Royal Academicians Barbara Rae and Albert Irvin exploit this, working quickly so that the end product is spontaneous and energetic. Rae builds layers of washes and painterly marks – sometimes on to collaged surfaces – balancing thicker paint marks with leaner painted areas (p.145). Irvin currently paints with three- and four-ringed dusting brushes to emphasise the direction and energy of his brushmarks (opposite), where previously he used scrapers and squeegees to manipulate the acrylic.

Differences in texture and direction of brushmark can also be seen in the work of Hayal Pozanti (p.144), where thinly painted shapes contrast with thick white acrylic, or in Andro Semeiko's work (p.147), where brushed, thinned paint is allowed to dribble down across the background. By contrast, Rachel Ross's paint surfaces are restrained, and the thinned glazes smoothed out,

showing that acrylic can be used to deliver illusionistic effects normally associated with oil paint (p.147). Glazes can also be seen in the work of Archibald Dunbar McIntosh RSW RGI (below), Narbi Price (p.239) and Ant Parker (p.147), where translucent paint or semi-opaque washes are laid down in such a way that the underpainting shimmers through.

Below: Toy Box. *Acrylic, by Archibald Dunbar McIntosh RSW RGI.*

Opposite: Greet II. *Acrylic on canvas, by Albert Irvin RA.*

PAINT AND MEDIA

Acrylics come in a large spectrum of colours and several grades, which can be confusing for the beginner. The three main grades are soft/medium body, heavy body and super-heavy body. All these paints have high pigment content, but the soft grades tend to be more translucent.

Acrylic 'enamel' spray paint

Heavy-body acrylic paint

Super-heavy-body acrylic paint

Fluid acrylic

Soft/medium body
This grade of paint is smooth and fluid, and perfect for pushing around in a free and easy style.

Heavy body
Heavy-body paint is thicker and more opaque, and is suited for more gestural work as it retains brushstrokes.

Super-heavy body
A very thick paint, with high pigment content; it can be applied with a palette knife for an impasto effect.

Fluid acrylics
A very liquid paint, with a consistency like double cream. Colours are more intense than those you can make simply by diluting medium- or heavy-body acrylic with water. This is for pouring, dripping, staining and spraying.

Heavy-body acrylic paint

Soft/medium-body acylic paint

Household emulsion

Flow improver

Pumice gel

Acrylic enamel spray paint

Nowadays the term enamel can be used to describe any solvent or water-based product paint designed to dry to a hard, high-gloss finish. Acrylic 'enamel' spray paint is generally favoured as a low-odour alternative to alkyd and oil-based enamels in aerosol form.

Student quality

Student-quality paint is cheaper, with less pigment. It tends to be more translucent than higher-quality paint, but is good for underpainting and large-scale projects.

Household emulsion

Emulsion is another variety of a polymer-based paint that is soluble in water. Unlike artist's acrylic paint, the range of emulsion colours is limited. Emulsion also contains less pigment and is thought to be less stable and less flexible than acrylic, with a tendency to crack. However, it is cheaper, and comes in bigger quantities, so it is perfect for larger projects such as wall murals or stage drops.

Acrylic can be applied over emulsion as both are water based. In fact, it is a very good surface to paint on as the emulsion acts as a basic primer. Emulsion benefits greatly from a coat of varnish, either matt or gloss. This not only seals the surface, but keeps dust attraction to a minimum.

Media and gels

There are many media and gels that can be mixed into acrylic paint to change its finish, drying time, and consistency. These products are developed to be chemically compatible, so it is advisable to stick to the same brands of media and gels as your paint.

Matt medium is added to make paint less glossy.
Gloss medium will give the paint extra gloss.
Retardant medium is used to thin the paint, but unlike its natural thinner, water, will help prolong the dying time of the paint – ideal for blending or wet-on-wet techniques.
Flow improver thins the paint without changing the colour strength, and helps washes to lie flat and even.
Medium gel thickens the paint, and also makes it more translucent.
Heavy gel is perfect for creating very textural effects.
Pumice gel contains fine pumice stone, which adds bulk to the paint.
PVA glue is often used as a cheap alternative to acrylic gloss gel media. Like emulsion, it is based on polyvinyl acetate rather than acrylic.

Medium gel

Heavy gel

TOOLS, SUPPORTS AND VARNISHES

Acrylic has very few restrictions when it comes to tools and supports. It can be painted on pretty much anything, primed or unprimed, and can be applied with any type of brush. Its only drawback is a soft, flexible surface that readily attracts dirt, so if you want your paintings to last you should protect them with a layer of varnish or frame them behind glass.

Soft-haired brushes

Brushes

Both natural- and synthetic-hair brushes can be used for acrylic paint, although I have found that the chemistry of acrylic paints is kinder to synthetic brushes (pp.102–103).

Soft brushes are best when using acrylic in its most fluid form, as they hold more moisture and will disperse a thin paint more effectively. Thicker and harder-bristled brushes are required when thick paint is being used, either straight from the tube or mixed with a little water.

Palettes

In theory, any non-porous surface can be used as a palette for acrylics. Plastic, glass or even sealed wood are ideal. Most artists who paint with acrylic use plastic trays or plates to mix paint. As acrylic is fast drying it is important not to have too much paint out at one time; put it on the palette as you need it. If you do like to have an array of colours, then keep them moist. A fine spray of water over the top of the paint will help to do this.

Surfaces

Surfaces

Traditionally there are three surfaces to paint on – canvas, board (wood or card) and paper. You may also want to experiment with plastic. Heavy, good-quality 100 per cent cotton rag watercolour papers, either cold- or hot-pressed, are recommended. Both can hold more water and are less likely to distort or warp (pp.94–95).

Acrylic paint on glass

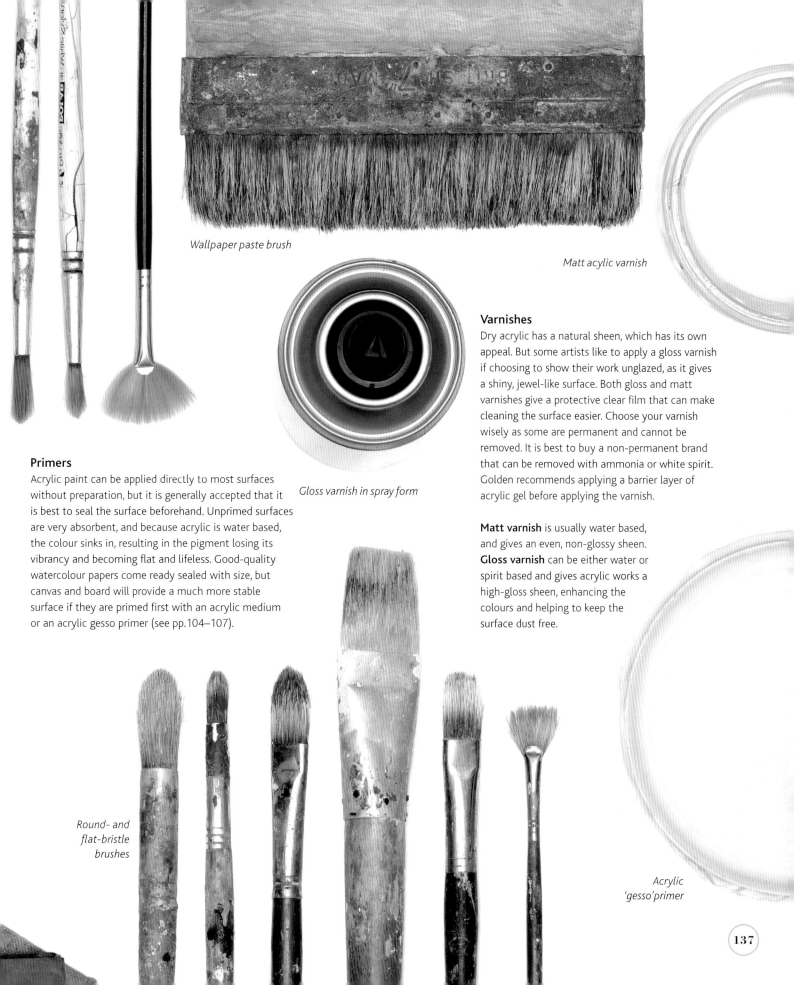

Wallpaper paste brush

Matt acylic varnish

Varnishes

Dry acrylic has a natural sheen, which has its own appeal. But some artists like to apply a gloss varnish if choosing to show their work unglazed, as it gives a shiny, jewel-like surface. Both gloss and matt varnishes give a protective clear film that can make cleaning the surface easier. Choose your varnish wisely as some are permanent and cannot be removed. It is best to buy a non-permanent brand that can be removed with ammonia or white spirit. Golden recommends applying a barrier layer of acrylic gel before applying the varnish.

Matt varnish is usually water based, and gives an even, non-glossy sheen.
Gloss varnish can be either water or spirit based and gives acrylic works a high-gloss sheen, enhancing the colours and helping to keep the surface dust free.

Gloss varnish in spray form

Primers

Acrylic paint can be applied directly to most surfaces without preparation, but it is generally accepted that it is best to seal the surface beforehand. Unprimed surfaces are very absorbent, and because acrylic is water based, the colour sinks in, resulting in the pigment losing its vibrancy and becoming flat and lifeless. Good-quality watercolour papers come ready sealed with size, but canvas and board will provide a much more stable surface if they are primed first with an acrylic medium or an acrylic gesso primer (see pp.104–107).

Round- and flat-bristle brushes

Acrylic 'gesso' primer

Techniques
THIN PAINT

Acrylic paint is a very flexible medium, suited to many techniques and styles of painting. When thinned with water, it is similar to watercolour and can be brushed on in soft, transparent washes, or splattered on to the surface. When thinned with more medium, it behaves more like a fast-drying oil paint and can be applied in thin glazes over thick or thin paint.

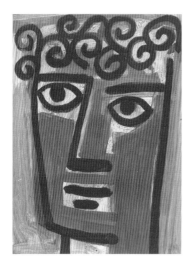 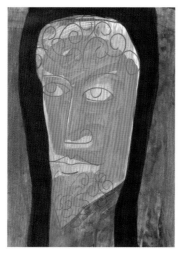 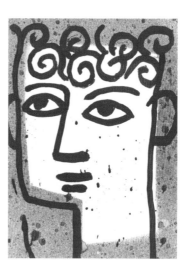 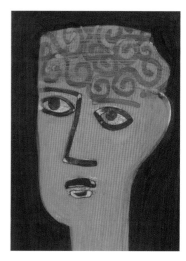

Thinned with water
Using acrylic almost as a watercolour is achieved when the pigment is thinned down with water, so that the paint is fluid and transparent. It can be moved easily around the surface and is perfect for underpainting. A soft-body acrylic is good for this as it mixes with water very easily and takes less effort to 'mash down' with a brush.

Washes over a drawing
You can apply thin or transparent acrylic paint over a drawing. This is more effective if the drawn line is bold and the drawing implements are water repellent, such as a good HB graphite pencil. Make sure your paint is very translucent as you only want to tint the drawing.

Spraying and dripping
Applying paint in spray form is ideal for creating uniform painted surfaces; it is also excellent for use with stencils. For a more dramatic and abstract approach, slightly thicker paint can be squeezed from a soft plastic container with a narrow nozzle and sponged, dripped, splattered or thrown on to the surface.

Glazing
This is the technique of applying a thin film of diluted paint to an already-painted surface. It can pull colours together for an overall unified look, and can also be used to 'knock back' certain elements of a painting, giving your work depth. It is best to use a glazing medium to dilute your paint, as it keeps the paint fluid and dries evenly.

Artist's tips

- Paint thinned with water can be kept in jars with screw-top lids. **(A)**

- For spraying, the paint must be mixed with a lot of water, as the pigment has to be in a very fine form before it can be ejected from the nozzle. **(B)**

- For dripping and splattering, it is important that the paint is at the right consistency – fluid like soft yoghurt. **(C)**

- When throwing or dripping paint, try placing your canvas or board on the floor so you have free movement around it. **(D)**

- When glazing, the ratio should be 90 per cent medium to 10 per cent paint.

- You have to work quickly with glazes because they become quite tacky in a short space of time. So mix the colour first and then add the medium.

- A glaze should be thin enough that the colour underneath shows through. To avoid blotching, it should only be applied on a completely dry surface. **(E)**

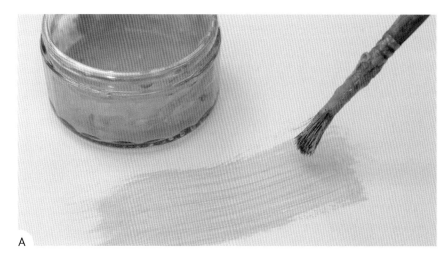

A

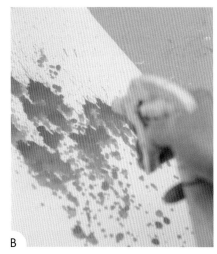

B

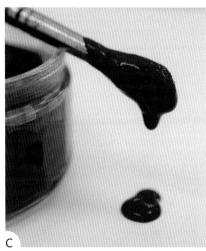

C

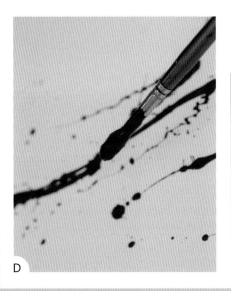

D

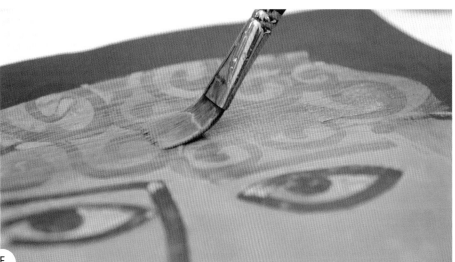

E

Techniques
THICK PAINT AND MIXED MEDIA

It is easy to be seduced by acrylic in its natural state, by the luscious consistency straight from the tube or tub. However, I recommend applying thick paint on to a surface of thinner washes, as a build-up of thinner to thicker paint produces depth and visual interest. Generally, it is best with acrylic to avoid thick-on-thick paint – it can lead to overpainting and the work can become laboured and turgid.

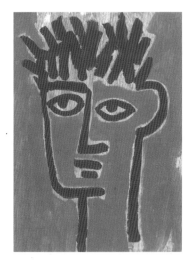

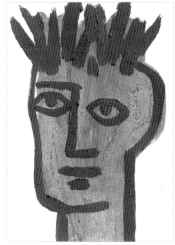

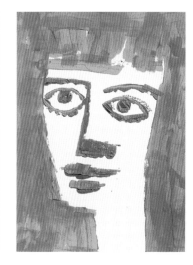

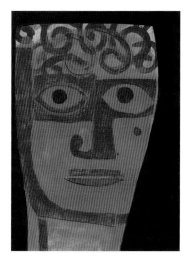

Thick paint straight from the tube
Heavy-body paint is best used straight from the tube or mixed with only a little water. When it is used with a firm brush it will retain brushmarks. Super-heavy-body paint, with its unique, pastel-like quality, can be applied with a brush or palette knife.

Bulking agents
These are added to paint to extend its natural consistency. For example, when mixed with a soft-body or heavy-body paint, an extra-heavy-body medium can increase the paint's volume, density and viscosity, which is essential for holding brush or palette knife marks.

Using a palette knife
A palette knife is perfect for 'impasto', whereby paint is applied to the surface (usually straight from the tube) and spread with a light hand pressure. The paint should have height, and resemble butter spread thickly on bread. The results are more angular and less versatile than those created using a brush.

Collage
This technique is used by many artists to add surface interest, and is particularly effective in abstract or semi-abstract work. Pieces of paper, cloth or card are stuck to either canvas or board with acrylic medium or PVA glue.

Artist's tips

- A good brushmark can be maintained if the paint is not overworked. Overworking flattens the paint and makes marks less evident.

- Due to their high pigment content, most good-quality acrylic paints do not change colour when dry. But media have a milky quality, which will make paint look lighter when wet. It can be useful to test some colours on a piece of board first to compare the wet state to the dry state and to see the effect of different gels and media on the colour. **(A)**

- When collaging, a thin wash of a (usually) light-coloured acrylic can be painted over the top. Once dry this will provide a secure, sealed surface on which to apply more paint. **(B)**

- Acrylic combines very well with other water-based media. Because it dries quickly it is often used as underpainting for oil paintings.

- Bulking medium extends the paint and increases brilliance and transparency. It will also allow you more working time. Pumice gel adds both texture and bulk. **(C)**

- Remember that although the colour will not change, the sheen of the paint will change from a gloss when wet to a soft finish when dry. Colours that are less opaque – yellows, for example – have to be built up in layers to increase their intensity.

- Dilute acrylic paint also comes in cans, which is a good way to gain a different kind of mark and texture. **(D)**

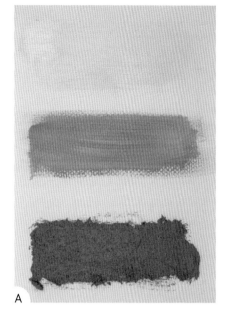
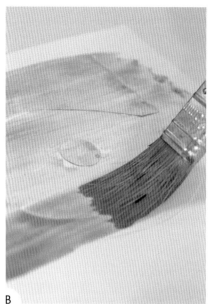

A

B

C

D

Artist profile
RICHIE CUMMING

Richie Cumming is an installation artist from Prestwick in Scotland. A graduate of Duncan of Jordanstone College of Art and Design, he regularly works on collaborative projects with the Blameless Collective, finding empty buildings and persuading organisations to provide materials. He chooses people to work with and is chosen in his turn. 'We find a space and then work out what we can get away with.'

Works are created in situ on brick walls, plaster, MDF, hardboard or cloth, with a mixture of household emulsion, spray paint and acrylic. Cumming chooses water-based paints because they are quick drying, and finds that, on a tight budget, household emulsion is perfectly good for the group's purposes. Generally the emulsion – usually donated leftovers – is applied first to establish the background and general composition. Spray paint is then used to outline and strengthen the shapes

where needed. Stencils are used to give a sharp edge. If funds allow, a better-quality artist's acrylic is used to paint in details; if not, emulsion is employed. Although the acrylic and/or emulsion are likely to be put on with a brush, sometimes they are watered down and sprayed from a plant mister to give a drippy, splattered look.

Cumming and his collaborators like varied surfaces. Walls are sanded back or roughly plastered. Areas may be collaged with wallpaper and printed images. Holes may be drilled or cut through walls to insert objects or enable visitors to spy on other parts of an exhibition. There may also be projected digital images, and places for the public to write or paint their own comments.

As the artists paint as a group, the working method is organic and responsive, with many deletions and overpainting – what Cumming describes as a 'visual argument'. They are used to working fast as the projects are time-limited and often reliant on hired equipment such as scaffolding and cherry-pickers. They are not particularly concerned about longevity; in fact the work is occasionally even cut up and auctioned off afterwards to provide funding.

Making work is a kind of compulsion for Cumming, and he does not really separate his creativity from the rest of his life. Motivated by politics, he wants to stick up a message rather than seek recognition as a painter. Indeed, many of his works consist of words rather than images. There is humour in what he does, as well as irony and emotion. His ideas focus on cultural heritage and the political hopes and disappointments of those around him. 'To me, it doesn't really matter how good your technique is. What matters is that you have something to say.'

Right: Bull Riach, *detail from the* Rough Cut Nation *exhibition, Scottish National Portrait Gallery, 2009. Acrylic, emulsion and paper collage, by Richie Cumming in collaboration with Pete Martin and Mike Inglis.*

Opposite top: Aye Man, *detail from* Rough Cut Nation. *Acrylic, emulsion, spray paint, paper collage, paste-up, ink and video projection, by Richie Cumming in collaboration with Kirsty Whiten, Fraser Gray, Martin McGuinness, Elph, Mike Inglis, Pete Martin, DUFI, Sarah Kwan, Rachel Levine and Aaron Sinclair.*

Opposite bottom: Freedom Versions v1 (*work in progress*), Stirling Old Town Jail, 2012. Acrylic, spray paint, paper paste-ups and emulsion on board, by Richie Cumming in collaboration with Rabiya Choudhry, Fraser Gray, Martin McGuinness, Kirsty Whiten, Pete Martin, DUFI, RUE FIVE and Mike Inglis.*

GALLERY

Left: Winter Sky, Bute. *Acrylic on canvas, by Simon Laurie* RSW RGI.

Below: Syntropic Planetary Importings. *Acrylic on wood, by Hayal Pozanti.*

Bottom left: Citroëns. *Acrylic on canvas, by Jeremy Dickinson.*

Opposite: Downpatrick. *Acrylic on canvas, by Barbara Rae* CBE RA RE.

GALLERY

Opposite: Seven Mesh. *Acrylic on canvas, by Mali Morris* RA.

Left: Unexpected Encounter. *Acrylic on canvas, by Andro Semeiko.*

Below left: Two Stripey Squash. *Acrylic on board, by Ant Parker.*

Below right: 2 dessertspoons. *Acrylic on paper, by Rachel Ross.*

Chapter Nine

OIL AND RESIN

Untitled *(detail). Oil on board, by Scott O'Rourke.*

OVERVIEW

Oil paint has a range that no other medium has. Because it is slow drying and sticky, the wet paint can be manipulated over one or more days, something that is not possible with water-based media. It can be rubbed, brushed and trowelled on, drawn and painted into, or rubbed, blotted and scraped off. And if things go wrong, the paint is easily removed, ready to start again.

Layering is faster in acrylic paint, but an oil glaze is transparent rather than milky, so it is easier to see what you are doing. Oil paint is also pretty much the same colour when it dries. There are some rules to observe if you want it to remain stable, but generally it is quite straightforward. In many ways it is the perfect paint because it is so flexible. It also has a good weight and body to it – a texture and substance that is physically satisfying.

Oil paint can be applied in many different ways. For example, Thomas Gosebruch (see p.170) deliberately allows oil and pigment to seep into the paper, while Tony Hull (p.104) thins his paint right down, exploiting the drips and transparency of glazes. Carla Klein and Joe Simpson blend and smooth the wet surface (p.172), whereas Lisa Wright's wet paint stands up, thickly textured (opposite). Tomma Abts (p.171) and Biggs and Collings (left) apply their vibrant colours precisely and cleanly, whereas Helen Berggruen (p.173) prefers to work and rework gesturally over a dry, crusty surface. Toba Khedoori paints on subtle, delicate oil washes over wax (opposite), and Scott O'Rourke constructs complicated surfaces from layers of dried paint (see pp.148 and 173).

Left: 807 Years. *Oil on canvas, by Biggs and Collings.*

The addition of fast-drying, oil-modified alkyd resins, which were invented in the 1930s, has meant that artists can now work more quickly and, we are assured by manufacturers, with more stability. Already used instead of linseed oil in house paint, these can be added to artist's oil colours as a drying medium, and are now available as artist's paints too. These innovations can be seen in Gary Hume's shiny surfaces (p.170) and Raqib Shaw's vibrant colours (pp.168–169).

There are some real health and safety considerations when using oils, because they must be thinned with turpentine or white spirit. Breathing in fumes from thinners can affect brain tissue, so you must work in a room with good ventilation, separated from living and eating quarters. Adopting working methods that minimise the use of thinners and/or painting with an alkyd resin as a painting medium, and trying out water-based oils, are also options.

Above: Untitled (Stick). *Wax and oil paint on paper, by Toba Khedoori.*

Above right: Melting Shadows. *Oil on canvas, by Lisa Wright.*

PAINTS

Artist's oil paint is made by grinding pigment in oil. Generally this is linseed oil made from flax, but nut, poppy or safflower oils are also used for their different qualities.

Oil paint in tubes
Straight from the tube, this is a thick, sticky paint that can be thinned with turpentine. It dries slowly, allowing the paint to be worked over several days or even weeks, depending on weather conditions, the thickness of the paint and the type of pigment. The paint's behaviour and consistency can also be altered by adding painting media.

Oil paint in tubes

Oil paints

Water-miscible oil paints

Water-miscible oil paints
Here the pigment is ground with oil that has been chemically modified so that it can accept water. Brushes can be washed out in soap and water rather than white spirit, and the paint thinned with water when painting. As the paint dries, the water evaporates, leaving the oil to set on the surface. Straight out of the tube, the thick paint handles pretty much like traditional oil; when thinned with water, it acts more like gouache. Care should be taken not to overdilute as this weakens the stickiness of the paint.

Artist's alkyd paints

Enamel paints

Alkyd paints

Alkyd paint is made from pigment ground with an oil-modified polyester resin (p.157) and the paint has a faster drying time than traditional oil paint. To work with, alkyd paint is more transparent and sticky in consistency than oil, but overall it handles in a similar way. It dries to an even, fairly shiny surface, and there are media that can be added to change the finish. It can be combined with oil paint, but thought should be given to drying times, and the rule to paint more flexible over less flexible should be observed (see p.163).

Household oil paints are an alkyd paint, as are many automotive enamels and spray paints. Unlike artist's paint in tubes, these paints come ready-thinned with white spirit.

Enamel paints

Nowadays, the term enamel can be used to describe any solvent- or water-based paint designed to dry to a hard, high-gloss finish. Many solvent-based products are alkyd paints, although some may contain other sorts of synthetic or natural resin, such as epoxy resin or dammar. Some are made by adding varnish to conventional oil paint – something that an artist can do if wishing to give a painting a really shiny surface. Enamels include car paints, as used by Raqib Shaw (pp.168–169).

Household paints

TOOLS, SUPPORTS AND MEDIA

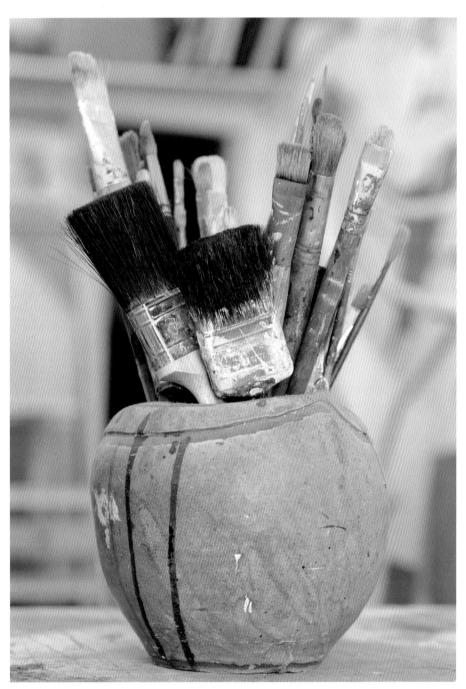

Primers

Oil paint is usually painted on to a pre-sealed surface. If the support is porous, such as paper, raw canvas or wood, the oil can be sucked from the paint and the pigment left with nothing to stick it together. Also, linoleic acid in the linseed oil in the paint will rot canvas. The quickest and easiest thing to do is to prepare the surface with an acrylic primer. But if an oil primer is to be used, rabbit skin glue, PVA glue or acrylic medium is painted on first to form a barrier between the oil and the support (pp.106–107).

Surfaces

Pretty much any surface can be painted on with oil paint so long as it is sealed. Canvas, wood, card, paper, metal, acrylic sheet and glass are all used as supports. However, unlike acrylic, oil paint grows more brittle with age and is susceptible to cracking on flexible surfaces in time. So, if longevity is an issue you may choose to work on a rigid surface or to mount paper and canvas on board (p.97).

Brushes

Both natural- and synthetic-hair brushes can be used for oil paint. Bristle brushes are best used to apply thick paint straight from the tube, while soft-haired brushes are good for thinner washes, glazes and detail. The thinners used with oil paint are not kind to any brush and are particularly harsh to soft hairs. Thorough cleaning in soap and water will prolong their usefulness.

Rabbit skin glue

Thinners

These solvents are used to dissolve the oil in the paint. Generally, brushes are cleaned with white spirit, and turpentine is used to dilute paint for underpainting. Both can be mixed with more oil or resin to make painting media, although turpentine is generally favoured over white spirit. As the paint dries, the thinner evaporates, leaving the oil to set on the surface.

Both products should only be used with good ventilation as the fumes are harmful to health. They should not be poured down the sink, either, as they can harm aquatic life and the water supply.

White spirit

This is a petroleum-derived product. Cheaper and less viscous than turpentine, it is usually used to wash out brushes. Although it should only be used with good ventilation, it is less harmful than turpentine and, despite imparting a slight deadening quality to paint, it may be used to thin paint and to make painting media.

Turpentine

Turpentine (abbreviated to 'turps') is made from distilled pine tree resin. It can vary in quality and pungency, depending on how it is processed. It is best to buy double-distilled turpentine or rectified turpentine in preference to other products, as it is purer and the smell is less pronounced. Turpentine is used to dilute paint when underpainting, as it has a slightly resinous quality that helps the thinned paint stick to the support. It is also an ingredient for making painting media.

Turpentine

Low-odour spirit

Spike lavender oil

White spirit

Health and safety

If concerned about health and safety, you may like to try cleaning your brushes with walnut oil, or using low-odour spirits or spike lavender oil as an alternative to turpentine and white spirit.

Low-odour spirit

If used correctly, this is a safer alternative to white spirit. It has been treated to remove some of its impurities and is slower drying, so does not smell as much. However, fumes will build up over time in a room containing drying paintings, so proper ventilation is still required.

Spike lavender oil

Distilled from a particular type of lavender, this is a slow-drying solvent that can take several days to evaporate. It was used extensively by artists in the past as a diluent, and you may want to consider it if you are allergic to turpentine. Unlike the thinners listed above, it is not considered dangerous to health. It does smell, though, and should still be used with good ventilation.

DRYING OILS AND PAINT MEDIA

These are oils that are used to make oil paint. They are also an ingredient in painting media, used to thin out and change consistency. These oils have their own characteristics, and advantages and disadvantages – for example, linseed oil yellows the most, but has the greatest flexibility. They all have different drying times so it is best to use one type of oil (or mixture) as your medium per painting.

Drying oils are touch-dry in a few days, but take many years to cure thoroughly, reacting chemically with oxygen in the air to form a strong, transparent film. This reaction is irreversible; once dry, they are not resoluble in turpentine. All yellow to a greater or lesser degree, and all become more brittle with age.

Poppy oil

Refined linseed oil

Stand oil

Linseed oil
Linseed oil is made from flax and is the most common binder for oil paint. There are three main types used in painting.

Refined linseed oil
Bleached and refined to make thin, pale oil, this is the linseed oil most artists mix with their paint.

Sun-thickened linseed oil
This is linseed oil that has been placed in the sun to oxidise and bleach. This makes it flow more easily and dry more quickly; it also increases transparency.

Stand oil
Stand oil is linseed oil that has been heated to alter its molecular structure. It is thicker, darker and more viscous than refined or sun-thickened linseed oil. It dries to an enamel-like surface with no brushstrokes, so is good for glazing. It is slower drying, but is said to yellow less over time than other linseed oils.

Other oils
These oils are sometimes used as alternatives to linseed oil because they are paler and are said to be less likely to yellow over time.

Poppy oil
Poppy oil is often used as a binder or medium with light colours. It dries slowly and so is useful if painting wet in wet. However, the slower drying time also makes it susceptible to cracking.

Drying poppy oil
Driers are added to the poppy oil to make it dry at the same rate as linseed oil. This helps avoid cracking when overpainting and working in layers.

Safflower oil

Dammar medium

Alkyd resin medium

Alkyd impasto

Safflower oil

Safflower oil is often used as a binder with white pigments.

Nut oil

Walnut or nut oil is thin and pale, and does not yellow as much as linseed. It is more likely to go rancid than other oils, so you are advised to keep it in the fridge. It can also be used to clean brushes.

Paint media

These paint media can be mixed with oil and alkyd paint to extend it for glazing, to make it dry more quickly or more slowly, or to change its consistency – thinner, thicker, shinier, stickier, more free-flowing or more matt.

Dammar medium

This is a natural resin that can be added to oil painting media to make paint shinier and speed up drying time. It comes in crystal form and should be dissolved in turpentine to make a liquid consisting of 1 part dammar to 1 part turps. (It is also used in a 1:3 ratio as a varnish – see recipe, p.110).

Alternatively, it can be bought ready-made. Be aware that dammar is susceptible to yellowing and that its use as a medium will make the dry paint resoluble in turpentine.

Wax medium

This is wax dissolved in turpentine – 1 part wax to 3 parts turps. It can be mixed in with paint to give it a matt, pasty quality. In different proportions, it is used as a second-layer matt varnish (see p.110).

Oil medium

A mixture of oil and turps, this is the simplest medium you can use. You can buy it ready-made, or mix your own using any of the drying oils here (although it is best to stick to one sort per painting because of different drying times). Start with a mixture of 6 parts turps to 1 part oil and use it to dilute the paint. Decrease the ratio of turps to oil if you want a thicker, more viscous medium, or if you are overpainting dry paint in layers (see Flexible over less flexible, p.163). The turps to oil ratio should never be less than 2 parts turps to 1 part oil.

Alkyd resin media

Alkyd resins are said to be less yellowing than traditional oil media, but an alkyd medium is still susceptible to yellowing and brittleness over time. Oil-modified alkyd media come in different consistencies, ranging from thin and fluid media that make the paint runny and sticky, through to bulky impasto media that both thin and thicken the paint at the same time. Their great advantage is that they make paint dry quickly. Those made for impasto effects help to reduce shrinkage and retain brushmarks.

Wax medium

Oil-painting medium

Techniques
SCUMBLING AND IMPASTO

Scumbling and painting with a palette knife (impasto) are both good ways to start an oil painting. They use paint straight from the tube, so are ideal for those allergic to oils, or wishing to avoid thinners. Both techniques enable you to feel and exploit the qualities of raw oil paint.

Scumbling stretches out paint, spreading and scrubbing it across the surface. Oil paint is shown to be malleable, capable of being thinned without thinner, and providing a range of tones without the addition of white or black. Impasto places thick oil paint on the surface, relishing its stickiness and opaqueness. This direct, textural way of working builds up a thick bed of paint that, unlike acrylic, remains 'open' – it can be scraped back and manipulated over one or more days.

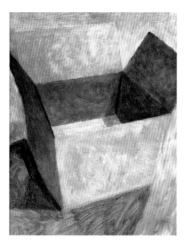

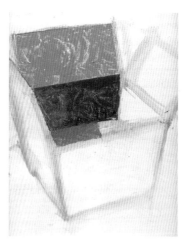

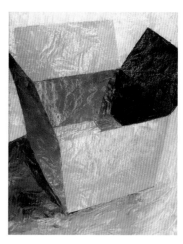

Scumbling
The design here was drawn out in charcoal. Undiluted paint was spread thinly and scrubbed across the primer with a flat bristle brush. Because it relies on a scrubbing action, scumbling is a deliberately imprecise way of working, and will result in soft, slightly blurry edges.

Scumbling (continued)
Each area of the painting has been filled in and the overall texture – typical of scumble – can now be seen. When dry, this could be overlaid with more scumble, resulting in a richer mix of texture and colour variation. Alternatively, it could be overpainted more smoothly in paint thinned with an oil medium.

Impasto with a palette knife
Here the design has been drawn out with oil paint thinned with turpentine. A palette knife was then used to scrape the undiluted paint on to the surface. The shapes were painted down from the top so that the hand did not drag in the thick paint.

Impasto (continued)
Each area has now been filled in. The greater precision of the knife edge has resulted in sharper edges. The paint in the box's shadow is thicker where colours have been overlaid and mixed. This could be developed further like this (wet in wet) or, when dry, overpainted with more impasto paint or paint thinned with oil medium.

Artist's tips

- A design can be drawn out in pencil, charcoal or paint diluted with a thinner such as turpentine. Remember that these will mix with the paint and potentially muddy it, so it is a good idea to brush back a dark charcoal drawing before painting, and to underpaint in a pale colour such as yellow **(A)**. If an underpainting is incorrect, it is easily rubbed back with a rag. (see A, p.163)

- A scumble can be made using any kind of brush, but the scrubbing action is not kind to the bristles. Use cheaper, more robust ox-hair brushes rather than expensive, soft sable. **(B)**

- Rub the brush on a rag between colours rather than washing in thinners. This makes the brush dry enough for the paint to drag, resulting in an interesting mix of colours in the scumble.

- The side of a palette knife can be used to paint up to and overlay edges. If possible, use a crank-handled knife as this will keep your hand away from the wet surface. **(C)**

- It is sometimes difficult to manoeuvre a palette knife into the best position. The board or canvas can be rotated to give better access, and a small painting can be held in the hand and angled.

- Paint can be built up thickly, but if it is too thick it will shrink back as it dries. Adding an alkyd resin medium such as Oliopasto will help solidify it, speed drying times and help preserve knife marks. **(D)**

- Thick, wet paint can be easily scraped off with a palette knife and replaced.

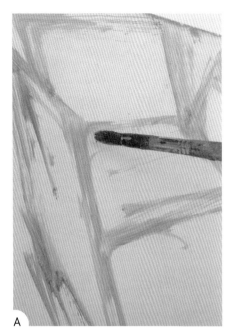

A

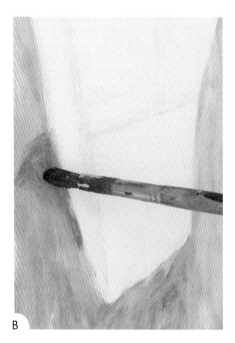

B

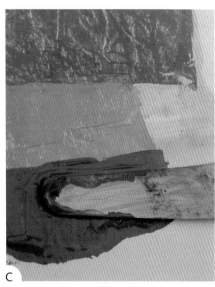

C

D

Techniques
WET IN WET, SGRAFFITO AND TONKING

Working with wet paint straight from the tube is a stable way of painting as no layers are involved. No thinners are needed either, if you wish to avoid turpentine.

Wet in wet requires courage and a certain panache. Paint is painted into or on to wet paint, so brushmarks and colours slide and mix. Done well, it has a fresh, slick feel and offers mark-making opportunities. 'Sgraffito' is scratching lines and texture into wet paint. Used with wet in wet, this is a good alternative to painting in lines. It is more controlled, and marks are easily erased by smoothing back and starting again. Tonking involves removing paint with paper to change colour, leave texture, or remove paint for reworking. Paint can be transferred to another part of the painting or another surface, rather like a monoprint.

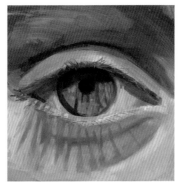

Wet in wet
Start on simpler areas with a large, flat bristle brush and thick wet paint. Then add more colours into this layer, letting them slide and mix. You can control this by how generously you load your brush. Place new tones and colours so they sit on the surface, or let them slide into the colour below. A smooth, non-absorbent primer can be helpful.

Wet in wet (continued)
Darker tones have now been pushed into the painting with a loaded brush. Some areas have been smoothed with a fan brush to contrast with the brushmarks added on top. The brush size was decreased as work progressed; final details were done with a long-haired sable rigger loaded with black, pulling into the wet paint.

Sgraffito
Here, thick white paint has been brushed over a black ground and the design scratched in with the blunt end of a small paintbrush, giving a black line. This is a useful way of working because lines can be easily drawn, painted out and redrawn without the paint getting too slimy.

Tonking
The painting was then developed by continuing to scratch out the design and blotting back some areas of the overpainting with newspaper to vary the tone and the texture. Other areas could also be painted into – wet in wet – to build up highlights.

Artist's tips

- For wet in wet, mix up lots of colour in advance. You can work freely without having to think too much about the colour combinations if these decisions have already been made.

- A mop brush or fan brush can be used to smooth the wet paint so that rougher brushmarks and different colours are merged together. **(A)**

- Experiment with manipulating wet paint straight from the tube. Here the paint has been put very thickly on the surface and the brushmarks are neither merged together nor smoothed back. **(B)**

- You can lay a coloured ground by rubbing paint into a primed surface and allowing it to dry. Alternatively, paint can be mixed directly into the primer. Painting over a toned or coloured ground (rather than white) can help you to work and think in different ways.

- You can scratch or scrape the wet paint with anything you like. The end of a paintbrush is handy, but nails, knives, pencils and pens are useful too. This is a nice fluid way of working because lines can be easily drawn, painted out and redrawn. **(C)**

- You can modify the thickness of the paint surface by removing some of it with paper or newspaper. Place the paper on the painting and rub gently or hard on the back with a finger, depending on how much paint you want to remove. This is called 'tonking', named after Sir Henry Tonks. **(D)**

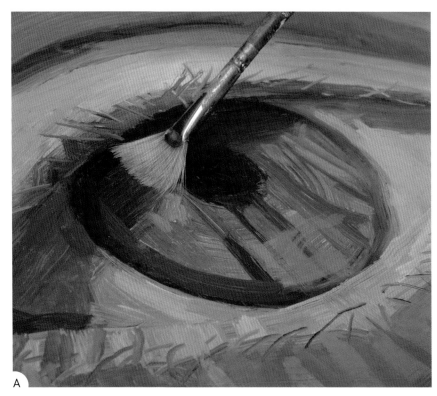

A

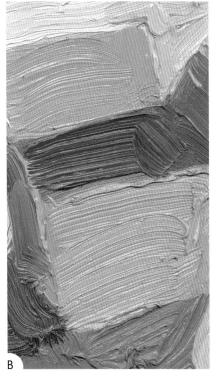

B

C

D

Techniques
WORKING WITH THINNED PAINT AND GLAZES

'Turpsy' paint (paint diluted with turps or white spirit) is used to draw out rough designs, or to create a more developed underpainting that is allowed to dry. The washy marks are then modified with thin layers on top (glazing), or covered and contrasted with thicker paint brushed or knifed on top.

For glazing, oil medium must be added so the paint dries more slowly than the layer below, and different layers can dry over time without separating or cracking. Adding more medium also adds lustre and gloss. This method can be used to modify the colours and textures of thinner or thicker paint below. Overpainting in opaque colours and tints partially obscures what is beneath, drawing areas of tone and colour together; translucent colours change or intensify the colour beneath.

Paint thinned with turpentine
The addition of turps made this paint easier to brush on. A small, soft brush was used and the colours were placed next to each other, as if in a jigsaw. Turps is generally thought to be the best thinner for painting with – its resinous quality, which other thinners lack, helps paint to stick.

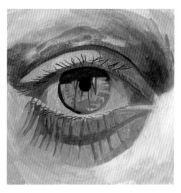

Contrasting areas of paint
As the painting develops, thicker, undiluted paint, mixed straight from the tube, has been used in places to cover and modify the thinner paint. Some areas have been rubbed back to the primer with a rag.

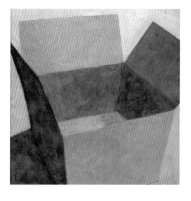

Painting on top of thick paint
Here the palette knife painting from p.158 has had a pale glaze painted over the top of it to lighten and unify the tones, and modify the colour. A linseed oil medium – 3 parts turps to 1 part linseed – was added to the paint.

Painting with glazes
The p.160 study was overpainted with two transparent purple glazes, and left to dry in between. Stand oil medium was used – first 6 parts turps to 1 part oil, later overlaid with a second glaze of 5 parts turps to 1 part oil. Semi-opaque lines (thinned with more medium) were painted into the final wet glaze.

The rule of 'flexible over less flexible'

Once it is touch-dry, oil paint can be overpainted with one or more layers. These can be thick or thin, but if using an oil medium, each layer should ideally contain more oil than the one before it.

The lower layers will take years to dry thoroughly and will contract slightly as they do so. Therefore it is wise to make sure paint put over the top will dry even more slowly so that it can move with the layer below. If not, the top layer may start to crack. Start with 6 parts turpentine to 1 part oil, ending with a mixture of not less than 2 parts turpentine to 1 part oil.

There is often confusion as to how this rule applies to an oil-modified alkyd resin medium such as Liquin. Unlike an oil medium, an alkyd resin speeds the drying time of the paint, rather than slowing it. It is also said to become more brittle than linseed oil over time. So, rather than adding more Liquin or Oliopasto as the painting progresses, it is sensible to make sure that all layers – including those with thick paint – contain roughly the same amount of alkyd medium.

Similarly, overpainting thick oil paint with a fast-drying dammar resin or wax medium can lead to cracking, so it is best to use these mediums throughout the work, preferably in a wet-in-wet one-layer painting where the paint composition is more stable.

Artist's tips

- White spirit or reduced-odour spirits are said to be less effective than turpentine for diluting paint for underpainting because they are less resinous, and if too much is added, the pigment may not stick properly to the support. Only add enough to wet the paint.

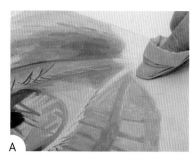

A

- One advantage of thinned oil paint is that it can be wiped off easily. Try drawing into the wet paint with a rag. **(A)**

- A semi-absorbent ground such as acrylic gesso on canvas or traditional gesso on board is good when painting in thinned paint. The texture of canvas holds the turpsy paint and allows for more to be added on top. On traditional gesso, thinned paint sinks in slightly rather than sitting on the surface.

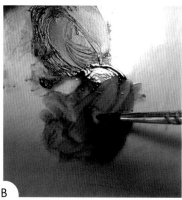

B

- Any of the drying oils on pp.156–157 can be mixed with turps to make your own painting medium. All have different consistencies and drying rates, and provide slightly different finishes. Sun-thickened linseed oil is more viscous than refined linseed oil, for example, and dries more slowly, so you can work into the wet paint for longer. A dammar resin medium will give a shinier, faster-drying finish, similar to an alkyd paint. Adding wax medium will give yet another texture and a matt finish. **(B)**

C

- Mix the paint with the glaze medium. Do not simply tint it – the density of the colour can be controlled on the surface of the painting. Brush on to the dry underpainting with a soft-haired brush. **(C)**

- If the glaze is too strong overall – or in places – dab at it softly with a soft, dry mop or fan brush to reduce it to a stain.

- Applying a transparent dark glaze is a good way of making shadows. Here, areas of shadow have been applied across the scumbled painting from p.158. **(D)**

D

Techniques
WAX, ALKYD, ENAMEL AND WATER-MISCIBLE OIL PAINTS

Alkyd, enamel and water-miscible paints are used by artists in conjunction with, or as an alternative to, conventional oil paint. Wax medium is used to change oil paint's consistency. Together these paints range from matt to shiny, and from bulky and waxy to very fluid. They feel different from one another and have their own strengths and weaknesses. These did not prevent me from producing very similar images here, but the brushmarks are actually very different when studied closely.

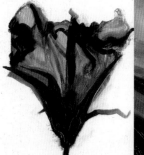

Alkyd paint

Alkyd paints are better known as household oil paint. These are sometimes adopted by artists because they are cheaper than artist's oils. The fresh, flat, shiny surface of Gary Hume's painting on p.170, for example, came from industrial alkyd paint.

This fluid, shiny paint spreads out when squeezed from the tube. It is sticky to work with and, although slippery, resists spreading easily without thinning with white spirit. Although adding alkyd medium gives a more translucent effect, it also needs further thinning with white spirit.

Once you have a good consistency, blending is easy and sgrafitto works well. It has many of the characteristics of oil paint mixed with a dammar resin medium. Its sloppiness makes painting with a palette knife tricky, but it holds its shape pretty well on the surface and can be worked back into with a brush. It is touch-dry in one day, and retains its shiny surface.

Water-miscible oil paint

Water-miscible oil paints seem to me to be a bit of a miracle – I find it difficult to understand how oil can be chemically modified to accept water. However, they do work perfectly well, allowing artists like Sally Wyatt (p.173) to paint in oil without mineral thinners.

This is a much more solid paint than the alkyd, and is quite waxy and opaque in feel. It is nothing like acrylic. Diluting with water gives a lean, matt wash rather like one given by oil and white spirit, and the paint feels more comfortable to work with if used more thickly. It does not spread far or merge readily, retaining the marks of individual brushstrokes even in washes.

Brushstrokes break off, creating a series of stop–start marks that characterise the painting technique. Ragging and sgrafitto work well, and palette knife painting is easy as the paint is thick. It dries matt and is touch-dry after two days.

Enamel paint

Enamel is a term that is now applied to any very shiny, self-levelling paint – spirit or water based. They usually contain a resin such as dammar, epoxy or alkyd. Raqib Shaw's rich, jewel-like enamel paintings (pp.168–169) are made with automotive enamel. Here, I have painted with Humbrol enamel, a spirit-based enamel developed for model makers and recently brought to the attention of the art world by the work of artist George Shaw.

Enamel paint is very liquid – much more so than alkyd. It has to be mixed with a brush and can be applied smoothly without thinning with white spirit. It pools easily, colours swirling into each other and sgraffito lines filling in. It dries quickly to a very smooth, very shiny surface. This can be overpainted in 10 to 15 minutes, but lifts if touched too soon. Some colours are a bit chalky, and I find it better to overlay transparent glazes rather than mix the paint up directly. The surface is easily spoiled by dust, so protect it in an improvised tent while it is drying.

Wax medium

Wax is in itself a painting medium, and the melting of wax to add to pigment is called 'encaustic painting'. Here wax is dissolved in turpentine (see recipe, p.157) to make a medium to add to oil paint. This thins and changes the consistency from glossy to matt, as seen in Toba Khedoori's work (p.151).

Wax medium has a loose consistency and when added to paint from the tube, it thins it and gives it a slightly grainy texture. The paint smooths out on the surface and dries almost instantly, limiting how far the paint will spread. It can be overlaid in a few minutes, though the paint remains soft and vulnerable until it is dry a couple of days later.

Sgraffito is easy. Despite the paint being matt, transparent wash effects are possible, and the colour is pure and bright.

Artist profile
SARAH PICKSTONE

Sarah Pickstone was born in Manchester and studied at Newcastle University and the Royal Academy Schools in London. In 1991 she was awarded a Rome Scholarship in Painting, and in 2012 she was the winner of the John Moores Painting Prize. Pickstone has work in the Saatchi Gallery in London, the Walker Art Gallery in Liverpool and the Mercer Art Gallery in Harrogate. She lives and works in London.

The paintings featured here come from a group of works all relating to women writers with a connection to London's Regent's Park – Sylvia Plath, Elizabeth Barrett Browning, Katherine Mansfield, Virginia Woolf and Stevie Smith. Drawings made outdoors of trees in the park were Pickstone's starting point, but new images evolved in the studio as she allowed her thoughts about the authors to influence the paintings. For example, a willow tree in the park is combined with an image of a woman bathing. This is a copy of a drawing that poet and novelist Stevie Smith made to accompany her poem 'Not Waving but Drowning', which Pickstone was reading at the time.

In *Mansfield's Moth*, the head of a woman morphs into the body of a moth, camouflaged against a silver birch tree. 'Katherine Mansfield presents herself in varying forms and I was interested – as with the Smith – in the possibilities for art, and women's art in particular, to be more than one thing at once.'

Right: Stevie Smith and the Willow. *Oil and acrylic on aluminum.*

Above: Mansfield's Moth. *Oil and acrylic on aluminium.*

These are large-scale works painted on very heavy aluminium panels, professionally primed with acrylic gesso. In the past Pickstone has made works on traditional gesso on plywood panels, but the plywood was bendy and the gesso cracked, so she now always uses acrylic gesso primer. Her painted surfaces are light, delicate and pared back. Yet, like the work of Prunella Clough, an artist she has long admired, they are rich in textural contrast. The use of acrylic enamel spray paint overpainted with oil allows her to exploit a great range of marks and gestures.

In *Stevie Smith and the Willow*, paint sprayed over white acrylic primer has resulted in a series of washy, slightly out-of-focus shapes that sit in the background and contrast with lines and triangles of thicker oil paint

brushed more deliberately over the top. In *Mansfield's Moth*, soft, textured paint sprayed through sharp stencils contrasts with large-scale, directional brushmarks thinned with white spirit, representing hair and wing. Other areas of the painting are a little more thickly worked, with paint mixed with a little linseed oil. As Pickstone explains, 'Oil paint is useful when you want a richer, more modelled form. It is generally more malleable.'

Pickstone sees painting as a positive and current means of expression. 'People get annoyed and frustrated with painting because it's a very fixed form, but it can have lots of different meanings. I'm interested in how you can open out meaning – I don't have fixed rules for myself.'

Artist profile
RAQIB SHAW

Raqib Shaw was born in Calcutta in 1974 and brought up in Kashmir. He worked in the family business selling ornate carpets and jewellery before moving to London in 1998 as a mature student to complete a BA and an MA at Central Saint Martins College. Major solo exhibitions have been held at the Pace Gallery and the Metropolitan Museum of Art (New York), Galerie Rudolfinium (Prague), Manchester Art Gallery, Galerie Thaddaeus Ropac (Paris), and the White Cube and Tate Britain (both London). Shaw's work can also be found in several public collections, including London's Tate and MoMA, New York.

Shaw makes paintings of imaginary worlds inhabited by exotic animals and birds, and strange hybrid creatures. His colours are vibrant, intense and harmonious, enhanced by the use of shiny enamel, neon and metallic paint. He uses a cloisonné technique inspired by Asian jewellery and metalwork, and further embellishes his surfaces with glitter and rhinestones.

Below: Ode to the Lost Moon when Innocence Was Young. *Oil, acrylic, glitter, enamel and rhinestones on birchwood.*

'The technique was really a result of the fact that I did not have any money when I was a student. I did not want to use oil paint because it's loaded with history, so I experimented with a lot of household paints because they were cheap.'

Shaw paints on rigid wooden panels or paper. After underpainting in oil, he lays the surface flat and draws out his intricate designs in gold with a stained glass liner. Using plastic bottles with fine nozzles, he squeezes pools of spirit-based enamel and automotive paint into the compartments formed by the raised lines. Colours are mixed and textures manipulated with a stick-like porcupine quill rather than a brush until they set into a raised shape surrounded by gold.

Shaw's richly coloured and bejewelled surfaces contrast deliberately with their content – close to, the hybrid figures and animals are seen to interact in cruel, violent, sexual and predatory ways. Shaw explains that these narratives are metaphors for the human condition, based on his own life experience. For example, *Ode to the Lost Moon when Innocence Was Young* is about his childhood in Kashmir. The trees, the cherry blossom and the swallows come from memories of the Himalayas, and the artist himself is represented by the solitary figure howling at the moon. 'It's the beginning of loss of innocence and solitude and isolation.'

As well as memory, Persian miniatures, porn magazines and the paintings of the Old Masters all feed Shaw's eclectic imagery. He has made ambitious series of works based on artists as various as Bosch, David, Holbein and Piranesi. This is an important part of his practice, and he is enthusiastic about taking inspiration from others: 'If my work can ever inspire people, my job on earth is done.'

Opposite: Death, Beauty and Justice I. *Acrylic, glitter, enamel and rhinestones on paper.*

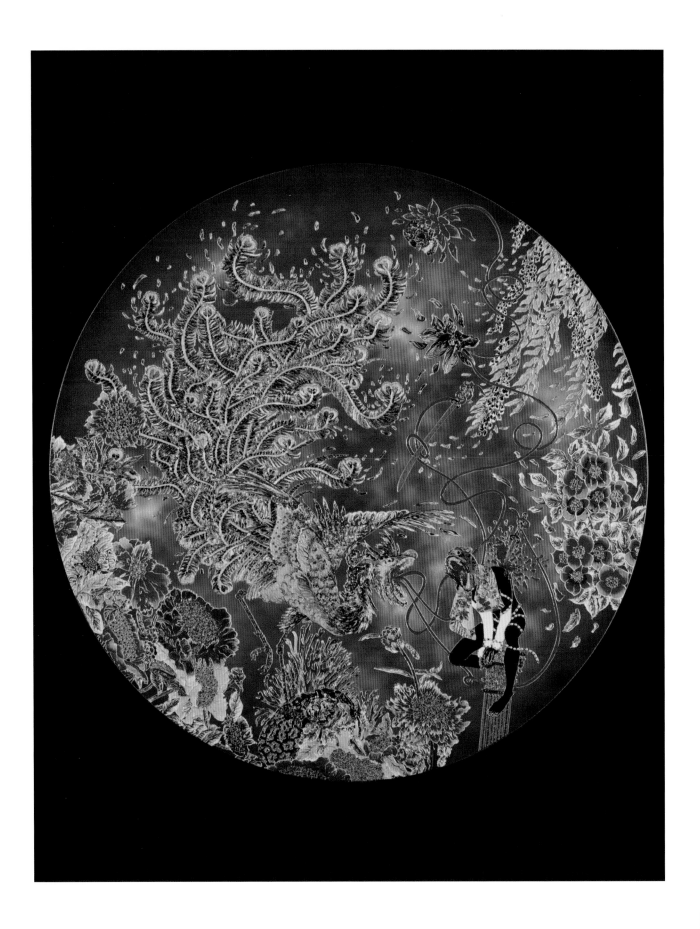

GALLERY

Above: No. 5. *Oil on paper, by Thomas Gosebruch.*

Left: Cuckoo in the Nest. *Gloss paint on aluminum, by Gary Hume.*

Opposite: Ihme. *Acrylic and oil on canvas, by Tomma Abts.*

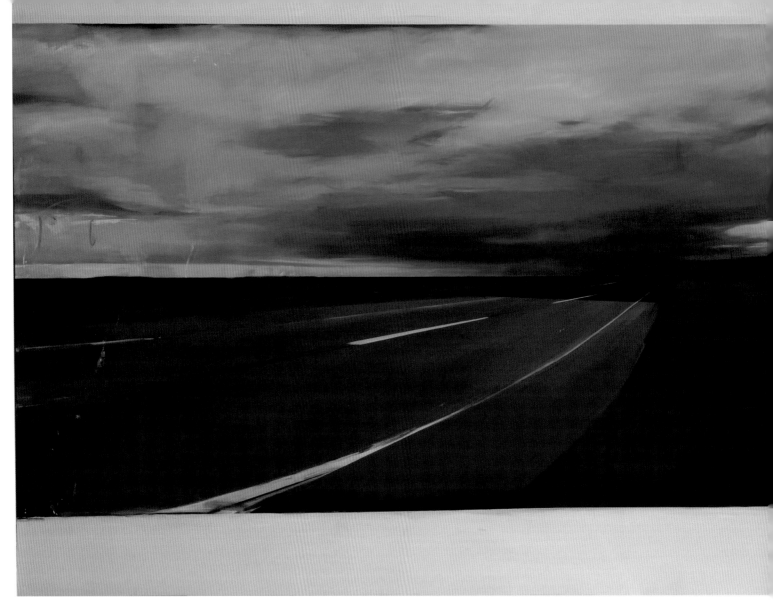

Above: Untitled. *Oil on canvas, by Carla Klein.*

Far left: Maxi Jazz. *Oil on canvas, by Joe Simpson.*

Left: Iznik, Blue Ground. *Oil on canvas, by Jan De Vliegher.*

Opposite top right: Untitled. *Oil on board, by Scott O'Rourke.*

Opposite left: Golden Gate Bridge from Crissy Field. *Oil on linen, by Helen Berggruen.*

Opposite right: Photo Opportunity. *Water-miscible oil on canvas, by Sally Wyatt.*

Chapter Ten

MIXED MEDIA
by Eleanor White

OVERVIEW

Mixed media describes work where a number of materials have been used. It refers to the supports on which an image is created, as well as the materials that have been used to draw, paint or print it. Collaged and overlaid surfaces are often a distinguishing feature of mixed media, as are unconventional and experimental working methods.

Many artists who use mixed media do not limit themselves to using traditional 'art shop' materials – they like to take risks and blur the boundaries. This attitude can be seen with artists such as David Tress (pp.182–183), who uses ink, watercolour and acrylic with tools such as a screwdriver to gouge and mark the paper as he works, and Michael Porter, who deliberately uses a mix of oil and water to see them pool and separate (opposite).

Some artists have an 'everything on' approach, where household gloss and emulsion may occupy the same canvas as acrylic and charcoal, printed matter, varnish, straw, cloth and metal. This can also result in an 'everything off' outcome, where some surfaces may not adhere to others as hoped. Anselm Kiefer sees this deterioration as part of the work, however, and deliberately combines incompatible materials, gluing and nailing objects to his canvases (pp.186–187).

A surface of collaged materials may be chosen to add meaning to a work. Both Ellen Gallagher (p.184) and Wangechi Mutu (pp.249, 251 and 258) work on top of found magazine or printed images that have significance for them, overlaying and interacting with them to find new meanings. Porter uses his own photos, which become a base on which to layer paint and other materials.

Mixed-media works can also come about from the need to rectify images. A pencil drawing that has gone wrong may become a background to apply paint to. This may not work, so on goes some collage paper, more pencil, some oil pastel and a wash of ink; and so it continues in no particular order. The image may have started large, only to be cut down later to remove an unresolved area. This may then be pasted on to a fresh, larger surface, offering a new start and yet another chance to develop the image.

Materials

- Take 15 to 20 supports, A5 or A4 (6 x 8in or 8½ x 11in) and ranging from primed and unprimed canvas, thin plywood or MDF, heavy white cartridge paper, brown and black sugar paper, newspaper, glossy magazine pages, brightly coloured card, gold or silver wrapping paper, and some old photographs, or photocopies of them if you want to keep the orginals. **(A)**

- Gather a wide selection of media – charcoal, pencils from 7H to 9B, erasers, rags, chalk and oil pastels, pigments, candle wax, beeswax, acrylic paint, oil and alkyd paint, ink, water, gesso, household filler, acrylic texture paste, PVA glue, shellac, dammar, a selection of large household brushes, hog's hair brushes (small, medium and large), small scraps of heavy card to make marks with, pallet knives, texture paste, sandpaper and a blunt craft knife. **(B)**

A

B

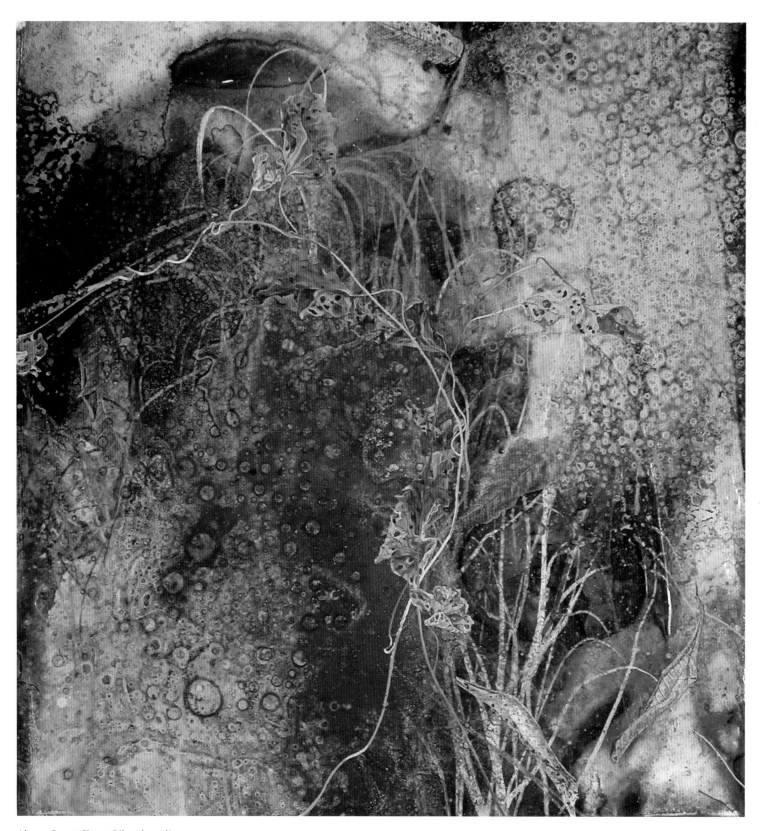

Above: Forest Floor. *Oil and acrylic on paper, by Michael Porter.*

Techniques
EXPERIMENTING WITH SURFACE AND TEXTURE

There are no real rules to mixed media, but you might like to start by trying out a variety of marks and media on different supports. This will give you a number of surfaces and textures that you can then work on top of to build an image. Play with your materials, aiming to keep an order to how you do it so that you can see the power of the mark, the material used and the effect both have on the support.

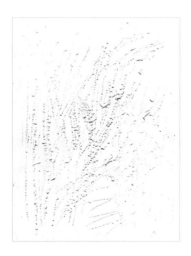 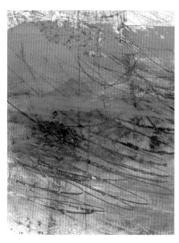 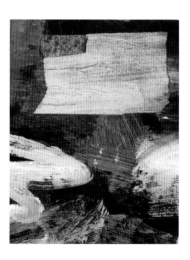 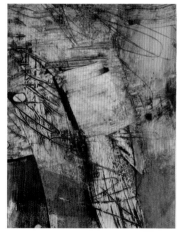

Attack and degrade
Cover white cartridge paper with scratch marks using a craft knife with a dull blade. Use a 7H pencil to make deep indents. Use vigorous stabbing marks, poking at the paper with your pencil. Rip the top surface, revealing softer, more absorbent areas. Sand back with sandpaper. If necessary, stick the paper on to card.

Draw and paint into the surface
Rub over this degraded surface with charcoal or a soft chalk pastel. Then use a large household brush, heavy with acrylic, letting some etched areas show through. Experiment with shiny and matt. Apply shellac, dammar or household varnish, gloss or enamel paint. Draw into these wet using a brush handle or card.

Paint into a surface of collaged materials
Painting across different surfaces causes paint to be absorbed in different ways, altering marks as they travel across boundaries, and adding interest to the surface.

Build up a surface
Take some card or board and cover it with texture paste or very thick acrylic. Scratch into the surface with any tool to raise the surface and create an uneven texture. Once completely dry, apply a wash of coloured ink using marks of different weights. The texture paste and acrylic paint will resist the ink.

Artist's tips

- Note that water-based materials applied over oil-based products may not adhere for very long. That is not to say you should not do it, but be aware that it is not a stable surface on which to base a major work of art that you want to last for a long time.

- Mixed media is better worked on a rigid surface as this will help the different layers to stay together – particularly if using wax and plaster.

- Wear latex gloves when rubbing in pigments, and a mask to protect against inhalation.

- Attacking or degrading the surface is all part of the process and can be done at any stage. As well as scratching, you could also burn the work, immerse it in water, corrode it, leave it outside in the sun, grow things on it, smash it up with a hammer or drive over it. **(A)**

- Charcoal and pastel will take differently to the various surfaces and you will see that they make the marks appear from the scratching and scraping. Also try rubbing in pigment. **(B)**

- Try gesso or household filler as an alternative to acrylic texture paste. You will find that they will absorb ink or paint in a different way. **(C)**

- Collage a surface with different materials and textures. It is best to use PVA glue rather than rabbit skin glue for mixed media, as animal size causes acrylic paint to crack. **(D)**

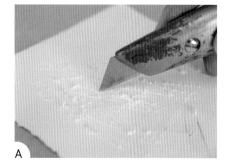

A

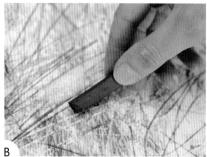

B

C

D

Techniques
WORKING IN LAYERS

Concentrating on mark making and not image can be helpful when experimenting with materials. However, you may like to think about inserting meaning by working on top of texts and photographs, and by incorporating found objects.

Overpainting and then scratching back
Overpaint oil pastel with acrylic and then scratch it back in places. This will give a good contrast between the darker overlaid marks and the vibrant colour of the scratched lines.

Using warm wax
Choose a photograph/magazine cutting. Paint or drip on warm candle wax or beeswax. Using a big household brush, splash dilute acrylic paint over the surface. The paint will adhere to the areas free of wax, and resist where you have used a heavier hand. More can be applied over the top to obscure parts of the text.

Painting over photographs
The shiny surfaces of magazines and photographs mean that dry paint can be removed from them by scratching. Paint acrylic thickly over the surface. Leave it to dry, then scratch back into the paint, using broad and narrow marks to reveal what is underneath.

Working back over textured supports collaged together
You should now have a collection of papers with diverse surface textures on which to build a small intimate image or, as here, to combine on a larger sheet as a background collage that has been overpainted further.

Artist's tips

- One of the appeals of mixed media is the freedom to start with a drawing of any kind before going on to paint on top. Oil pastel has the advantage that it can be used as a resist, but pencil, pastel, ink and charcoal will all give good contrasts and show through translucent paint. **(A)**

- Use a sharp knife or pair of scissors to scratch the paint away. **(B)**

- Wax can be used as a way of embedding found objects in the surface of a work. **(C)**

- Take any of your surfaces and begin to apply an image over it. If you find any of the marks below too powerful, knock them back by painting over them with semi-transparent paint. You can lift some of the paint by 'tonking' with newspaper (see pp.160–161) if it is too thick. **(D)**

- Always consider how much of the underlayer to leave, and how much to obliterate. It is good to see mixed media as a never-ending circle of over/under/on/off, observing what works and what does not, and learning to recognise the moment when it is right.

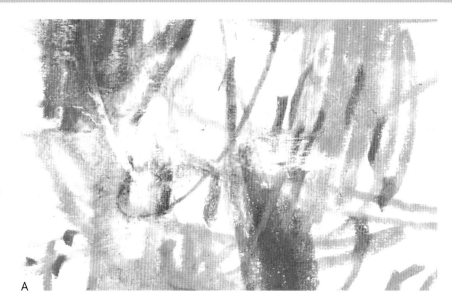

A

B

C

D

Artist profile
DAVID TRESS

David Tress was born in London in 1955, but has lived and painted in West Wales since 1976. He has exhibited widely in Europe and America, and has work in public collections including the National Museum of Wales and the Pallant House Gallery, Chichester. He is represented by Messum's Gallery in London.

As a young man, Tress explored conceptual and performance art, but on leaving college, largely rejected this approach. Following in the footsteps of British artists such as Cotman and Turner, he began to draw and paint from the landscape.

Although created by referring to sketches made on the spot, these are not straightforward representational views. The eternal flux of nature and the impossibility of capturing light and time are at the heart of Tress's work. Back in the studio, he takes a subject and, through his bold use of mixed media, grapples with it physically, allowing control to vie with chaos.

Paint, ink and watercolour create depth and surface alongside drawn marks in pastel or graphite. To these traditional materials Tress brings an energetic individuality by gouging and attacking the paper surface in a process that alternates between destruction and creation. Typically, he uses heavy watercolour paper, gluing a number of sheets together, working the initial image on to this, ripping it up, then rearranging the format. He also makes use of an irregular outer edge, as well as the relationship of shapes and marks within the composition.

The process of freeing the materials to take their own course might appear in conflict with the draughtsmanship that underlies the emerging image. But according to Tress, 'Unless you've been trained to draw – that good old solid background of representational painting (perspective, space, tonal relationships) – you can't do it. Structure is absolutely essential, and a lot of that is hidden under the layers.'

This dual approach allows Tress to make work about the transitory and the ephemeral. In *Evening City Easy* he embraces the everyday, as seen from a car window. Nothing is fixed or still. Grime and half-light, road signs and constant movement are all represented. In *Light Across (Loch Kishorn)*, the image captures the turbulent nature of weather. The structure of the landscape comes and goes as the paper is built up or degraded, and materials are allowed to be or not to be.

For Tress, the success of his paintings comes down to his willingness to take risks and react to his work intuitively. 'The fight to achieve a painting and the real risk that it's going to fall to bits and be a complete disaster seems to be an essential part of trying to do something that has the excitement and experience of the landscape itself.'

Below: Evening City Easy.
Mixed media on paper.

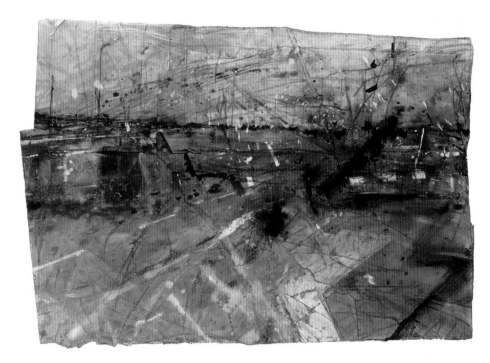

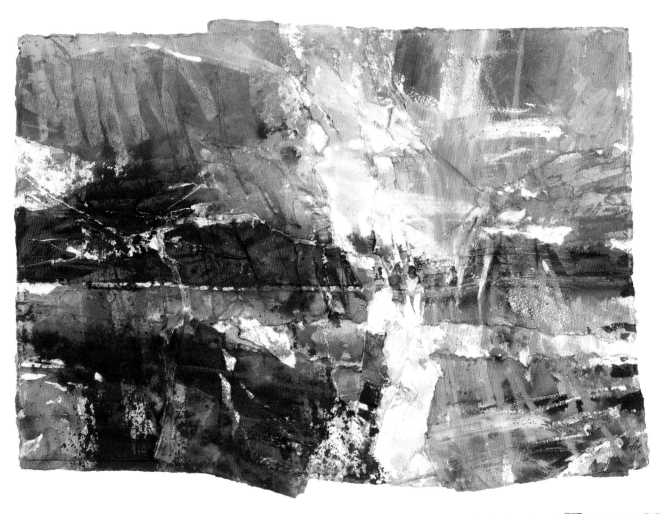

Above: Light Across
(Loch Kishorn).
Mixed media on paper.

Right: City Light
(Cement Lorry).
Mixed media on paper.

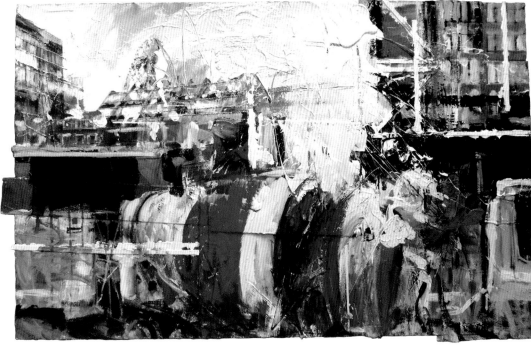

GALLERY

Above: Coral Cities. *Ink, watercolour, gold leaf, cut paper and plasticine on Ebony Magazine page, by Ellen Gallagher.*

Above right: Wasp's Nest. *Gesso, shellac and pencil on muslin on card, by Paul Martin.*

Right: Bowl. *Oil, acrylic and wax, by Peter White.*

Opposite: OGVDS [Spring]. *Pencil, marker pen, oil paint, watercolour and wax on linen on wood, by Andrew Bick.*

GALLERY

Above: Sketching ideas for the sculpture Taedda. *Wax and pencil on paper, by Alexandra Harley.*

Right: Sprache der Vogel 1988–2011. *Oil, acrylic, salt, brick, mortar, aluminium and steel on canvas, by Anselm Kiefer.*

Chapter Eleven

MAKING PAINT

RECIPES

Although shops sell pretty much everything an artist needs ready-made, this section provides some easy recipes for making types of paint that cannot be bought. Many artists wish to incorporate found materials into their work, and animal size, wax and egg have been used for centuries as binding media. Each type of paint has very different qualities, and their use can also impart meaning.

There is real pleasure to be had in exploiting the very different qualities of binders, and working directly with pigments. As well as trying out traditional recipes for egg, oil, wax and size, it is possible to make a simple, if slightly gritty, sticky homemade paint by mixing pigment with PVA glue, acrylic gel, shellac, linseed oil, dammar medium or alkyd resin.

Found materials such as earth from the garden, or ash from burnt items, can be dried in the oven, sieved and then ground down until smooth with a pestle and mortar. For water-based media such as glue paint, egg tempera, PVA glue and acrylic gel, it can be helpful to soak the pigments first in a little distilled water and then mix them to make a paste before adding. Alternatively, buy your pigment as a ready-made paste. Although it will not be lightfast, you could also incorporate fluids from plants.

Right: Dieppe. *Egg tempera, by Jane Dowling.*

Here, Dowling mixes powdered pigments with egg (see pp.194–195). The thin, luminous washes are typical of the medium.

Grinding pigments

For a smoother, more stable version of pigment paste or oil paint, invest in a glass muller with a ground glass or stone slab and grind the pigment into the water or oil.

1 Place the pigment on the slab. Different pigments require different amounts of medium, so add drops of water or oil gradually with a teaspoon and mix with a palette knife to make a dry paste. **(A)**

2 Grind in a circular motion with the glass muller. You will find that pigment will build up around the sides of the muller and around the edge of the grinding area. Scrape this up with a spatula and replace in the middle of the slab. Keep grinding until the paint feels smooth. Add more pigment if it feels too wet. Some pigments absorb more water or medium, and some take longer to grind than others. **(B)**

3 Store in airtight jars. Oil paint can be covered with a little water to keep it fresh.

A

Health and safety
While many pigments are simply earth, it is not good to ingest or inhale them. Wear latex gloves and a mask, especially if handling harmful cadmiums, chromiums and lead white.

B

Grinding found ingredients
You may wish to use found ingredients such as soil or rock. If so, you will need to bash them up a bit to get rid of the lumps. Drying them in the oven before adding to non-water-soluble media (oil or wax) will help them to combine well.

1 Push found materials through a sieve to remove lumps. **(C)**

2 Grind down oven-dried earth with a pestle and mortar. **(D)**

3 Grind pigment with water to make a pigment paste.

C

D

Glue paint or distemper

Glue paint has a beautiful, matt, translucent surface, and is made by adding pigment to animal glue size. The thickness and opacity is controlled by how much pigment you add to the glue.

Preparing rabbit-skin glue size
This can be used as a sealant for canvas, paper or board; as glue for collage; and as a binder for pigment.

1 Put 1 measure of glue crystals in a small saucepan. Add 16 to 20 measures of water and soak for up to half an hour.

2 Dissolve the crystals over a gentle heat. Stir and do not allow the glue to boil or it will lose its stick. **(A)**

3 If using as a sealant, apply hot.

4 Store in the fridge. It should be reheated gently prior to use.

Glue paint or distemper
1 Sprinkle pigment or mix pigment paste into warm glue. Add more or less depending on how saturated you want the colour to be. **(B, C)**

2 Paint on to the support while warm.

3 Work with layers that are only matt-dry – not completely dry. This will ensure they bond well.

4 If the surface is dry, coat with size and let it soak in before painting.

Paintings will need framing behind glass as they are resoluble in water and therefore vulnerable to dirt.

A

B

C

Tip
Test the strength of rabbit-skin glue size by removing a little of the liquid and cooling. It should set solid like jelly and be just breakable when pressed with a finger.

Glue distemper will dry flat, matt and lighter than when wet.

Wax encaustic

This very stable painting medium does not shrink or yellow over time, but paintings are vulnerable to dirt and scratches and should be protected behind glass. The paint is applied hot, dries quickly, is beautifully translucent and can be built up quickly and thickly.

Ingredients
- 1 heaped tablespoon of beeswax pellets
- roughly half a teaspoon of dry pigment

1 Melt the beeswax pellets in a jar placed in water. **(A)**

2 Alternatively, spoon the beeswax pellets into a metal muffin tray and heat it on a free-standing metal hotplate until melted. This method allows you to have a palette of different colours. **(B)**

3 Stir the pigment into the wax. If using found material, this should be completely dry as wax and water do not mix. **(C)**

4 Experiment with adding more or less pigment, depending on how saturated you want the colour to be.

5 Apply the paint by dipping a brush into the hot mixture and painting on to the support in short strokes.

6 The wax will solidify almost at once. Hard paint on the brush can be loosened by placing back in the warm containers.

A

Tip
Do not use your best paintbrushes for wax encaustic. They can never be cleaned of the wax.

B

Wax encaustic

C

Egg

Paintings in egg are built up in thin, translucent layers. The paint dries quickly, allowing these to be overlaid every 15 minutes or so. Unlike watercolour, the more layers that are added, the darker and more luminous the colour becomes. When new, a painting in egg tempera will need protecting behind glass, as the surface can be easily scratched, but over time – 50 years or so – it gradually hardens and eventually becomes very tough.

Preparing an egg for use as a binder

1 Break an egg and allow the white to flow into a container. **(A)**

2 Place the yolk in the palm of your hand and wash it gently under the tap. Pass it from palm to palm until it is dry enough to pick up by its skin. **(B)**

3 With one hand, pick up the yolk by its skin and hold it over a container. With the other hand, pinch the yolk until the sac breaks.

4 Allow the yolk to run into the container, leaving the skin behind. **(C)**

5 Add half an eggshell of water, preferably distilled – tap water contains chemicals that may react with the pigment. **(D)**

6 Mix with a brush. It should be the consistency of thin cream. **(E)**

A

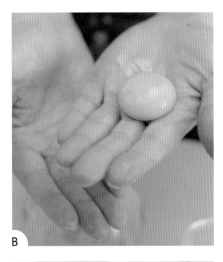

B

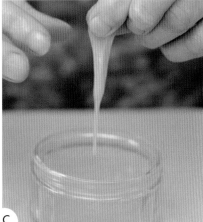

C

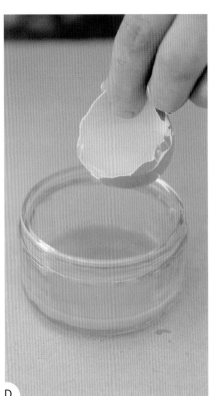

D

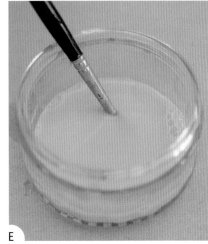

E

Egg *(continued)*

Painting in egg tempera

1 With a brush, mix a little of the egg/water mixture with the pigment until it forms paint. **(A,B)**

2 Using a dry brush, paint it out thinly on to card, thick paper or a gesso ground on board. **(C)**

3 The paint should be built up in thin layers with a flickering action rather like shading with pencil. Spread the paint out as you work. It dries quickly and can be overlaid after 5 to 20 minutes, depending on the absorbancy of the ground. The layers will pick up if the paint is not sufficiently dry, or if the egg mixture is too strong or too weak.

Egg yolk and linseed oil emulsion

This recipe produces an egg tempera that has some of the qualities of oil paint, and dries to a more glossy sheen. A leaner mixture can be made by adding less oil and water.

1 Place the egg yolk in a jar with a tight-fitting lid. Drop by drop, and stirring after each addition, add one level teaspoon of linseed oil to the egg yolk.

2 Drop by drop, and stirring after each addition, add one level teaspoon of distilled water to the egg/oil mixture.

3 Shake the ingredients together as if making a salad dressing. The mixture should emulsify.

The paint builds up in layers, becoming darker and shinier.

A

B

C

Primers

Traditional gesso primer

This is an absorbent to semi-absorbent ground for oil or tempera, glue paint or encaustic. Similar to plaster, it should only be used on a rigid support. It can be applied thickly for a textured surface, or sanded back very smooth.

Ingredients
- 1 measure of rabbit-skin glue size
- 2 measures of whiting (chalk) OR
 1 measure of whiting and 1 of titanium white powder sifted together

1 Heat the size until warm.

2 Take off the direct heat and sprinkle in all the whiting. **(A)**

3 Allow the whiting to sink in. Stir with a brush until you have a thin, creamy liquid. **(B)**

4 If the gesso cools and thickens, it can be gently reheated. It will become liquid in a moment and should be removed immediately from the heat.

A

B

Applying gesso flatly to board

1 Prepare the board by sizing and covering with muslin (p.97).

2 Paint on one coat of gesso by rubbing into the surface with a flat bristle brush. If bubbles form at this stage, rub the gesso into the surface with your fingers to get rid of them. **(C)**

3 Leave to go dull.

4 Apply up to four coats in alternate directions, waiting for each one to go dull before applying the next. The muslin should now be covered.

5 Apply at least one coat to the back of the board, to prevent it warping.

6 Texture can be added to the final coat by stippling with the brush.

7 The surface will go white when dry. Sand with wet-and-dry sandpaper for a smooth surface.

8 Apply one last coat of size and allow to dry.

> **Tips**
> Rub a little crushed charcoal into the surface before sanding. This will sit in the hollows and help you to see when the surface is really smooth.
>
> Touch the surface with your tongue. If it sticks as though to blotting paper, another coat of size is needed.

C

Primers (continued)

Egg–oil emulsion primer

This primer is suitable for oil, tempera, glue or encaustic. Two coats will give an absorbent ground; four thin coats a non-absorbent ground. Sand between coats for a smooth surface.

Ingredients
- a medium (50g) egg
- refined linseed oil
- 450g (16oz) titanium white powder
- size

1 Break the egg into a jar with a lid. **(A)**

2 Add four half eggshells of cold water. Use both half eggshells twice. This helps to ensure that the measurements remain consistent if the eggshell has broken unevenly. **(B)**

3 Add two half eggshells of linseed oil (use both half eggshells once).

4 Put the top on the jar and shake hard for 5 minutes to emulsify. **(C)**

5 Place the powder in a large bowl or saucepan, make a well in the centre and dribble in the emulsion slowly. Mix and blend, smoothing out the lumps, until it looks like cream cheese. **(D)**

6 Add lukewarm size a little at a time, stirring and blending until the primer is like thin cream. **(E)**

7 Use a brush or a wooden spoon to mix. Add more size for an absorbent ground. **(F)**

8 Wait an hour between coats. The primer will solidify and need warming. If it is too thick, add a little water.

A

B

C

D

E

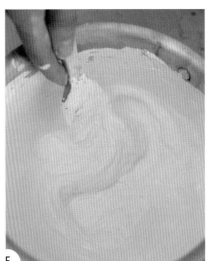

F

Artist profile
FRANCES HATCH

Frances Hatch lives in Dorset, close to the sea. She is a graduate of Aberystwyth University in Wales, and Goldsmiths and Wimbledon School of Art in London (where she completed an MA in printmaking). She is a senior tutor at West Dean College, Chichester.

Hatch works directly from the landscape, using paint made from the materials she finds there. She forages for her palette of earths, clays, litter and organic matter. These materials are then mixed with water-based binding mediums on-site and applied to supports such as sturdy paper, board and found wood.

Her binding mediums are PVA adhesive, artist-quality acrylic binders and rabbit skin glue. She embeds stains and textures within layers and then works back into the surface to reveal concealed elements. Hatch deliberately adopts ways of working that reflect geological processes such as deposition, abrasion and corrosion.

Below: Palette, Torvizcón, Spain

'Mindfulness of the nature and provenance of the materials is vital. I use as I find, and I get the "feel" of each substance that I incorporate.'

Hatch's materials are often ancient, but can also be contemporary. Rabbit droppings, spent fireworks and litter all find a place in the work. Solids such as clods of earth are broken up so that the binder can penetrate them; warm size is mixed with grated chalk cliff to make gesso; and clays are 'squidged' into a paste before medium is added. Hatch may apply binder to a surface and draw through it with her raw materials. At other times she extends her pigments with medium and water so that they can seep and insinuate into the surface. Application is with a brush, her hands or available tufts and twigs.

Hatch has worked in Antarctica and the northwest highlands of Scotland, as well as along the coastline of southern England. Choosing to use whatever is at hand means that she approaches each location with limited equipment. If colour other than what is available seems necessary, she will incorporate gouache, acrylic or watercolour with the found material.

Each site offers its own particular selection of tools and materials, and using them sustains a connection with a specific place – with both its past and present.

'By grubbing around for my tools and pigments I make discoveries about a place that I might otherwise have missed. If I return, even a day later, a different set of possibilities arise because I'm different and I'm encountering matter, water, light and air that continually fluctuate.'

Opposite top:
Old Harry, High Water, *from the 'Stack' series. Animal protein (rabbit skin glue), cliff material and gouache on Khadi paper.*

Opposite bottom:
Song of the Grass. *Animal protein glue, cliff and beach litter from Charmouth (Dorset) on two hardboard panels.*

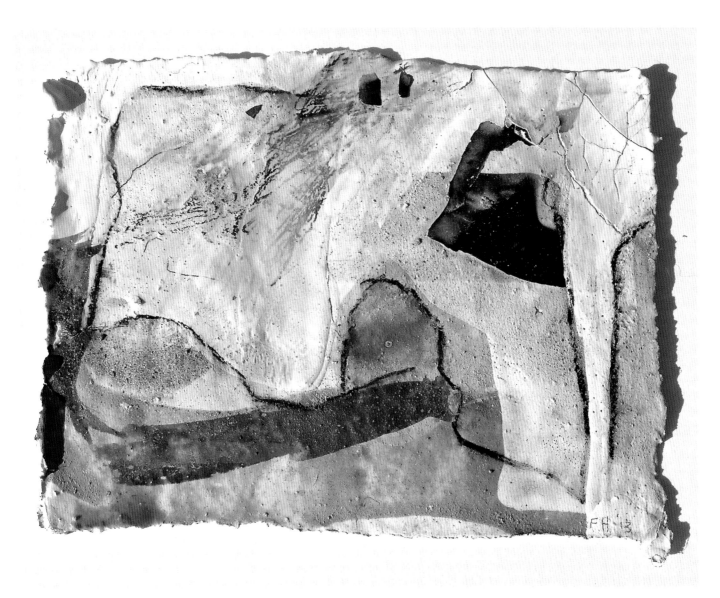

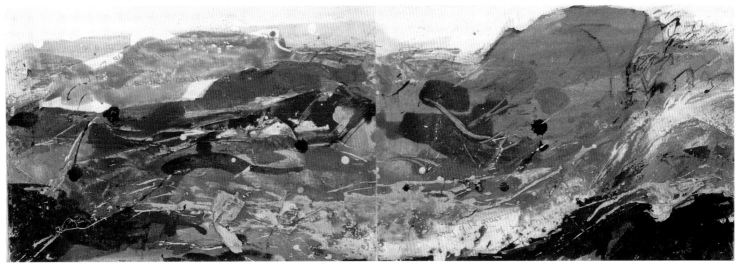

GALLERY

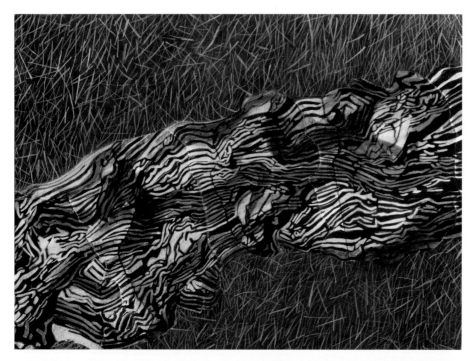

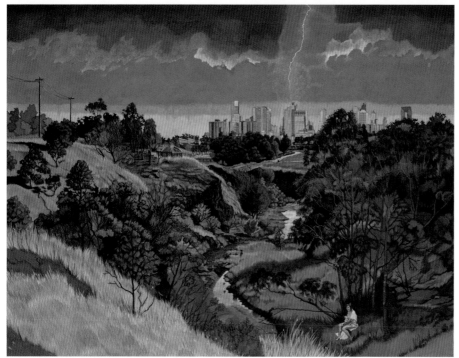

Above left: Stream. *Egg tempera on card, by Kate Wilson.*

Above: Cathedral. *Rock dust, by Steve Thorpe.*

Left: Summer Storm. *Oil and egg tempera on linen, by Eolo Paul Bottaro.*

Opposite top: Crossing the Yellow River. *Oil and encaustic, by Paul Martin.*

Opposite bottom left: Untitled. *Wax on board, by Marion Thomson.*

Opposite bottom right: Portrait of Caroline. *Egg tempera, by Antony Williams.*

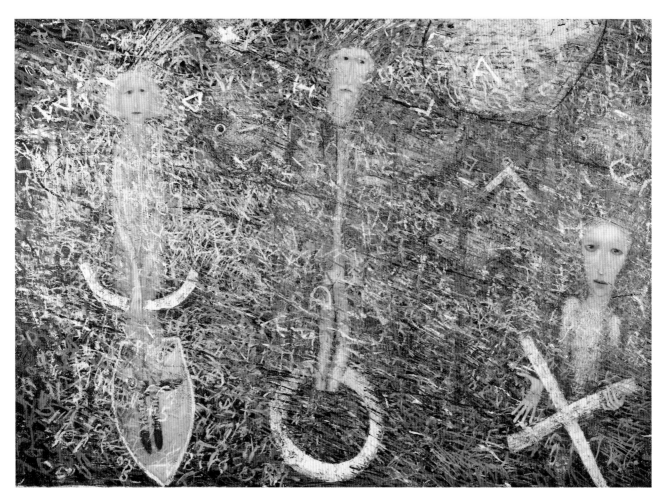

3

THE BIGGER PICTURE

Piano Chair *(detail).*
Digital animation, variable
dimensions, edition of
five, by Robin Rhode.

OVERVIEW

Artists have long drawn and painted flowers, fruit and collections of objects to reflect on the human condition. In fact, all objects have the power to point beyond their immediate reality, allowing the exploration of wider themes. Playing cards, fruit, chocolates, cake, cardboard boxes, bottles, rocks, books, flowers, shoes, clothing, jewellery, electrical equipment, cutlery, money, furniture, cars, stuffed animals, toys – all are potential still life objects.

For example, Cindy Wright's dead flies may remind us of our own mortality (p.219), while James Bridle's decision to draw the outline of a drone plane on pavements in Istanbul and Washington was a political act and deliberately contentious (opposite). Karin Broker and Helena Goldwater's drawings and paintings of flowers say something about femininity and sexuality; the former juxtaposing roses with the written exploits of women in situations of conflict, the latter hybridising plant parts (pp.218 and 214).

Simple objects such as chairs may point to the absence of people, as in Toba Khedoori's quiet pencil drawings (p.212), or represent modernist ideals, as in Robin Rhode's animations (pp.216–217), while James White's paintings of basins, bacterial spray, shower heads and plastic bottles remind us of the cold, shiny surfaces of everyday and the sheer banality of life (p.215). Alternatively, Steven Peirce creates his own surreal reality by setting up, lighting and painting his own homemade objects (p.219).

For some, the chosen object becomes an opportunity to explore the act of painting or drawing. For example, both Jan De Vliegher (p.219) and Lisa Milroy (right) talk of how their first concern is the stuff of paint. Indeed, looking carefully at objects is a good way to practise drawing and painting skills. Small objects are controllable, allowing you to explore in private, formal matters such as shape, form, composition and accuracy. Scaled up, they can help the beginner make more ambitious work.

Although you may well choose to make your work from memory like Milroy, from photographs like De Vliegher or project and trace your subject matter to gain a simplified line, this chapter introduces ways of drawing accurately from observation. Working directly from real objects is a useful discipline – you will find that you are able to look at things more intensely and that you become aware of how things work in space. Adopting a variety of ways of working can strengthen your natural ability and help stimulate new ways of thinking.

Below: Book, *Oil on canvas, by Lisa Milroy* RA.

Opposite: Drone Shadow 002, Kemeralti Caddesi, Istanbul. *Road paint on pavement, by James Bridle.*

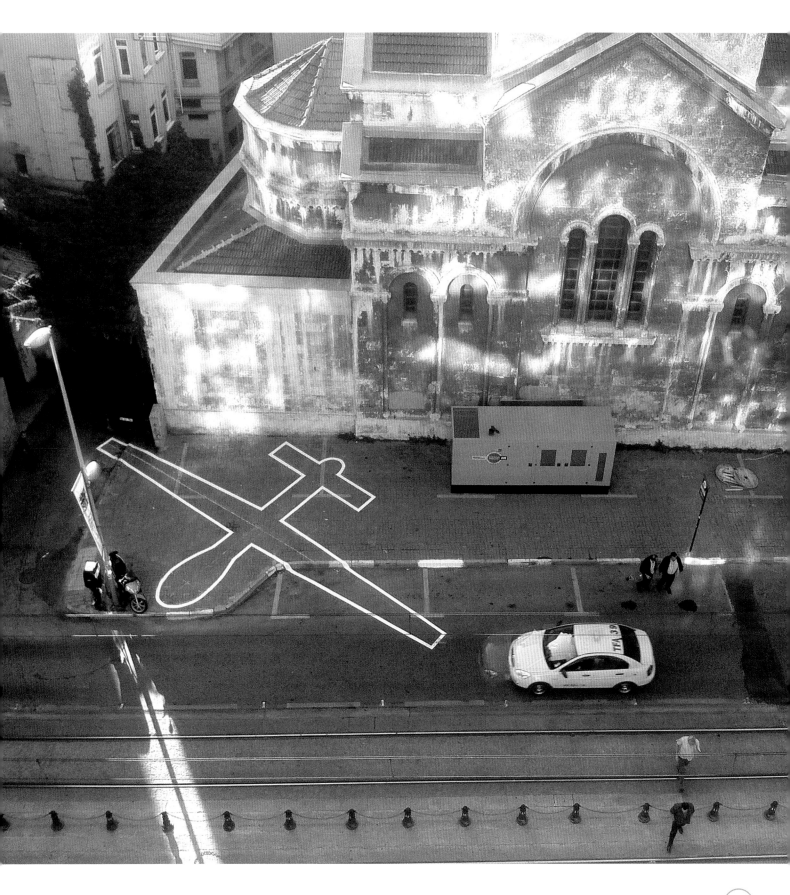

DRAWING FROM OBSERVATION

Set up an arrangement of up to three simple objects on a piece of paper and try out these different ways of looking and drawing. If you are a beginner, it will help if these objects are round or amorphous, rather than square – bottles or rocks, rather than boxes – so you do not have to think too much about linear perspective at this stage (pp.210–211).

Continuous line drawing

Draw in line without removing your pencil from the paper. Look carefully at the objects, not the paper, and feel your way. Let your hand follow your eyes, slowly drawing what you see. Modernists such as Matisse often used this way of working to abstract from what they saw and, like them, you will end up with a simplified drawing. It may also be extremely inaccurate, but do persevere – this is an excellent way to improve your looking skills.

Gridding

Now draw in extra lines to help you judge distances, angles and the relative sizes of objects. Try using horizontals and verticals to compare the tops, bottoms and sides of objects. Use them to see how high one object is against another. Draw in lines between objects to feel the distance between them in space.

Negative shapes

Negative shapes are the spaces between and around objects. Half-shut your eyes to shut out detail, then look for and make a drawing of the negative shapes, treating the still life as a series of interlocking patterns. This can help you relate one object to another and to draw difficult outlines more easily. It is quite an intuitive way of working.

Measuring

After sketching out the objects, take some rough measurements using your thumb against your pencil. Compare width with height and compare one object's size to another. For example, the bottle here is roughly three times as high as it is wide. The metal ring is about twice as high as the bottle is wide. This will help you to spot if you have drawn things the wrong size.

Continuous line drawing

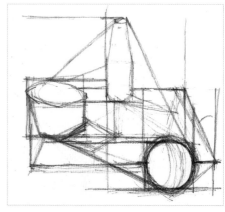
Gridding

Negative shape

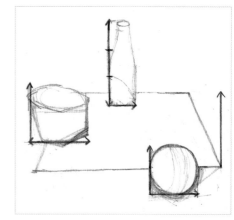
Measuring

Measuring

Hold your pencil up over the 'real' still life to make connections and see how the objects line up. This will help you when gridding. **(A)**

Comparisons must be made with a straight arm so that all your measurements are taken from the same place and are therefore consistent. Here, the width of the bottle is being measured. **(B)**

Compare any angles – such as the sides of the paper – to imaginary vertical lines. It makes it easier to see if they go left or right. **(C)**

Add one more object to your set-up. Can you fit it in? What do you notice?

Now try drawing the same still life from different angles.

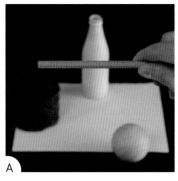

A

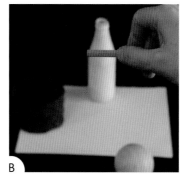

B

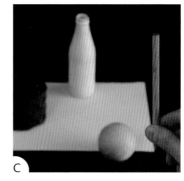

C

Below: Still Life with Electric Fan. *Egg tempera, by Antony Williams.*

Antony Williams here paints two very ordinary objects in the corner of a room, but the care with which they are arranged and the intensity of his gaze make for a compelling piece of work.

DRAWING BOXES USING PERSPECTIVE AND CRATING

Objects with straight edges are difficult to draw from observation; it is a challenge to perceive the angles and direction of the lines. However, applying the rules of one- and two-point perspective may help you understand what to look for.

Below: Boxes in two-point perspective.

Drawing boxes

Look at a box from the front. Put yourself in a position where you can see a little bit of the top and one facet of the box as an undistorted shape. Can you see the lines of the sides appearing to converge towards an imaginary point that is level with your eyes?

Next, turn the box so that you can see one corner, two equidistant sides and a little bit of the top. Can you see the lines of the two sides appearing to converge towards two vanishing points on the same imaginary eyeline?

Now, turn the box so that you can see a tiny bit of one side and a lot of the other. It should be almost straight on but not quite. You should see the lines of the left side disappearing quickly towards a vanishing point on your eyeline. The other facet of the box is so close to being straight on, that its lines are only converging very, very slowly towards a point outside the picture.

Now use the theory to draw an imaginary pile of boxes. What do you learn? Can you use this knowledge to help you draw a pile of boxes from observation as well? If you find it difficult to work it out, make use of gridding and negative shapes (p.208) to help you confirm the basic direction and angle of the lines. Look at Chris Hough's painting (far right). See if you can roughly work out the horizon line and the vanishing points for the model buildings. (For more on linear perspective, see pp.232–233.)

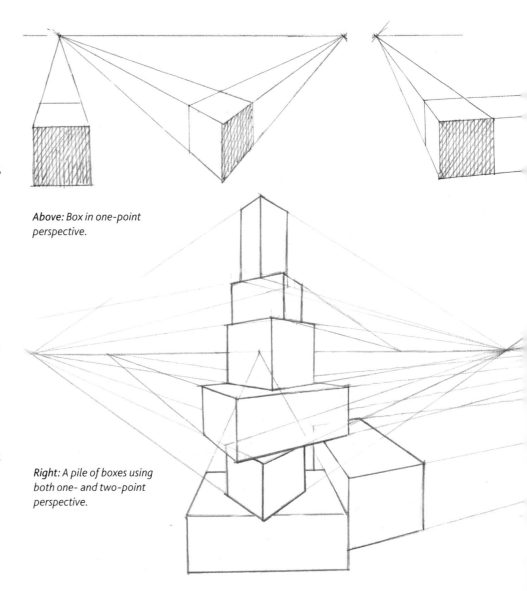

Above: Box in one-point perspective.

Right: A pile of boxes using both one- and two-point perspective.

Crating

Using boxes to help you draw more complicated objects is called 'crating'. It is useful for tackling objects at any height or angle, both when drawing from observation and visualising freehand. Richard Talbot used this method to imagine what Jasper Johns' iconic painting *Target* might look like from the side.

A lamp, as here, can be drawn into a stack of boxes. Draw one rectangular box and divide it into three: one for the base, a second to contain the round lenses and a third for the rounded top. Then try placing a slimmer box on top, the right size to contain the handle.

Cross the diagonals of the sides to help you find the mid-points. This will then help you draw the distorted semi-circles used to make the curved top and the ellipses made by the circular lens. **(A)**

Once the structure of the lamp is understood, it can be drawn at any angle or height. **(B)**

Below: Missing the Target. *Pencil on paper, by Richard Talbot.*

Right: Saratov Station Model. *Oil on board, by Chris Hough.*

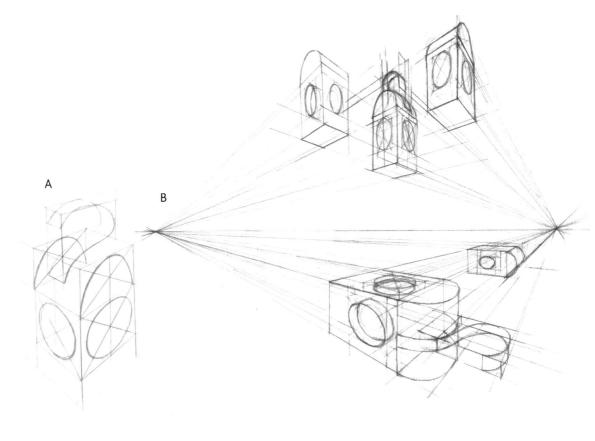

A

B

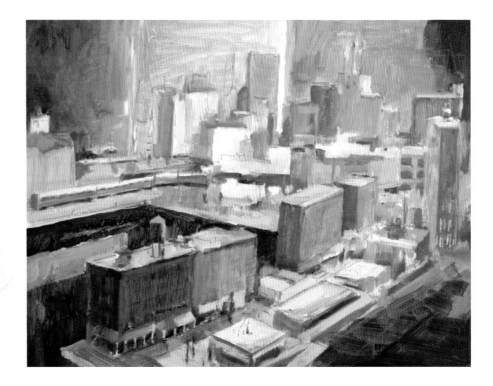

TONE AND LIGHTING

To draw in tone is to describe how light or dark something is, and it will record the effect of a particular kind of light. Light can be used to transform what we see – an object viewed under a fluorescent strip is harshly exposed, but seen by candlelight the same object is half hidden, mysterious in shadow.

Start by comparing the tones of the actual objects and decide if they are light, dark or grey. Here the bottle stands out as a light shape against the dark cloth, but it is much the same tone as the white paper. The ball is mid-tone, so shows up against the white paper and black cloth. The metal ring is the darkest object, darker even than the black drape.

The way the light falls on an object will modify the tones, making areas look lighter or darker. Side lighting and cast shadows can be used to make an object appear more dramatic and more solid. Here, the white bottle and the mid-tone ball become darker, while the metal ring and the drape become lighter in places.

Making judgements about tones and tonal contrast will be easier if you can see the set-up as a series of interlocking shapes. Half-shutting your eyes and using a viewfinder may help. A viewfinder can also be used to help you decide which way round your shapes fit best on the paper (p.224).

Experimenting with lighting can change the look, and even the meaning, of your subject matter. For example, the shadow cast by the sweet chestnut in Kate Wilson's watercolour (right) helps propel it forwards on the paper, giving a sense of movement.

Comparing tones

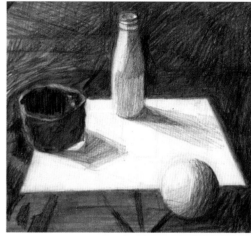

Side lighting and cast shadows

Above: Sweet Chestnut. *Watercolour on paper, by Kate Wilson.*

Above: Untitled. *Graphite on paper, by Toba Khedoori.*

212

Artist's tips

Varying your marks and the gesture with which you draw – how hard, how fast – will change the look of the resulting image. For example, Toba Khedoori's soft shading and gentle tonal contrast enhance the vulnerability of her objects.

- **Cross-hatching** is a very precise way of working and, because of the straight lines, is generally better suited to angular objects. **(A)**

- **Shading** around the form is a good way of working if you have a curved object, or one that is quite tactile. Bend your lines around any contours and be sensitive to the direction of the line. **(B)**

- **Dots and dashes** in various forms can be used to give texture to your darks and lights. You may also want to experiment with shading on textured paper, which is a quicker way to get a similar, though more regular, effect. **(C)**

- **Scribble** – let yourself go! To do this, you should look for the overall shape and draw loosely from the middle out to the edges. When you are happy, darken those areas that are in shadow. **(D)**

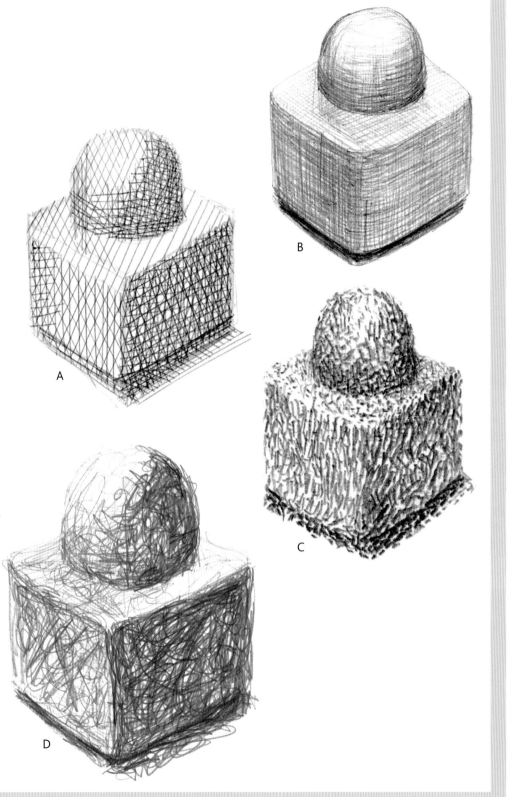

A

B

C

D

THEMES AND WAYS OF WORKING

You will find that your choice of object gives meaning to the work. Your choice of medium and the way that you draw or paint will also influence the message.

For example, to paint flowers in watercolour is to reference a European scientific tradition of botanical illustration, with possible allusions to sexual reproduction, decay and death. In fact, sexuality might be the real theme of the paintings, as is the case with Helena Goldwater (right).

It can be a helpful exercise to draw and paint the same object several times using different materials and working methods. You will then be able to make comparisons and gauge how the message varies each time. Experiment with scale and speed of working, and with mark and gesture, as well as working in colour and black and white.

Tip
Write materials and actions on slips of paper and select one at random to help you to experiment and work through various possibilities in an intuitive way.

Right: DNA.
Watercolour on paper,
by Helena Goldwater.

Working with themes

The objects set up on the preceding pages have been selected for their shapes, and because they are fairly straightforward to draw. The next step is to choose objects for their significance.

Think about what you want to say, and adopt materials and ways of working that reinforce your ideas. Writing materials and actions on slips of paper and selecting at random will help you experiment with various possibilities. Using the wide range of materials suggested in this book, try the following approaches:

- Draw and paint from observation, a photograph, a computer monitor or tablet, from sketches or from memory.

- Project and trace, working over an existing image.

- Work large, work small, enlarge, reduce, simplify, duplicate, cut up, collage, fragment, distort.

- Reproduce what you see, work precisely, imprecisely, in an abstract manner.

- Use: a ruler, gesture, blind line, chance.

- Duplicate or pair with other objects. Consider location.

Examples of some objects and their possible meanings

Flowers
Femininity, purity, love, sex, spring, new life, faded, pressed, preserved, decay, death, botanical, specimen, new knowledge, science.

Clothes/shoes
Body, fashion, history, culture, male/female, sexual allure, identity, texture, pattern, wealth, poverty, status.

Letters
Personal, secret, enclosed, stamps, communication, distance travelled, foreign lands. Handwritten vs typed: friendship, love, loss, ink, nostalgia, vs impersonal, business, money, advertising, junk mail, bad news.

Right: Anti Bacterial Action! *Acrylic metal primer, gesso, oil and varnish on aluminium panel, by James White.*

Cleaning fluid
Non-art object, utilitarian, sterile surfaces, barren, housework, house proud, cleanliness, advertising, ugly, deliberate, plastic, text, Pop art.

Right: Letter with Moth and Key. *Acrylic on paper, by Rachel Ross.*

Below right: Boot. *Acrylic on canvas, by Andro Semeiko.*

Artist profile
ROBIN RHODE

Robin Rhode (born in 1976, Cape Town, South Africa) was raised in Johannesburg and studied Fine Art at the Technikon Witwatersrand from 1996 to 1999, as well as Production Design at the Association of Film and Dramatic Art, briefly, in 2000. This multi-disciplinary artist engages a variety of visual languages, such as photography, performance, drawing and sculpture, to create arrestingly beautiful narratives that are brought to life using quotidian materials such as soap, charcoal, chalk and paint. Using a simple process of stop-motion animation, Rhode depicts a character, often himself or a doppelganger, interacting with various drawn objects and situations. He then photographs each carefully staged scene as he redraws, erases and traces the forms to bring each work into action.

Coming of age in a newly post-apartheid South Africa, Rhode was exposed to new forms of creative expression motivated by the spirit of the individual rather than dictated by a political or social agenda. The growing influence of hip-hop, film and popular sports on youth culture as well as the community's reliance on storytelling in the form of colourful murals encouraged the development of Rhode's hybrid street-based aesthetic. His strategic interventions transform urban landscapes into imaginary worlds, compressing space and time, as two-dimensional renderings become the subject of three-dimensional interactions. By bringing objects such as grand pianos, playground equipment and fancy cars to abandoned streets, Rhode highlights the absence of these everyday items and calls attention to them as objects of desire. Rhode believes in working intuitively, and experiments over time to bring out varied meaning from his objects. He states, 'It's important that I push the objects further through drawing and push the meaning of the objects into something else.'

Given his first major museum solo show by Haus der Kunst, Munich, Germany (2007), Rhode has since had major solo exhibitions at a number of important museums around the world, including the Hayward Gallery, London (2008); the Wexner Center for the Arts, Columbus, Ohio (2009); the Los Angeles County Museum of Art, California (2010); the National Gallery of Victoria, Melbourne, Australia (2013); and the Neuberger Museum of Art, Purchase, New York (2014).

Rhode has also participated in several group exhibitions, notably the 51st Venice Biennale (2005); MoMA's *New Photography* (2005); the 2010 MoMA exhibition, *The Original Copy: Photography of Sculpture, 1839 to Today*; the 2010 SITE Santa Fe Biennale; the 2011 MoMA exhibition, *Staging Action: Performance in Photography Since 1960*; and the 2012 Sydney Biennale. His work can be found in numerous public collections, including the Centre Pompidou, Paris; the Museum of Modern Art, Solomon R. Guggenheim Museum and Studio Museum in Harlem, New York; and Walker Art Center, Minneapolis. Rhode lives and works in Berlin, Germany.

Left: Paries Pictus – Connect the Dots: Car (*performance detail*) 2013.

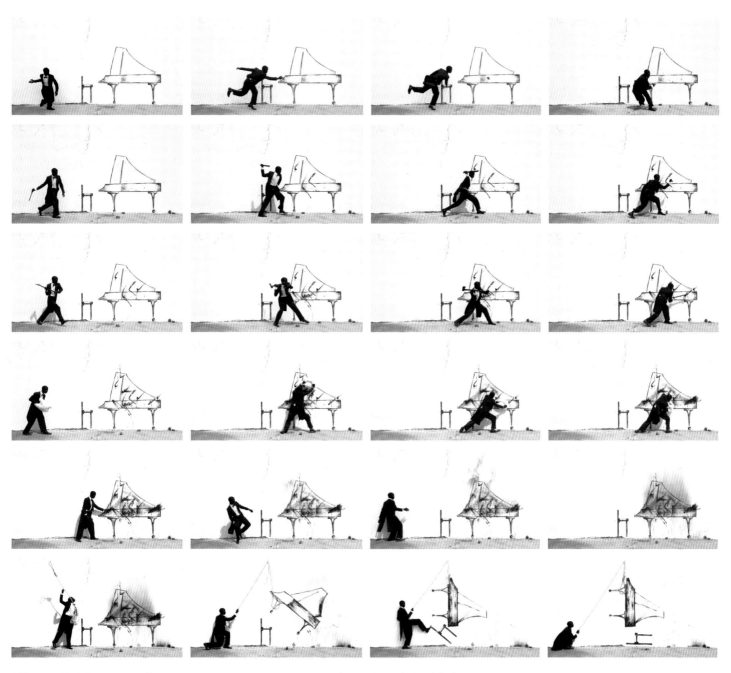

Above: Piano Chair. *Digital animation, variable dimensions, edition of five.*

Left: Piano Chair *(detail).*

Text contributed by Lehmann Maupin, New York.

GALLERY

Opposite: Fighting Pretty.
*Conté crayon on formica,
by Karin Broker.*

Top left: The Spiral. *Oil on
canvas, by Stephen Peirce.*

Top right: Sèvres,
Pêches. *Oil on canvas,
by Jan De Vliegher.*

Left: Fly. *Oil on Belgian linen,
by Cindy Wright.*

Chapter Thirteen

ENVIRONMENT

by **Simon Burder**

Red Rain. *Oil pastel and graphite on paper, by Robyn O'Neil.*

OVERVIEW

As human beings we are always interested in how we relate to the places around us, whether it is our homes, gardens and cities, or the wider environment of the regions we inhabit – even the places that are beyond our reach (at least without specialist equipment and skills) because they are inhospitable to human life. We may observe reality, or conjure imaginary landscapes that represent our longings for a lost past, or our hopes and fears for the future.

Today's artists may use any material or procedure, be it traditional drawing and painting, digital media, direct intervention in the landscape, documenting or mapping. Many, such as Robert Perry (pp.236–237) or Martin Beek (pp.224–225), doggedly pursue the 'plein air' tradition of Constable, Corot, the Barbizon painters and the Impressionists, aiming to complete entire works in front of their outdoor subject in all weathers, often with the aid of ingenious homemade equipment.

By contrast, the watercolours of Christopher Le Brun (p.234) reference the idealised mythical world of the classical landscape tradition, promoted by Claude and the popularity of Italy for eighteenth- and nineteenth-century artists on the Grand Tour.

Others refer to photos and archive material to convey a sense of place and history, such as Emma Stibbon's monumental drawings, which incorporate volcanic ash from her chosen site (p.226), or Narbi Price's urban close-ups – anonymous locations of historical murders (p.239).

Landscape can also be understood through mapping. This can address issues of political power and identity, as in Irish artist Kathy Prendergast's work (p.238), or produce the plan-like drawings that help Japanese Outsider Artist Norimitsu Kokubo make sense of his world (opposite).

Using technical drawing to disturb expectations of realism, British artist Paul Noble (opposite) constructs imaginary cityscapes reminiscent of Hieronymus Bosch and Escher, while the Austrian magic realist Torsten Slama designs houses for a future in which people will live on other planets (p.235).

MASTER GATES

Left: Master Gates. *Pencil on paper, by Paul Noble.*

Below: Presidio: In the Sand Hills Looking East with ATV Tracks and Water Tower 2. *Oil on canvas, by Rackstraw Downes.*

Right: Economic Revolution: The City of Yokaichi School for the Disabled. *Ball-point pen and coloured pencil on paper, by Norimitsu Kokubo.*

The impact of photography and, to a much greater extent, the digital revolution cannot be underestimated, on both the landscape artist's compositional choices and the very function of traditional media and approaches. The digital drawing tools popularised by David Hockney remain closely tied to their traditional media counterparts, but the internet age has made us acutely aware of our place in the universe, and artists are finding ever more inventive ways of expressing concern for the environment. In Britain, Richard Long pioneered Land Art using real rocks and mud; the environmental artist Peter Fend engages with scientific data, maps and text to propose ecological solutions (p.229); and Outsider Artist Ben Wilson paints miniatures on chewing gum stuck to London streets – partly to decorate, partly to defy anti-graffiti laws (p.228).

ON LOCATION

There are many ways to begin working from your surroundings. Remember, though, that you may have to work rapidly, or be able to work undisturbed over a period of time. These factors will then affect your response.

A familiar location that you can visit repeatedly helps provide a source for sustained study. This can range from the intimate interior of a room at home to the large public interior of a shopping centre, underground carpark, train station or airport; from the peace of a private garden to the space of a park; from the view down your street to the view of a city from a high building; from the view down a lane across fields to the vista across miles from the top of a hill or mountain.

The equipment you need may vary from a simple sketchbook and pencil to canvas, easel, paints, brushes and other tools. Martin Beek, for example, uses a cheap folding table as a palette.

Viewfinder

You can use a viewfinder or camera to frame the subject horizontally (landscape) or vertically (portrait), far away or close up.

A viewfinder can either be a fixed-size aperture cut out of a single piece of card, or two L-shaped pieces of card taped together to make apertures of variable proportions. The aperture should have the same orientation and proportions as your intended paper.

Below: Martin Beek painting on location at Hailey, near Ipsden in Oxfordshire, UK.

Far left: A viewfinder helps to visualise a possible composition.

Left: Using a viewfinder to look at close-up detail can help you to see possibilities for abstraction.

Content contributed by CHRIS HOUGH.

Artist's tips

- A high vantage point can reveal several aspects of a landscape – all the scars and characteristics of human habitation, as well as the changes that may have been caused by natural phenomena, such as flood or drought. A landscape can also be viewed across the year, which will reveal changing seasonal patterns. **(A)**

- Sketch an entire vista until you discover smaller areas that interest you the most. You can then explore these in greater detail, as Chris Hough has done with this pen and ink sketch. **(B)**

- Focus on areas of different size and scale.

- Look at something beneath your feet, such as grass or a manhole cover.

- Add something you have noticed, such as fencing or electricity cables, crossing the composition in a contrasting medium or colour for a different spatial dimension.

- Draw or paint quickly; give yourself a time limit or work from something moving, such as water or clouds.

- Work for longer periods, and keep returning to the scene – to incorporate a different response to it, or to record developments in your own interest. Map the changes occuring in such locations as tidal estuaries, areas of high agricultural use or construction sites. Record sites in different weather and light conditions.

- Record the changes with photography, as Liam O'Connor did with his evolving drawing of a building site at the British Museum. Compare *View from the Model Room Window 2010–13 (28/11/2011)* here with his later drawing on p.25. **(C)**

A

B

Digital tip
For 'plein air' working at speed or in poor weather, use a tablet from inside a parked car, as Martin Beek has done for his *Landscape near Ipsden* (iPad Brushes app). **(D)**

D

C

IN THE STUDIO

While many artists like to complete an entire work on location in front of their subject, for others this is either not practical or not their intention. Working in the studio, an artist is removed from their source of inspiration, so will need strategies for developing work based on the environment.

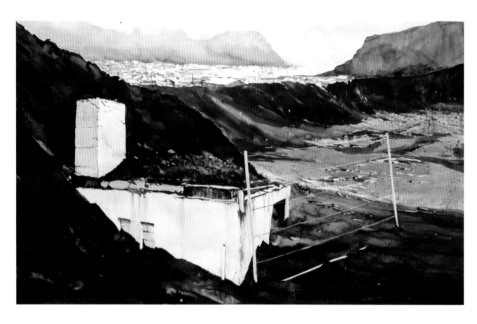

Above: Gerðisbraut 10, Heimaey. *Ink, carbon and volcanic ash on paper, by Emma Stibbon RA.*

Top right and above right: St Bartholomew Church *(sketchbook study) and* St Bartholomew Church, a Study *(finished drawing). Both pencil on paper, by Ute Kreyman.*

Emma Stibbon

'Back in the studio I will often manipulate or adapt an image. Often I will photocopy my photographs, collage sections and then redraw over this. I am interested in pulling the viewer into the pictorial space, so perspective or the arrangement of composition is often guided by this. I am interested in the way the camera crops and frames the view (and in cinematic devices too).'

Ute Kreyman

'Initially I did a series of studies on-site in my sketchbook. I then started the large drawing on-site in the church, mapping out the architecture of the walls prior to completion of the drawing in the studio. I then made alterations to windows and floors, based on my imagination.'

Artist's tips

- Enlarge sketchbook drawings by photocopying them, then drawing or tracing from them.

- Work from photographs, drawing directly or tracing. Or paint and draw on top of photographic prints.

- Choose details from your sketchbook to enlarge and rework in another medium.

- Use systems of perspective to construct a convincing space.

- Work from materials collected in the environment, such as rocks or plants.

- Overlay two or more drawings from different viewpoints on the same paper. Unify the image by choosing which parts to keep and which to erase. This exercise can give a sense of the wider space of your location.

- Make models or arrangements of objects that can stand in for landscape subjects.

- To study the movement of water, find equivalents to translate into images of the forms of its flow.

- Wet, fold or crumple paper, then work with ink or paint on the uneven surface and allow the materials to find their own level. Respond to the resulting surface: cut or tear it into appropriate shapes and rearrange them to form a collage, or draw on the surface to establish/ re-establish the image.

- Mix materials from the environment such as sand or salt with your painting medium. Salt will make media, such as ink or watercolour, disperse in a different way.

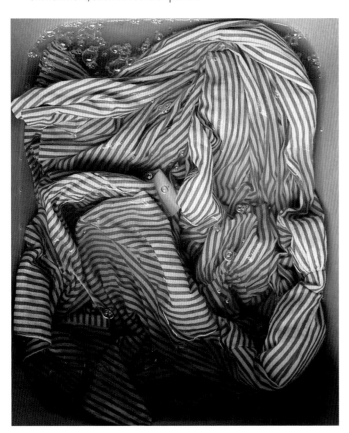

Above: Here a child's stripey summer dress is immersed in water to generate ideas for how to depict the flow of water.

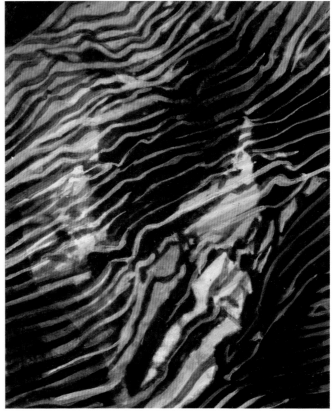

Above: In Flow *(egg tempera on paper), Kate Wilson drew from photos of rocks and folded textile, then painted over a collage made from the drawings.*

CONNECTING WITH THE EARTH

The desire to work creatively with the environment leads many artists to find ways of connecting more closely with their subject than seems possible purely by standing in the landscape and observing it. By incorporating actual material found in a particular location, such artists aim to enrich the surface of their work, but also to allude to the physical reality of the place – its history and its geology.

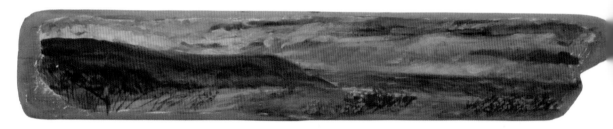

Frances Hatch (see pp.198–199) is an example of working in this way, incorporating found materials in her work. She responds intuitively to her coastal location, adding these materials to her paintings and drawings using PVA and rabbit skin glue, or drawing with pieces of wood charred by a heathland fire instead of art-shop charcoal. Tania Kovats is another example (see p.41). She wets her paper with sea water, allowing the evaporation of the water and effect of salt on ink to mark and make the drawing.

Artists may also use materials found in an environment as the substrate for their work. Joy Girvin paints her seascapes on pieces of driftwood, while Ben Wilson paints on the chewing gum he finds on the street. This needs careful preparation. Wilson heats the gum with a blowtorch and coats it with acrylic enamel before painting his images with acrylic. Christopher Cook found his artistic epiphany in what must be one of the earliest forms of drawing when he drew an image directly in the sand of the River Ganges.

Top: The Edge of Land Near Botallock, Cornwall. *Tempera on driftwood, by Joy Girvin.*

Above left: Ganges Sand Drawing. *By Christopher Cook.*

Above: View of St Paul's from Tate Modern. *Acrylic enamel on chewing gum on brick, by Ben Wilson.*

Maps are themselves also ways of visualising and commenting on the environment. By omitting or obscuring specific details normally found in maps, the city drawings of Kathy Prendergast (p.238) draw attention to the organic development of urban environments, inviting contemplation of the patterns of human presence on the landscape.

With his associates at Ocean Earth, 'ecological engineer' Peter Fend uses satellite imaging to track environmental changes on a global scale, but still uses a pencil to draw maps of the world's ocean basins, which he sees as a kind of Duchampian *Fountain* water-recycling system for improving the use of the planet's energy resources.

Artists may also use found materials to make paint. Steve Thorpe chooses significant places and routes to walk, and makes work by collecting stones from the locations he visits, which he then grinds down into powder to make into paint. This connects his work directly with both his landscape subject – becoming a record of his journey – and the whole geological origin of paint. The idea of journey is also often reinforced by incorporating part of a map.

Top: Global Feed Viewing Station. *Satellite data and video, by Peter Fend.*

Above: Rock/Tower. *Rock dust, by Steve Thorpe.*

Right: Antarctica-Centered World. *Pencil on paper, by Peter Fend.*

COMPOSITION

Working with the environment presents various possibilities for composition, ranging from the classic landscape with horizon, to a cropped close-up, plan view or geometric arrangement, presented in a regular or organic format.

The Golden Section

Many landscape artists instinctively use the theory of the Golden Section as a basis for composition, without reference to its exact mathematical rules (pp.268–269). A simplified version is sometimes referred to as 'the rule of thirds', in which the format is divided into thirds and focal points in a landscape are placed where the horizontal and vertical divisions intersect.

Wide angle

Rackstraw Downes uses a panoramic format to take in as much of what is in front of him as possible. The format is extremely elongated, although the landscape features still conform approximately to the rule of thirds. The tower is placed off-centre on the horizon, which is between one quarter and one third down from the top. Curving rhythmic lines of tracks in the sand and shadows forming interlocking triangles help to connect the wide spaces.

Classic composition

Alan Ramdhan's drawing of buildings exhibits many of the characteristics of the Golden Section. It is organised into a series of smaller and larger rectangles with off-centre divisions. This gives it a sense of order and stability, while maintaining interest through a certain asymmetry.

Above: Sketch of Imaginary Buildings. *Graphite pencils on paper, by Alan Ramdhan.*

Below: Presidio: In the Sand Hills Looking East with ATV Tracks and Water Tower. *Oil on canvas, by Rackstraw Downes.*

Geometric plan view

Alasdair Lindsay finds the pattern and colour in aerial views to create pared-down, abstracted geometric compositions in the modernist tradition of Californian artist Richard Diebenkorn. The square format of *Allotments* is divided horizontally and vertically into thirds, creating nine smaller squares with off-centre subdivisions. Predominantly blue, the smaller asymmetric areas of red create movement in an otherwise orderly symmetrical composition.

Organic format

The drawings of Kathy Prendergast grow organically to find their own edges, following maps that represent the geography of urban development. The result is a form that floats on the paper, the roads trailing off as they meet the surrounding empty space. This emphasises the density of a city population compared with the sparsely populated country. The repetition of many lines drawn with varying weight to represent roads and other features forms an internal pattern of interlocking shapes that unifies the surface and draws the eye to different focal points.

Low horizon

The sky is the main feature in Thomas Verny's pastel drawing of Montpellier. He places the horizon very low, implying a high viewpoint over the cityscape. The tower on the horizon is positioned at the classic Golden Section division. The large clouds occupy the upper third of the composition.

Top left: City Drawings Series, London N13. *Pencil on paper, by Kathy Prendergast.*

Top: Allotments. *Acrylic on board, by Alasdair Lindsay.*

Above: Les Toits de Montpellier. *Pastel on canvas, by Thomas Verny.*

PERSPECTIVE

Perspective refers to a range of ways artists use to depict three-dimensional space on a two-dimensional surface, from instinctive observation, through linear perspective developed during the Renaissance, to the distortions of multiple viewpoints made possible by Cubism, photography and cinema.

Linear perspective

Linear perspective is a mathematical drawing system based on a fixed view from a single eye, which enables artists to draw and paint things from imagination in the correct proportion and from any angle. Its rules closely parallel naturally observable perspective, which is actually more complex because we usually look with two eyes.

The basic principles

The height of your eye above ground level is your eye level. If you could see an unobstructed view into the far distance you would see the line of the horizon. This would appear to be at the same height as your eye level. An object in the distance, which you know is the same size as one close by, will appear smaller.

One-point perspective

When looking at regularly shaped objects straight on, horizontal parallel edges (orthogonal) seem to converge to one vanishing point on the horizon/eye level, as in Kate Wilson's painting (right). In reality this does not actually happen because if you were able to stand exactly in front of, and square on, to a building, for instance, you would not be able to see the sides anyway.

Two-point perspective

Usually we see objects from all sorts of angles, and the different sides of regularly shaped objects may have horizontal parallel edges that seem to converge in different directions to two different vanishing points on the horizon/eye level. **(A)**

Above: Blue Sky over Weir Road. *Oil on board, by Kate Wilson.*

Orthogonal lines converging to a vanishing point

A

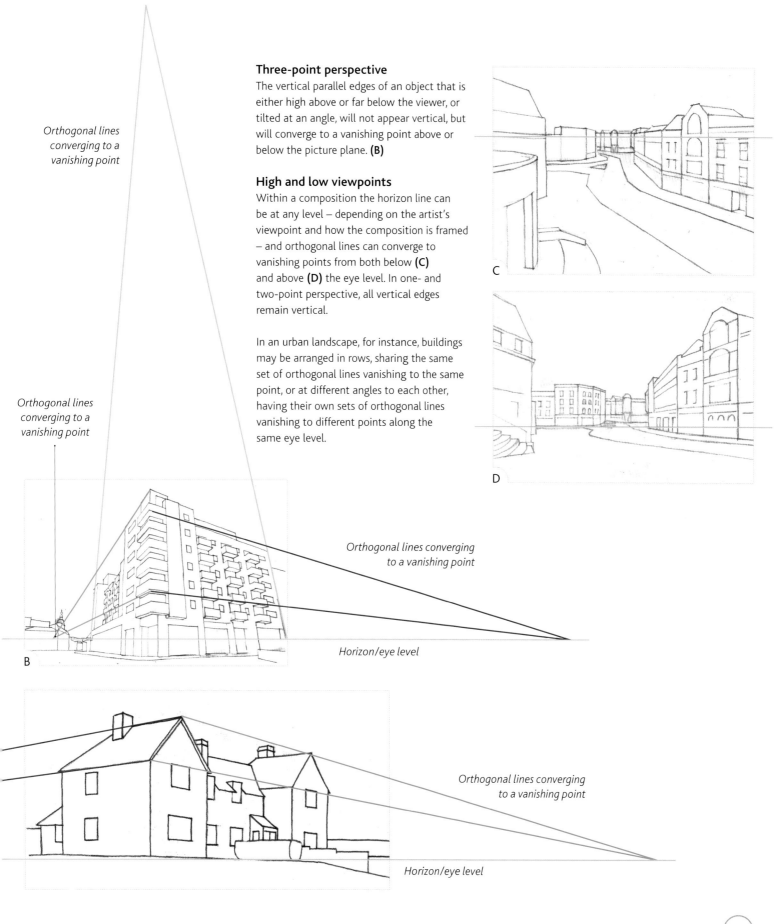

Orthogonal lines converging to a vanishing point

Three-point perspective

The vertical parallel edges of an object that is either high above or far below the viewer, or tilted at an angle, will not appear vertical, but will converge to a vanishing point above or below the picture plane. **(B)**

High and low viewpoints

Within a composition the horizon line can be at any level – depending on the artist's viewpoint and how the composition is framed – and orthogonal lines can converge to vanishing points from both below **(C)** and above **(D)** the eye level. In one- and two-point perspective, all vertical edges remain vertical.

In an urban landscape, for instance, buildings may be arranged in rows, sharing the same set of orthogonal lines vanishing to the same point, or at different angles to each other, having their own sets of orthogonal lines vanishing to different points along the same eye level.

C

D

Orthogonal lines converging to a vanishing point

Orthogonal lines converging to a vanishing point

Orthogonal lines converging to a vanishing point

Horizon/eye level

B

Orthogonal lines converging to a vanishing point

Horizon/eye level

PERSPECTIVE

Aerial perspective

Aerial, or atmospheric, perspective is the use of tonal and colour contrasts to create a sense of three-dimensional space, as in the works here by Christopher Le Brun and Joy Girvin. Strong contrasts in tone appear to come forwards, while areas that are close in tone appear to recede in space. Tone can be built up by mark making. Variations in the size and strength of these marks can also be used to give the illusion of space. Some of the landscape drawings of Van Gogh are great examples of this. Colours also have a significant effect on each other, creating a sense of space – typically blues, or more accurately greyer tones, are seen to recede, while bolder reds, or brighter hues, advance.

Above: The Complete Journey. *Watercolour, by Christopher Le Brun* PRA.

Left: A Walk through the Orchard, Trelissick. *Pastel and Conté crayon on paper, by Joy Girvin.*

Opposite top: Multiple viewpoint study. Pencil on tracing paper, by Simon Burder.

Opposite bottom left: Barbican 2. *Oil on canvas, by Oliver Bevan.*

Opposite bottom right: Experimental Moon Unit. *Pencil and coloured pencil on paper, by Torsten Slama.*

Wide angles/distortion: using photomontage to combine viewpoints

Linear perspective only works within a fairly narrow field of vision. When combining multiple viewpoints for a wider or moving subject/viewpoint, a degree of distortion occurs. This was realised by Cézanne and the Cubists and Futurists.

More recently, David Hockney has popularised the use of photography to record multiple views of a subject. The camera shows how perspective bends at the extremities of vision. Overlaid tracings and Photoshop are useful tools for photomontage, as seen in Simon Burder's sketch (right).

In his painting *Barbican 2*, Oliver Bevan bends conventional linear perspective to show what it is like to look down into the spiral space below, while taking in the towering buildings above.

Parallel projection

Parallel projection is a discipline of technical drawing. It is not the same as perspective, as parallel edges do not converge, but rather go in three different directions. The main system of parallel projection is 'axonometric', which means 'to measure along axes'. In axonometric projection the edges of planes that are turned away to show more than one side of an object are drawn at 45 degrees to horizontal. In isometric projection, which is a type of axonometric projection, these edges are drawn at 30 degrees.

Parallel projection is often used to show architectural forms in three dimensions, to a scale that allows measurements to be taken from the drawings. Since the parallel edges of forms remain parallel in all directions, same-size objects that are further away do not get smaller as in perspective, so pictures look distorted. This can be exploited to create ambiguous spaces, as in the work of M. C. Escher. Artists like Paul Noble and Torsten Slama use such an approach to heighten the otherworldly atmosphere of their images.

Artist profile
ROBERT PERRY

Robert Perry was born, brought up and educated in the Black Country, the industrial heartland of the West Midlands. As a child he was fascinated by landscape: 'When I was nine years old I had the idea of taking a sketchbook with me and made my first drawing on the spot.' He pursued his interest with a passion, studying at Stourbridge College of Art and Birmingham University in the 1960s.

Perry has had solo exhibitions in major public art galleries, museums and cultural centres in England, France, Spain and Germany, at venues including the Council of Europe in Strasbourg, and Le Centre Mondial de la Paix in Verdun. He has also made numerous appearances on British and French television, and is an elected member of the Royal Birmingham Society of Artists.

Below left: 5.50pm 27 September 2008. Moel Dynogydd. *Oil on canvas.*

Below: Trenches in Aveluy Wood. 4.40pm 7 February 2000. *Oil on canvas.*

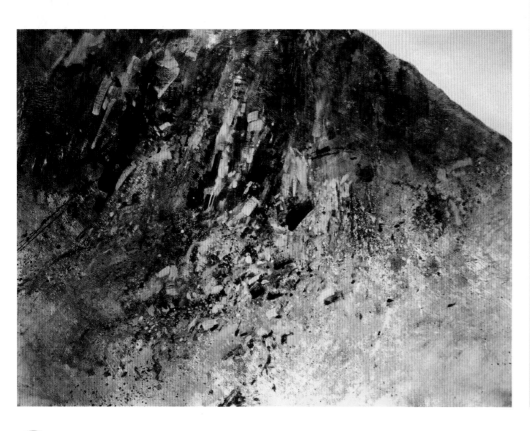

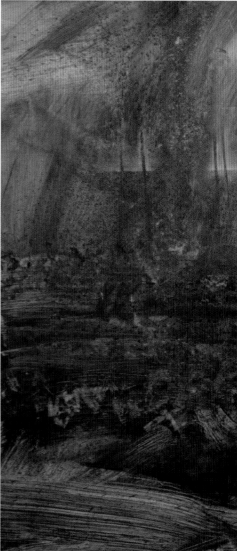

Perry bases much of his work on the Midlands industrial landscape, although he is also an inveterate traveller and committed internationalist. A landscape painter in the English tradition, he travels widely throughout Europe, working exclusively on location, summer or winter, painting mountains, forests and lakes. Fiercely anti-war and a member of Amnesty International, he is well known for his work at various sites from both World Wars, including the Somme, Ypres, Verdun, Auschwitz, Oradour-sur-Glane and Normandy.

Applying his engineering skills, Perry fabricates ingenious items of specialised equipment, including enormous easels and his unique mobile 'field studio', a large, specially adapted van that enables him to undertake expeditions of considerable duration and distance.

He deploys an array of brushes, scrapers, rollers, spray guns and airbrushes (powered by a modified portable compressed-air cylinder), and materials found on-site – leaves, grasses, twigs – to apply or manipulate paint and create the textured surfaces that characterise his work.

'When you work on the spot you have to adapt to constraints of time or conditions. These necessitate the development of innovative and unorthodox techniques, enabling you to summarise your subject matter with fewer, swifter and more expressive brushstrokes. Virtually every piece is done at a single sitting, lasting anything from one to six hours. It is this intense time pressure, combined with the complete and absolute awareness of your environment, that gives the work a dynamic energy almost impossible to achieve in a studio situation.'

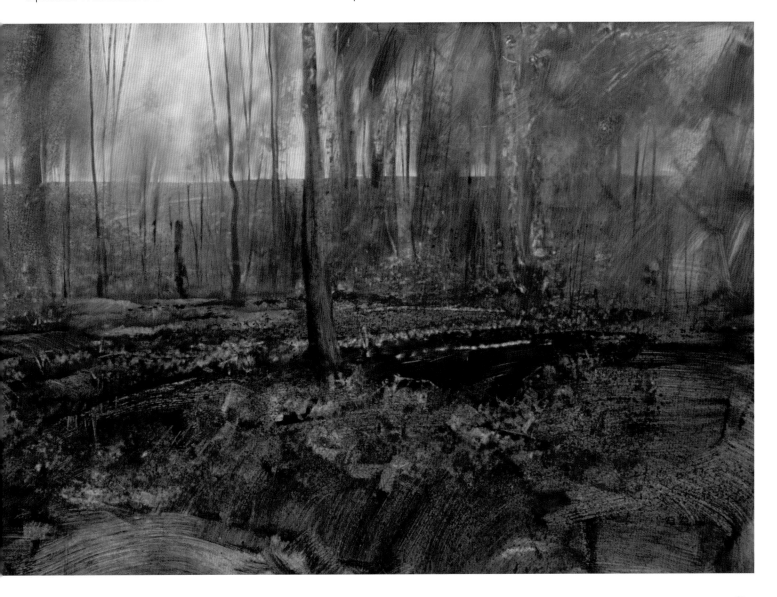

GALLERY

Right: City Drawings Series, London N13. *Pencil on paper, by Kathy Prendergast.*

Below: Red Rain. *Oil pastel and graphite on paper, by Robyn O'Neil.*

Opposite: Untitled Kerbstone Painting (MJK). *Acrylic on canvas, by Narbi Price.*

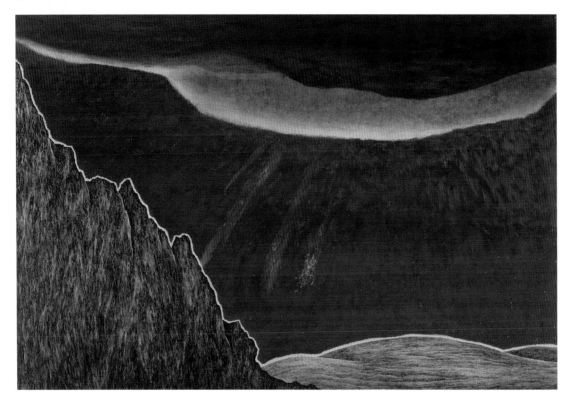

Chapter Fourteen

THE HUMAN BODY

by **Alison Harper**

*Photograph by
Andrew Wamae.*

*Painting by
A. Harper.*

OVERVIEW

Drawing and painting the human body is alive and well in contemporary art. This section features a range of current artists who are working with the figure in fascinating and varied ways.

You may be surprised to learn that throughout art history and across different cultures a realistic approach to the figure, using accurate proportions, has been the exception rather than the rule. A truth-to-nature approach has existed at certain times, with varying degrees of idealisation, but generally a range of mild to strong stylisations of the human body have been the standard, and this is still very much in evidence today.

Some contemporary artists, such as Kehinde Wiley (far right), combine an observed, realistic approach with exaggerated elements. David Shrigley (p.244) and Wangechi Mutu (pp.249, 251 and 258) draw and paint figures from their imaginations. The act of observation becomes a tool for heightened awareness in Gwen Hardie's work (p.248). Paula Rego (pp.244 and 256) and Henry Kondracki (p.257) engage in storytelling with characters drawn from observation, memory and imagination.

Some of the age-old themes in art are also being reworked today, as a result of the greater number of women artists. A century ago, women were barred from the life room in art schools, and themes such as motherhood and sexuality were usually depicted by men; today's women artists now explore these from a female point of view. Eileen Cooper's warm-hearted paintings tell of intimate and significant moments, such as birth (p.250). Contrastingly, the writhing infants and unfinished lines in Jenny Saville's *The Mothers* (right) appear to depict the tiredness and resignation of motherhood. Women are also refashioning images of men as sexual beings, the objects of their desires, their 'female gaze' turned outwards. Rosemary Beaton, for example, draws and paints naked men in provocative and humorous poses (pp.246–247).

Art is always being reinvented, but it continues to address questions about human existence. Studying art from the past and from other cultures can be hugely fruitful, and today these fusions are happening spontaneously – the conventions of one artistic tradition can be broken apart and recycled in combination with another to act as a vehicle for a new message. Artists such as Kehinde Wiley and Paul Gopal-Chowdhury (p.257) are producing new approaches to the figure, influenced by European painting and non-Western aesthetics, to explore notions of racial and cultural identity.

Drawing from observation, memory or imagination, employing collage or reworking found images are all great starting points for working with the figure. Maintaining a reinventing mindset and remaining authentic to your own experience, all approaches are valid.

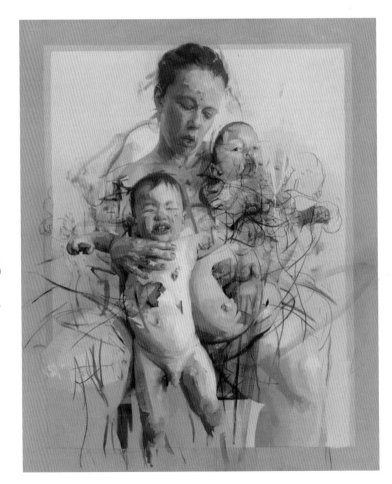

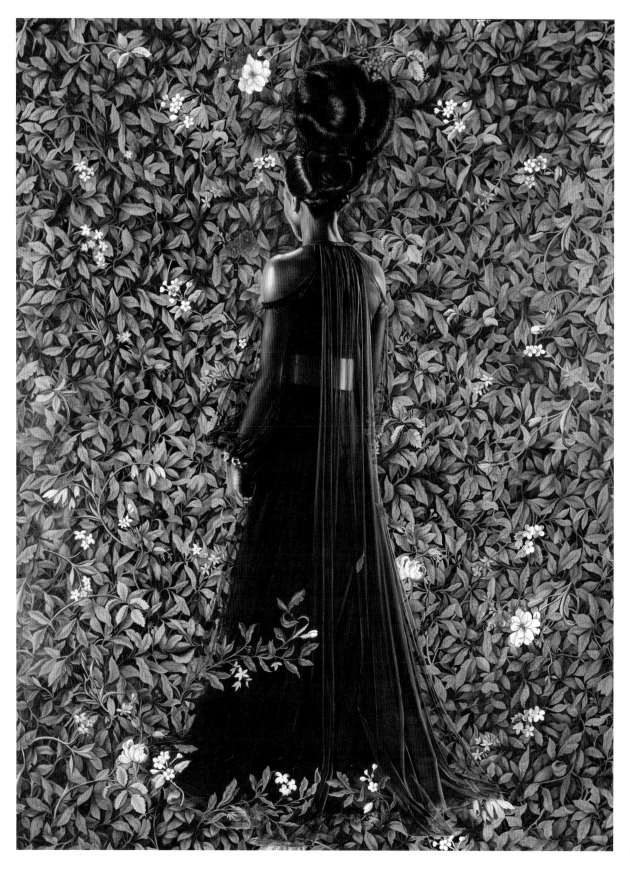

Opposite: The Mothers. *Oil and charcoal on canvas, by Jenny Saville.*

Left: Princess Victoire of Saxe-Coburg-Gotha. *Oil on canvas, by Kehinde Wiley.*

DEVELOPING IDEAS

Artists work in different ways to generate ideas, and with practice they find out what works for them. Try a variety of approaches to see what is effective for you. It may be helpful to make the following distinctions when starting.

With **image first, idea second** we start with images and look for the idea through the image. With **idea first, image second** we start with an idea and look for images to support it.

Artist David Shrigley describes the second approach: 'Another method is to write a list of things to draw before I start: a tree, an elephant, a lorry, an orgy, etc. This gives each drawing a starting point. I think the starting point is important for an artist. Once you've started the battle is half-won.'

Below left: Your Brother. *Pen on paper, by David Shrigley.*

Below: Joseph's Dream. *Acrylic on paper on canvas, by Paula Rego.*

Projects

Image first, idea second

- Collage. Collect drawings, paintings or photos, then cut them up and reassemble them into new figures. Invent some settings using collaged images or draw/paint your own – or use plain backgrounds.

- Film stills. Draw/paint from an image paused on the screen, emphasising/exaggerating the aspects that are important to you.

- Draw/paint/photograph from life. See what is out there. Life is stranger than fiction, and themes will emerge to work from.

- Draw from memory/imagination/dreams. Do not worry about accuracy or realism, just get your images on paper.

- Look at old paintings and figures in museums from different cultures and eras, then use these as a basis for your ideas.

Idea first, image second

- Brainstorming – Game of chance. Write down seven headings: nouns, adjectives, adverbs, environment, weather, people and emotions. Under each heading write 10 words. Choose a word randomly from each category, e.g. by the sea, raining, train, green, quickly, old man, delighted. Make a drawing/painting from this.

- Brainstorming – Identifying themes. Compile a list of words, then choose a few words that you like from this. Make drawings from the words or find supporting imagery to collage with. You can also make drawn/painted versions of your collages.

- Storytelling. Draw from a point of time in a story. Redraw it many times from different perspectives and viewpoints. Play with different compositions and varying scales for the figures.

- Go out and take photographs according to a pre-set theme. This could be visual, such as 'Woman with red hair', or abstract, such as 'Loneliness'.

- Match poem titles or newspaper captions with seemingly unrelated images and look for new connections.

- Watch films or read books, and take notes. Identify themes and research them through all media.

Left: She Seemed Like a Nice Girl. *Pastel and charcoal on paper, by Alison Harper.*

DRAWING THE FIGURE FROM OBSERVATION

Drawing people from observation is an invaluable practice if you want to include the human figure in your work. A good way to start is by drawing friends, family and even yourself in the mirror, and/or sketching people when out and about. Carry a small sketchbook with you everywhere.

People will move so you have to be fast – this is a helpful exercise for being fearless with your drawing. Try to catch people when they are still for a few minutes, for example watching TV or sitting on a bus or in a café. When we draw we observe more closely, and we discover details we would otherwise overlook.

Below left: In the Park. *Pencil in sketchbook, by Alison Harper.*

Below right: Man Sitting. *Gouache on paper, by Rosemary Beaton.*

Bottom left: Sketches of Boy. *Pencil on paper, by Alison Harper.*

Drawing from observation in relation to memory and imagination

Even if you prefer to work from imagination, practising drawing the figure from observation will give your work greater depth and credibility. You will be able to invent figures more easily as you can make use of the forms and poses you have studied.

Planes technique

This technique helps to create the illusion of form in the body and objects. It is a kind of mini-perspective applied to smaller situations. Try to think of the body as three-dimensional. The body has different sides – for example, front, behind, side, on top, underneath. Simplify the figure into basic planes (sides or facets) and postpone detail until the basic structure is observed and understood. Bodies and objects then become easier to draw, and your drawings will also be more convincing.

- The body is flexible; where there is a joint, the body can bend! Try to simplify the figure and break it down into basic angles. **(A)**

- Record these angles right from the start and your figure will have life even before you have fleshed it out.

- Next add planes. Think 'top, side, behind, front, underneath'. **(B)**

- You can practise drawing planes on figures in magazine or newspaper photos. The sports pages in newspapers are good for extreme poses.

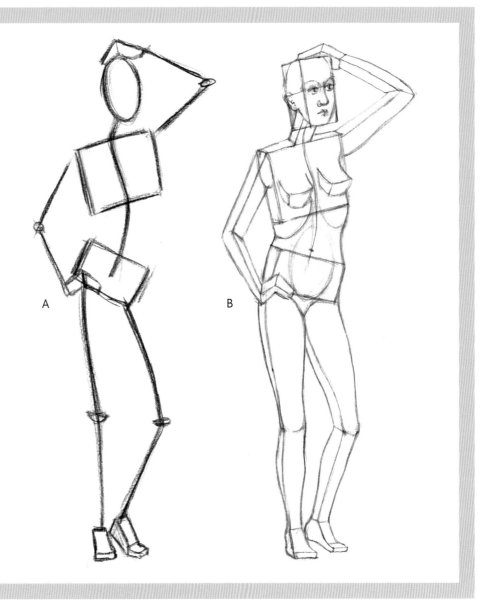

A

B

Working methods

Paula Rego (pp.244 and 256) and Rosemary Beaton (these pages and p.257) have a range of working methods, and both draw from observation, but in different ways. In her later work, Rego begins by drawing from models she has deliberately posed in costumes and settings. Drawing what is in front of her, she chooses what to emphasise and leave out according to what will add power and serve her idea. Working with a live model, Beaton improvises while she is drawing, like an unscripted conversation, reinterpreting the body and its colours, and playfully attributing meaning as she finds it.

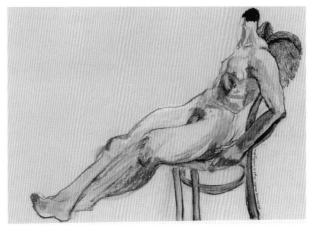

Left: Angel in Waiting. *Pastel on paper, by Rosemary Beaton.*

THE NAKED BODY

In contemporary art, less significance is placed on traditional skills in drawing and painting than on the strength of the idea behind a work. However, life-drawing classes remain popular in the Western world, mainly outside art schools. Studying the naked figure from life has lasting appeal; it is not just about honing skills, but answering a fascination for this precious human vehicle. Drawing from life gives you a vocabulary of forms and generates ideas. It also helps you to invent figures from your imagination, and to draw and paint clothed figures.

The artists Jenny Saville, Gwen Hardie and Wangechi Mutu have all worked with the naked figure in very different ways.

Saville is known for her paintings of large women, seen from extreme perspectives. Painted with strong gestures in naturalistic colours, her assertive images appear to reclaim the female body from the genteel painted nudes of the past.

Gwen Hardie creates images of stillness and beauty, observing close-up areas of her own body – painting luminous flesh in an intimate moment of heightened awareness. The cropping and magnification of skin renders the particular part of the body mysterious, leaving us with the image shifting back and forth between recognisable form and atmospheric illusion.

Wangechi Mutu's singular images dance between the beautiful and the grotesque. She creates hitherto unseen figures, made from a combination of materials, including fur, paint, glitter and collaged fragments of photos, which give the figures an expressive physicality. In her series 'Histology of the Different Classes of Uterine Tumors' she uses nineteenth-century medical diagrams as a basis for her collaged heads. Anguished faces emerge from the paper as a searing contrast to the impersonal and implied patriarchal tone of the medical texts and diagrams.

Right: Body 08.29.13. *Oil on tondo, by Gwen Hardie.*

Projects

- Attend a life-drawing class. Try alternating between drawing objectively (what you see) and experimenting with different media, emphasising elements of the figure that interest you. Combine this with blind drawing (not looking at the paper).

- Look at different 'maps' of the body from a variety of medical systems, such as acupuncture, osteopathy, reflexology, Chinese medicine, Western medicine, Indian tantra, Leonardo's drawings. Make your own maps of the body.

- Draw the skeleton and muscles from a found image. Collage tissue paper 'skin' in layers on top of the drawing, allowing some of the insides to show through. Think about inside/outside, texture and physicality.

- Plastic skeletons can be bought to aid drawing, but they are expensive. Find illustrations of anatomy in books or online, which you can study by copying or tracing, and use as a basis for an idea.

- Draw your own body using mirrors.

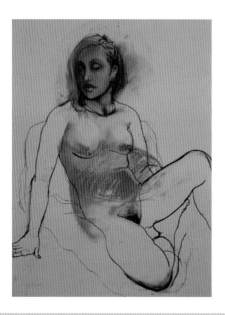

Left: Nude. *Charcoal and pastel on paper, by Alison Harper.*

Above: Uterine Catarrh from Histology of the Different Classes of Uterine Tumors. *Mixed media collage on found medical illustration paper, by Wangechi Mutu.*

IMAGINATION AND THE EMOTIONAL RESPONSE

Working imaginatively requires letting go of preconceived ideas, and entering into the unknown. To engage with the imagination and an emotional response, it helps to feel that you can take risks and that you do not have to make sense. Remain connected to your feeling or idea while you work; if you become distracted, your work may have less depth or be more bound up in technique.

Certain artists use emotion as the driving force for an artwork and will abandon realism for expressive effect. In her dream-like imagery, Eileen Cooper creates imaginary settings as the backdrop for telling stories of magical moments in relationships and family life. In her drawing *The New Baby*, the mother's head is drawn huge and cropped close; the baby by contrast is drawn tiny and sits in the palm of her hand. This manages to convey both wonder and fragility. Putting the idea/feeling at the forefront of our intention, we give ourselves permission to suspend physical truths.

Right: The New Baby.
Charcoal on paper,
by Eileen Cooper RA.

Projects

- 'Blind drawing'. Draw/paint someone from life or memory/imagination without looking at the paper. You will achieve expressive distortions that can then be developed further.

- Try to feel the emotion of the theme in your body, allowing the marks, shapes, colours and choice of medium to reflect this – for example, bold, fearless marks to signify strength, or a light, delicate touch to indicate shyness.

- Distort the figure according to what is important. For example, a small head/big body denotes monumentality, while a big head/small body conveys vulnerability.

- Draw/paint/collage to music to connect with feeling and ideas.

- Use coloured or patterned paper or painted colour ground for an atmospheric starting point.

- Invert the tones in the face and body like an X-ray.

- Experiment with the computer. Scan images and then manipulate them digitally for expressive effects. Use the new images as a basis to work from.

- Draw round yourself or someone else on a piece of paper. Relax, close your eyes and identify sensations/emotions like warmth or tension, and give them texture, shape and colour. After 5 to 10 minutes, paint what you experienced.

- Psychological self-portrait. Paint what you feel, not what you see. Sometimes it is easier to draw/paint a felt response to someone without them in front of you.

- Paint to a poem. Respond to the emotion, imagery and atmosphere. Allow seemingly illogical responses to emerge. Suspend critical judgement.

- Paint a childhood memory. Try to remember as much detail as possible – the atmosphere, light, sights, sounds and smells. Details tell a story. Try to paint as confidently as a child.

Left: The Storm Has Finally Made It Out of Me Alhamdulillah. *Mixed media collage on linoleum, by Wangechi Mutu.*

HEADS AND PORTRAITS

People want to paint and draw people; human beings are compelling subjects. But when is it an image with a person/people in it and when is it a portrait? A work can perhaps be identified as a portrait if the person is named, but even this loose definition can be challenged. American artist Kehinde Wiley uses Old Master paintings as the basis for his portraits of modern black men and women, retaining the paintings' original titles. In **Napoleon Leading the Army over the Alps** (original by Jacques-Louis David, 1800), Wiley recreates the pose, including the horse, but replaces Napoleon with a young black man in contemporary clothes, and the sky with an ornate pattern. In doing so he plays with symbols of power, redistributing it to the historically disenfranchised black man.

Above: Napoleon Leading the Army over the Alps. *Oil on canvas, by Kehinde Wiley.*

Wendy Elia

Wendy Elia has painted a series of paintings entitled 'The Visit'. Working in series gives Elia the opportunity to explore wider issues than the life of one individual. In her moving portrait *The Visit V (Mary)*, Elia's elderly mother and great grandchild are posed centrally, looking confidently at the viewer. The directness of gaze contrasts with Mary's physical frailty. Images and objects in the room tell a story of a life lived and of death, the next stage to come.

Top: It's All True. *Pastel on paper, by Alison Harper.*

Above: The Visit V (Mary). *Oil on canvas, by Wendy Elia.*

Projects

- Self-portrait. Practise drawing/painting heads. Try drawing your features close up, from different angles and in various light conditions.

- Composition. Before painting, make small sketches thinking about your options, e.g. format (landscape or portrait), scale (large, medium, far away), placement (low/high, left/right/middle), setting/context options (plain/outside/inside/observed/imagined/realistic/fantastical), cropping (avoid cropping figures at joints and on top of lines of the body).

- Transcription. Borrow from paintings of the past. Reuse content/themes and/or technical elements such as colour and composition.

- Tableau vivant. Recreate old paintings by asking friends or models to pose, then photograph the scene and use it as the basis for a painting.

- Monoprint head from a photograph. Paint a portrait in oils (so it stays wet) on top of clear acetate placed on top of a photograph. Use the photograph underneath as a guide. Place the acetate face down on to paper primed with oil or acrylic primer, then push firmly to take a print.

- Paint from a 'selfie' taken on your phone.

- Collage or paint a head from photographs. You can also use wrapping paper or wallpaper as a background.

- Word portrait. Interview your sitter and write down key words. Cut out and assemble these words into the shape of their head and body.

- Biographical portrait. Map a life's journey on to a body shape, chronicling individual events or emotional phases.

Tips for drawing faces

Subtle expressions

Look for the asymmetry in the face and features. Each eye can vary in shape but also in expression. Complex expressions can be created by the eyes looking in slightly different directions. Keep this subtle, though – too much will create a cross-eyed look!

Eyeballs

Remember the eyeball is a sphere. The iris and pupil are two smaller circles on top of a sphere, and they create an elliptical shape in profile. When drawing eyelids across the eyeball, draw them curving round it, or your eyes will look flat.

Despite having the same overall structure, the shape and appearance of eyes will also vary according to age, race and expression. This variation occurs in the way the eyelids cover the eyeball.

Noses

Draw three circles for a nose as seen from the front, with the middle one the largest. Practise the formula first, then try it out observing your own nose in a mirror. The circles help create the structure. To turn the nose, decrease the size of the furthest circle. Eventually, as the nose turns, the furthest nostril/circle will disappear.

Mouths

The most important and darkest line is the middle line. The structure of the mouth can be described in small and subtle panels. The upper lip is usually darker in tone than the bottom. For an open mouth, remember teeth form a semi-circle, not a straight line.

Artist profile
MUNTEAN/ROSENBLUM

Markus Muntean (born in Graz, Austria) and Adi Rosenblum (born in Haifa, Israel) have worked in collaboration since 1992. Based in Vienna and London, they have shown widely, including solo exhibitions at Tate Britain, the Team Gallery in New York, the Galerie für Zeitgenössische Kunst in Leipzig, the Kunsthalle Budapest and the Australian Centre for Contemporary Art in Melbourne.

The duo are perhaps best known for their painted figure compositions of beautiful teenagers. The young people lie, sit or stand in groups, and their poses and faces express boredom, sadness and angst. Below, painted on the canvas, are subtitles that appear to voice their concerns. The paintings seem to comment on what it means to be young.

These works also invite us to reflect on image manipulation. The artists point out that the teenagers' body language is deliberately formulaic. They ask their models to adopt poses from the Western pictorial tradition, generally ranging from Mannerist sources to Romanticism, and often employing striking gestures – 'formulas of pathos', to use art historian Aby Warburg's term for the visual representations of heightened emotional expression. Muntean/Rosenblum's comprehensive oeuvre demonstrates that the same gesture may have contrary meanings in different epochs.

Preparatory drawings reveal that the texts are pasted together from cuttings from magazines and books on philosophy. As Muntean says, 'Because we are so used to reading a caption beneath a picture, you think that it must be explanatory. Then you read the text and there might be some kind of reference to the painted figures in the picture, but in a way there's not.'

Below: Nemesims *exhibition view.*

Below right: Untitled (Nowadays young people...). *Acrylic, oil and marker on canvas.*

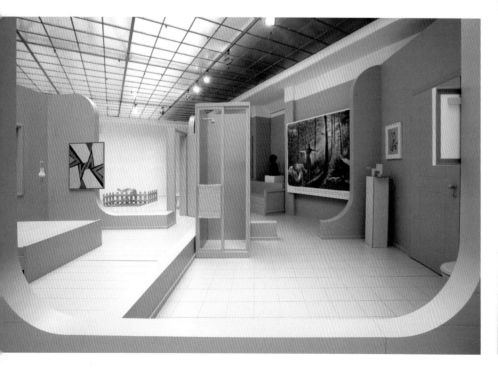

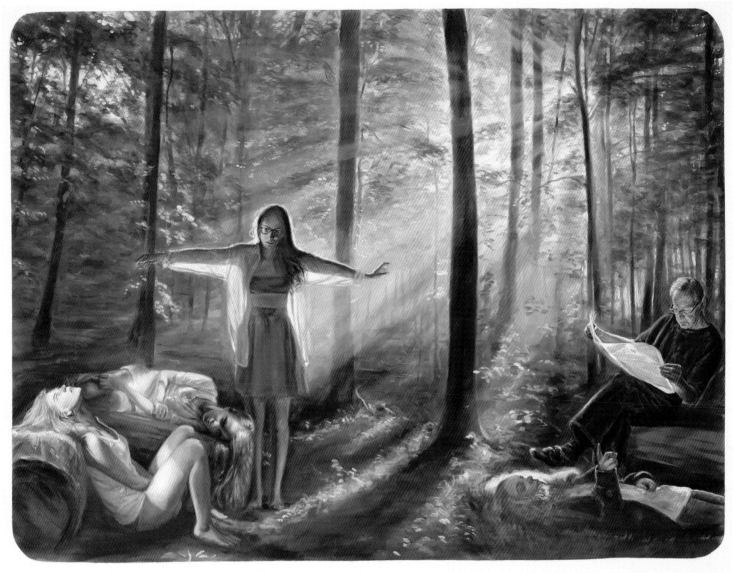

WE WERE AFRAID OF THESE THINGS THAT MADE US SUDDENLY WONDER WHO WE WERE, AND WHAT WE WERE GOING TO BE IN THE WORLD. AND WHY WE WERE STANDING AT THAT MINUTE, SEEING A LIGHT, OR LISTENING, OR STARING UP INTO THE SKY: ALONE.

Even the traditional figurative painting style is there to create a certain aura and emotional impact. Rosenblum explains, 'This painterly approach is quite difficult to achieve … it doesn't have to be painting for painting's sake. At the same time, it must be clear that the brushstrokes are important.'

Their drawings, paintings and films are often shown as part of larger installations that contextualise the works. For their *Nemesims* exhibition, they chose to site their paintings of languorous teens in an interior based on the computer game, The Sims. Success in this game – which involves playing with animated dolls in a self-designed

virtual doll's house – is to earn enough money to buy the perfect lifestyle. Furniture, books, clothing, a swimming pool, a bigger house and works of art – all these things equal happiness for the Sims. So in this context the paintings have something to say about a link between contentment and acquisition.

'We try to come up with a complex structure, like a polyphonic piece of music, where each voice has its own input to make and has a certain limit to independence. This complex structure is part of our aim to create a system of precise ambiguity.'

Above: Untitled (We are afraid…). *Oil on canvas.*

Text by KATE WILSON.

GALLERY

Right: The Funeral. *Charcoal on paper, by Alison Harper.*

Below: Love. *Pastel on paper mounted on aluminium, by Paula Rego.*

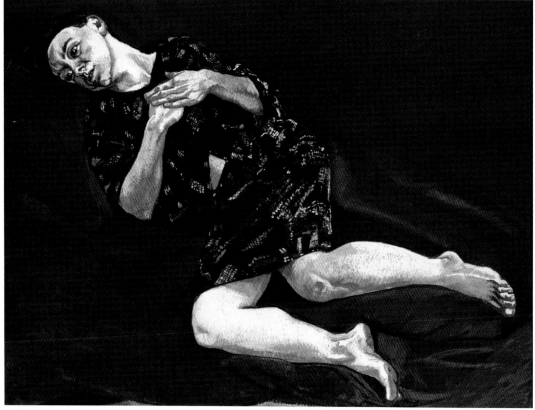

Opposite top left: Italian Goddess Flora. *Oil on canvas, by Rosemary Beaton.*

Opposite top right: Shivering Boy. *Oil on canvas, by Henry Kondracki.*

Opposite: Don't. *Oil on canvas, by Paul Gopal-Chowdhury.*

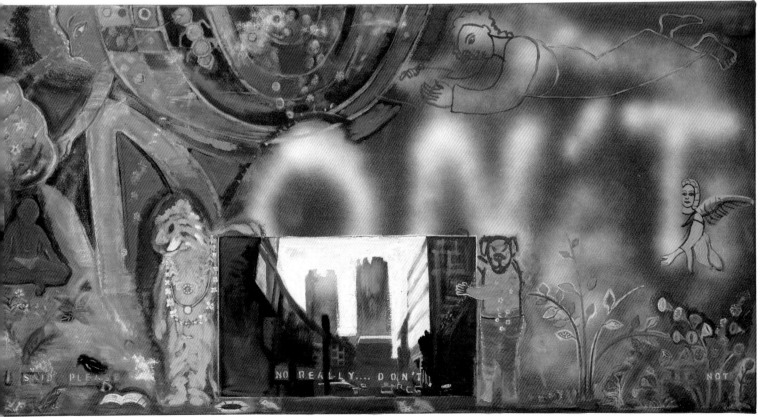

GALLERY

Opposite left: Ovarian Cysts from Histology of the Different Classes of Uterine Tumors. *Mixed media collage on found medical illustration paper, by Wangechi Mutu.*

Opposite top right: Strap Hangers. *Oil on canvas, by Charles Williams.*

Opposite bottom right: Transitions *(detail, fifth image)*. *Hand-incised, exposed colour photographic paper, by Paul Emmanuel.*

Above: Lovers Meet at Journey's End. *Oil on canvas, by Eileen Cooper* RA.

Chapter Fifteen

MAKING VISIBLE

by Simon Burder

807 Years (detail).
Oil on canvas, by
Biggs and Collings.

OVERVIEW

It is hard to distinguish fully between abstract and representational art. Whether landscape, portrait, figure or still life, a picture must consist of fundamental elements: line, tone, shape, volume, weight, balance, division, edge, movement and colour; abstract work tends to bring these to the fore. Abstract artists become more interested in the surface and presence of a work than the image it represents; subject matter may even distract them, or obscure their primary purpose.

Abstraction evolved out of the experiments of early twentieth-century artists such as Kandinsky, the Cubist work of Picasso and Braque, Constructivism, Dada and Surrealism. Artists wanted to go beyond the mere representation of things. They were starting to explore how to visualise pure form, music, the subconscious and the actual stuff of painting and drawing.

How do artists begin not to work representationally?

Abstract artists still look at the world around them, whether that is the physical world of places, people and things, or the world of ideas, language, music, mathematics and science.

They may begin from observation, from which drawn or remembered shapes, spaces, masses, colours, tones and textures are placed in new contexts and relationships to each other. Albert Irvin RA feels that his paintings are informed by his movement through the urban environment where he lives and works. Jill Evans remembers details: the density of yellow road paint, a worn pathway, the weave of a shirt fabric. For others, for example Daniel Zeller (pp.22–23) and Joy Girvin (p.28), ideas may come from such sources as aerial and satellite photography, anatomy and microscopic imagery. Art materials themselves and the intuitive actions of the artist on them are frequently at the heart of abstraction. Zheng Chongbin (pp.38–39) and Marion Thomson (p.88) work in this way. While absorbing these influences and ideas, artists working non-representationally may also consider their emotions and make associations with the interior world of the subconscious. Heather Upton (right), for example, is drawn to 'the interconnectedness of everything'.

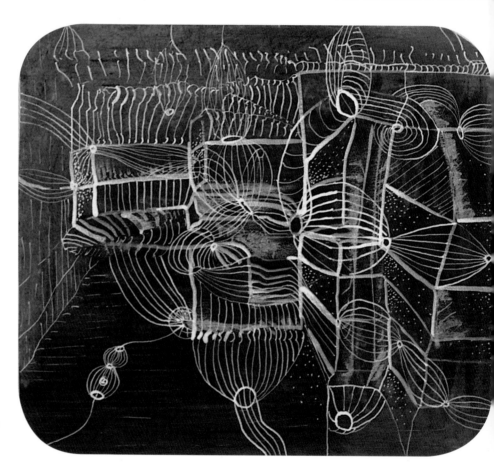

Above: Chamber. *Ink and acrylic on cardboard, by Heather Upton.*

Opposite: Inextinguishable. *Acrylic on canvas, by Albert Irvin RA.*

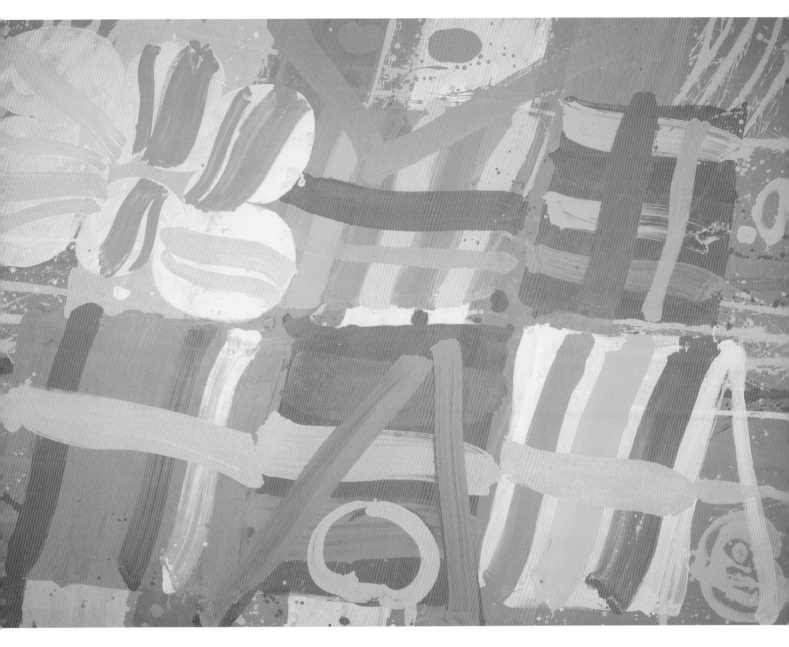

Seemingly at odds with such an approach is the work of artists who start with a system. This could be based on geometry, number sequences, perspective, programming languages, colour relationships, texts, language and lists. Artists working like this often talk of the need for control and giving themselves limits. Some go so far as to avoid the personal touch or sense of authorship, to create something that has a machine-made quality, or that appears to have generated itself.

Certainly a common characteristic of artists whose work is non-representational is a search for a balance between being in control and allowing accident, the desire simultaneously to know and not know what they are doing – to be 'in the moment' like the improvisation of a jazz musician – yet to create something that is complete and finished.

'Not knowing what the outcome might be is what makes me want to start another painting.'

TOMMA ABTS
Interview with Christopher Bedford, 'Dear Painter', in *Frieze* #145, London, March 2012

ABSTRACTION

You might assume that abstraction consists of copying observed shapes and placing them in a new context. Although this could be a start, more often it is less directly connected with observation.

Just as musical compositions do not usually sound like a particular thing, but exist in their own right, so visual abstraction aims to evoke an equivalent experience. This can be, for example, a sense of balance or imbalance, movement, weight, space, excitement or revulsion. It can be achieved by considering the contrast and layering of colours or materials, placement and scale of shapes, thickness of paint or direction of brushmarks.

You need an idea or feeling – better described as an impulse – to get started. This can come from anywhere; something seen or heard, read, felt or dreamed. The observation is recalled and used without reference to its original source. Artists describe starting by putting down a wash of colour or making a mark and then responding to it. Does it seem anything like the impulse; is it too static or too heavy? The work develops from what has gone before, from the brushstrokes just made or perhaps from a previous work, scanned, printed out, cut up, reassembled, painted over.

Sometimes artists impose rules on themselves – a series of repeated actions, for example. The process can be thought of as making moves in a game, adding to, covering up or disrupting the earlier decisions. Give yourself permission to play. With practice you will develop a heightened sensitivity to the right moves.

Left: OGVDS [Autumn]. *Acrylic, oil paint, pencil, watercolour, wax on linen on wood, by Andrew Bick.*

Above: This Was the Secret I Asked You to Keep. *Gouache on paper, by Susan Absolon.*

264

Artist's tips

Playing with abstraction

- Write a list of words. To avoid illustration use abstract words rather than words describing concrete things, and choose three or four. On separate sheets of paper draw groups of marks or paint colours in response to each word. Bring the sheets together, perhaps cutting out shapes from each and reassembling them. Repeat the marks or colours on more sheets. Change the size of the marks or the shapes. **(A)**

Right: Charcoal Direction 2. *Charcoal and acrylic on paper, by Jill Evans.*

A

- Draw a line across a sheet of paper. Make a rule: for example, shake a dice to decide how many times the line must cross over itself on its journey from left to right. Add tone, texture or colour into the separate areas divided by the line. You could let the dice direct your decisions on colours or tones and their placement. Consider balance and contrast. **(B, C, D)**

- Experiment with mixed media to discover possibilities for abstraction led by materials. See pages 178–181 for suggestions.

B

Tip
When trying both these exercises, turn the support and view it from every side. Does the image work better in one orientation or another? Try also to find an intention for your decisions.

C

D

COLOUR AND MUSIC

Colour is always seen in a context. Its appearance changes according to its relationship to neighbouring colours and the space it occupies. Its meaning also changes according to learnt cultural associations. This mutability can be the entire subject of some artists' work.

Artists may use colour for many different purposes:
• For immediate physical presence.
• To express meaning, whether emotional, personal or universally symbolic.
• Systematically – for example, limited to exact trichromatic primaries or particular complementary hues to control the effect of layering or optical sensation.
• Arbitrarily, simply to identify separate layers, such as in the computer-generated work of Manfred Mohr (pp.272–273).

Artists will also approach their use of colour in lots of different ways:
• Improvisatory – each decision is made in response to what has gone before, resulting from the individual's subconscious repertoire of mark making and/or external visual references.
• Controlled – perhaps with a grid structure and predetermined set of colours.

Many artists are somewhere on a spectrum between these extremes, combining aspects of both improvisation and control.

'In my paintings I try to bring out the differences in the colours through their interaction and, whilst allowing each colour to retain its own distinctive character, not let any one colour dominate and shatter the unity.'

GINA BURDASS

Opposite left: Two Greens (dark). *Acrylic on grained linen, by Gina Burdass.*

Opposite right: Two Greens (white). *Acrylic on grained linen, by Gina Burdass.*

Right: Wilbury. *Acrylic on canvas, by Mali Morris* RA.

Visual music and synaesthesia

Artists frequently relate their use of colour to music, whether free-form jazz, the mathematical structure of Bach, or more contemporary serial-music composers. Correspondences between the structures of music and colour harmony have been investigated since Plato. Visual music was defined as the translation of music to painting by Roger Fry when describing the work of Kandinsky, who believed that combinations of colours produce vibrational frequencies akin to musical chords. This is easily confused with synaesthesia; some artists are triggered by music to 'see' particular colours and attempt to capture their music–colour sensations in painting. Colour organs, video and computers are also used to generate colour responses to music.

Projects

Where to start?

- Select a colour or group of harmonising colours. Disrupt this selection with a contrasting colour to set up a reaction, or to obscure the previous layer. Look for a balance by using complementary colours of the same tonal value.

- Consider the key of the colour – full-strength pigments for a high key, or tinted or shaded colours for a low key. It is likely that the colours will resonate more if there is a change of key – for example, if a higher-key colour is introduced into a mainly lower-key image.

- Consider the placement and shape or space occupied by the different colours in relation to the format of the work. Do the shapes have a particular significance – for example, sharp pointed or soft curved – or are they simple, neutral carriers of colour? What tensions, or optical or spatial effects, occur if certain colours are placed at or near the edge or in the centre of the composition?

THE FIBONACCI SERIES AND THE GOLDEN SECTION

Geometry, perspective and numerical systems may be used to structure and develop abstract visual imagery. The Fibonacci series and its close relation, the Golden Section, have been used since Ancient Greek times to inform the creation of architecture and painting in ideal harmonious proportions. The growth patterns of many living organisms exhibit these proportions: for example, a pine cone grows in two opposing sets of spirals – 8 in one direction and 13 in the other, two adjacent numbers in the Fibonacci series. Abstract art based on this number sequence can therefore also be seen as rooted in observation.

The Fibonacci series

The following numerical sequence appeared for the first time in the West in 1202, in a book by the Italian mathematician, Fibonacci:
1, 2, 3, 5, 8, 13, 21, 34, 55, 89, 144...
(1, 1+1=2, 1+2=3, 2+3=5, 3+5=8, 5+8=13, 8+13=21...)

The Fibonacci series is algorithmic (see right), the rule being to add together the previous two numbers in the sequence to make the next one. Each adjacent pair of numbers is very close to the ratio 1:1.618, which describes the proportions of the Golden Section.

Perspective

Perspective can be used to create imaginary objects and spaces. Usually two-dimensional images represent three dimensions. Depending on our interpretation of the planes, the same form may appear to project or recede, sometimes simultaneously – famously in the 'impossible triangle' of Roger Penrose and the work of M. C. Escher. It is possible too, by complex layering, to represent multiple dimensions, normally only comprehensible through mathematics. See *Missing the Target*, by Richard Talbot (p.211).

Algorithms

Algorithms are sets of instructions to direct the carrying out of a sequence of actions. Complex algorithms incorporate numerous alternative choices to arrive at the desired outcome. Computers function in this way, and artists such as Manfred Mohr use computer programming to set up multiple sequences of visual outcomes that would otherwise be almost impossible to predict or calculate. A simple algorithmic procedure for artists could be based on actions determined by throwing a dice.

Above right: Square Root Phi Series Spiral 2.13. *Watercolour, pen and ink on cotton paper, by Mark Reynolds.*

Right: Fibonacci. *Oil on canvas, by Anthony Jones.*

What is the Golden Section?

If we divide a rectangle with a straight line into two unequal parts in a way that we find aesthetically pleasing, more often than not we will divide the rectangle into parts of one third and two-thirds. This relationship is very close to the ratio 1:1.618. The position of this division into two unequal parts is known as the Golden Section, and a rectangle drawn with these proportions is known as a 'golden rectangle'. The larger part is a square, while the smaller part is itself a golden rectangle, which can then be infinitely subdivided in the same proportions.

How to draw a golden rectangle

1 Draw a square *ABCD*. Then measure half *AB* = *Aa*. Now measure *aC*. **(1)**

2 With a pair of compasses, extend distance *aC* from *a* through *B* to find *E*. **(2)**

3 Complete the rectangle *AEFD*. **(3)**

4 This can be further subdivided into smaller golden rectangles. **(4)**

1

2

3

4

LANGUAGE, LETTERS AND MAPS

The written word has a visual appearance as well as being a carrier of linguistic meaning. This duality is a rich source of abstraction.

The flow, repetition, shape and pattern of handwritten script and printed letterforms and other symbols of communication — for example, from maps or music — may be used for their formal qualities. They may be readable or intentionally obscured so the painted or drawn surface becomes of equal or greater importance than the original, and the act of reading is transformed into looking.

For some artists the choice of words is significant; we are meant to 'read' an image both visually and linguistically, to be aware of the relationship between the meaning of words and what they look like. US artist Alexandra Grant (p.275) chooses idiomatic phrases to study the nature of language as a signifier of thought, and uses the device of mirror writing to highlight ideas of translation between language and art. She questions how we 'read' and 'write' images, and the place of handwriting in the era of electronic communication.

Text also enables artists to represent statistical or conceptual information visually. The content may vary, from the route of a city walk to a list of their top 100 favourite artists or the collapse of a large international bank. Information is collected and organised as a list, then plotted on an actual geographical map, or arranged as a 'mind map' or flow chart. Lines connect or separate ideas; colour is used to code and categorise.

Where to start?

- Find a headline word from a magazine. Crop a close-up selection from the word so that the letters are no longer easily legible. You will see that the negative spaces between the letters become just as interesting and important to the composition as the letters. **(A, B)**

- Cut the word into several thin slices. Rearrange the slices, offsetting them to the left or right, swapping their order or turning them round so the word becomes a pattern of illegible positive and negative shapes. **(C)**

- Make a painting from the magazine word. Try using colours that you associate with the meaning of the word. Distort or reverse the shapes. Repeat the shapes, changing their scale.

Tip
Scan the word and use Photoshop to try out various selections.

Opposite left: Notebook. *By Rachael Clewlow.*

Opposite right: Godot. *Oil on aluminium, by Brian Dupont.*

Left: OS Explorer No. 316 Newcastle-upon-Tyne. *Acrylic and pencil on paper, by Rachael Clewlow.*

Artist profile
MANFRED MOHR

For the last four decades, German artist Manfred Mohr has made abstract art based on computer-generated algorithmic geometry. A pioneer in his field, he has received many international awards, and has exhibited widely across Europe and America, including the Museum of Modern Art in New York. His work is held in collections including the Centre Pompidou in Paris, the Josef Albers Museum (Bottrop, Germany) and the Kunstmuseum in Stuttgart.

Mohr's art is not reliant on the world around him, nor on his own emotions or feelings. 'I think abstract art is the centre of absolute freedom because you're not referring to anything. It comes to life through nothing.'

Influenced by the writings of Max Bense, his is an abstraction made by applying logic. 'I always try to find some rules that are nothing to do with me emotionally.'

A keen jazz musician, Mohr has always treated visual compositional elements as if they were notes of music to be moved around and rearranged to make something new. The computer enables him to explore all possible configurations in a logical way and, like the Greek-French composer, Iannis Xenakis, to generate art based on mathematical probability systems. The resulting works can then be presented in a variety of ways – displayed on a screen or as printed drawings, paintings and sculptures.

Left: P1611_2. *Pigment ink on canvas.*

Above: Bild16-167-Edda. *Gouache on canvas.*

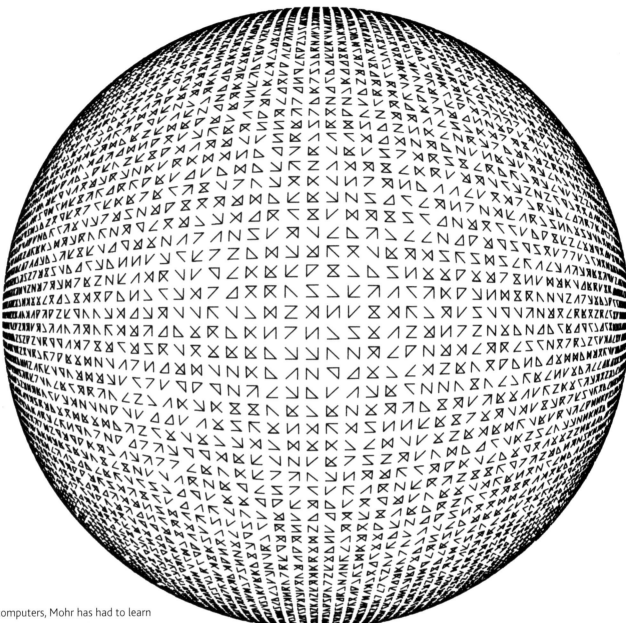

In order to work with computers, Mohr has had to learn how to express himself mathematically. 'If you want to work with a machine you have to be able to talk clearly about what you want to do – otherwise the machine doesn't understand a thing.' He has also had to relearn how to think about drawing. 'You have to define things. If you want to make a line, you have to define [an] end point and starting point – and what's in between.'

Mohr has explored the possibilities for his lines first in two, then three, then four dimensions. Now in his seventies, he is making work in the eleventh dimension. 'It's a visual result that I'm playing with; the complexity of the structure. You cannot understand visually what's going on but there is an incredible form invention through the "logic", which one can understand.'

He first started using colour when he reached the sixth dimension. By this time there were 720 different paths from A to B, and each diagonal line could be viewed in 15 ways. 'I wanted the craziest colours possible; random colours – not based on colour theory. The more different they are, the more they show the spatial relationship.'

Mohr wants his work to be seen as art rather than computer art. 'I want to invent something through my rules which takes a stance on its own and doesn't have to refer to its past. It has to be so visually good in itself that it can stand alone.'

Above: P218 Sphereless.
Plotter drawing, ink on paper.

Text by KATE WILSON.

GALLERY

Opposite: Heit. Acrylic and oil on canvas, by Tomma Abts.

Left: Century of the Self (2). Mixed media on paper and fabric, by Alexandra Grant.

Above: Minor Third Series: Transitions from Diagonal and Half-Diagonal 1.13. *Watercolour and coloured ink on cotton paper, by Mark Reynolds.*

GALLERY

Left: Drawing for Free Thinking
2012. *Pastel hand-massaged
on to the walls of the Manton
Hall, Tate Britain, London,
by David Tremlett.*

Above: Telebrás (Rio). *Household
gloss on canvas, by Sarah Morris.*

OS Explorer No. 316
Newcastle-upon-Tyne.
Acrylic and pencil on paper,
by Rachael Clewlow.

4

RESOURCES

GLOSSARY

ABSTRACT – art that does not aim to represent observed reality. To abstract from = to extract shapes or textures from observed reality.

ACETATE – a transparent sheet made of cellulose acetate film.

ACID-FREE PAPER – paper that has been treated to neutralise the acids naturally occurring in wood pulp. Paper that has not been treated quickly yellows and grows brittle.

ALLA PRIMA – a painting that is completed in one go with wet pigment.

BINDER – a sticky substance such as gum arabic, oil or acrylic resin mixed into ground-up pigment to 'bind' it together and glue it to a surface. Each type of paint owes its distinctive properties to its binder.

BLOOM – a white discolouration on the surface of varnish, often caused by applying the varnish before the paint is properly dry.

COLLAGE – an artwork made up of various materials pasted on to a single surface.

CONCEPTUAL – art that values the concept or the idea behind the artwork above traditional aesthetic and material concerns.

DILUENT – liquid used to dilute the medium that binds the paint.

EXTENDER – material added in with the pigment to bulk out the paint. Often used in cheaper-quality or 'student' colours.

FIGURATIVE – art that is representational.

FROTTAGE – a rubbing of a textured surface, taken using a pencil or other drawing material.

FUGITIVE – pigments or dyes that fade quickly in sunlight.

GEL – a colourless acrylic medium used to thicken or extend paint.

GLAZE – a thin layer of transparent or semi-opaque paint laid over another to modify the tone or colour.

GROUND – see **SUBSTRATE**

HATCHING or **CROSS-HATCHING** – to build up tone and texture with closely set parallel lines or overlapped parallel lines.

IMPASTO – thick paint.

INSTALLATION – an art exhibit constructed within a gallery made up of a number of parts that are made to be seen and understood in relation to one another.

LIGHTFASTNESS – ability of a pigment to resist fading when exposed to sunlight. Also described as 'permanence'.

MEDIUM – used to describe the different types of art material, e.g. pastel, oil paint. Also, any substance added to pigment to make or modify properties of paint.

MODERNISM – generally used to describe the succession of art movements since the Realism of Gustave Courbet in the late nineteenth century, culminating in abstract art and its developments in the 1960s.

OPACITY – the power of a pigment to cover up or obscure the layer below. Some pigments are more opaque than others, and some are valued because of their relative transparency.

PALETTE – describes both the surface on which colours are mixed, and the range of colours used.

PASTE – acrylic medium to which a bulking agent such as marble dust has been added. Used to thicken and alter the consistency of paint.

PIGMENT – the natural or synthetic material that gives colour to a paint.

PLEIN AIR – drawing or painting outdoors.

POLYMER – PVA (polyvinyl acetete) and acrylic are polymers. This term describes their chemical structure.

RESIST – a material that repels paint.

SCUMBLE – applying a thin, often broken layer of scrubby, undiluted paint across the top of another.

SGRAFFITO – a method of scratching back into paint to reveal the surface below.

STIPPLE – drawing using dots rather than lines.

SUBSTRATE – the surface that an artwork is painted or drawn on.

SYNTHETIC – made by chemical sythesis; man-made rather than occurring in nature.

THINNER – see **DILUENT**

TONE – the particular quality of lights and darks in an artwork. E.g., in a tonal scale from light to dark, there are many tones or variations in between. Applies to colour as well, where some colours are seen to be lighter or darker than others.

TONKING – invented by the painter Sir Henry Tonks; creating a texture by pressing a piece of paper down on to the surface of a painting to remove excess wet paint.

TOOTH – the degree of texture or roughness of a surface, allowing drawing or painting materials to grip.

UNDERPAINTING – a first layer of paint put down to establish the composition and often used to create colour contrasts.

VALUE – used to describe the tonal position of colours on a scale from light to dark.

FURTHER READING AND USEFUL WEBSITES

INFORMATION ON MATERIALS

• The Canadian Conservation Institute, 'Conservation Resources: Preventive Conservation and Agents of Deterioration'. *www.cci-icc.gc.ca/resources-ressources/agentsofdeterioration-agentsdedeterioration/index-eng.aspx*

• Tom Hale and Rachel Dani Witkin (White Cube, London), 'Sow's Ears and Silk Purses: Maintaining the Art Works of Anselm Kiefer', Courtauld Institute of Art, London, 2008. *www.courtauld.ac.uk/conservation-easel/contemporary-painting/documents/CIA_Silk_Purse_Sows_Ears_Final_Authors.pdf*

• Frank N. Jones, 'Aspects of Longevity of Oil and Acrylic Artist Paints', *Just Paint* issue 12, Golden Paints, 2004. *www.goldenpaints.com/justpaint/jp12article1.php*

• Ralph Mayer, *The Artist's Handbook of Materials and Techniques*, 5th edition. Dover Instruction, New York, 1991

• *painting.about.com*

• Monona Rossol, 'Data Sheet: Solvents', 2010. *www.usa829.org/Portals/0/Documents/Health-and-Safety/Safety-Library/Solvents.pdf*

• Daniel V. Thompson, *The Practice of Tempera Painting*. Dover Art Instruction, New York, 2000

• *www.wetcanvas.com*

• Christina Young, 'Interfacial Interactions of Modern Paint Layers', Courtauld Institute of Art, London, 2006. *www.courtauld.ac.uk/people/young-christina/PDF%205%20MPU.pdf*

INFORMATION ON THEORY AND PRACTICE

• *abstractcritical.com*

• Peio Aguirre, Negar Azimi, Marina Cashdan, *Vitamin P2: New Perspectives in Painting*. Phaidon Press, London, 2011

• Marina Cashdan, Carina Krause and Gavin Delahunty, *Vitamin D2: New Perspectives in Drawing*. Phaidon Press, London, 2013

• Alison Cole, *Perspective*. Dorling Kindersley, in association with the National Gallery, London, 1992

• Charles Darwent, Kate MacFarlane, Katharine Stout and Tania Kovats, *The Drawing Book: A Survey of the Primary Means of Expression*. Black Dog Publishing, London, 2007

• Steve Garner (ed.), *Writing on Drawing: Essays on Drawing Practice and Research*. University of Chicago Press, 2008

• Matila Ghyka, *The Geometry of Art and Life*. Dover Publications Inc., New York, 1977

• Frances Hatch, *Drawn to Antarctica: An Artist's View*. Viriditas Press, Poole, Dorset (UK), 2009

• Bruce MacEvoy, Handprint (colour theory). *www.handprint.com/HP/WCL/wcolor.html*

• Marie-Anne Mancio, Hotel Alphabet (writings on art). *www.hotelalphabet.com*

• Michael Petry, *Nature Morte: Contemporary Artists Reinvigorate the Still-life Tradition*. Thames & Hudson, London, 2013

• Janet L. Ford Shallbetter, Peter Piper's Palette Picker (interactive colour resource). *www.worqx.com/color/palette.htm*

• *turpsbanana.com*

MANUFACTURERS

Canson *www.canson-infinity.com*

Caran d'Ache *www.carandache.ch*

Conté *www.conteaparis.com*

Daler Rowney *www.daler-rowney.com*

Faber & Castell *www.faber-castell.co.uk*

Fabriano *fabriano.com*

Gamblin Artists Colors *www.gamblincolors.com*

Golden Artist Colors *www.goldenpaints.com*

Hahnemühle *www.hahnemuehle.com*

Khadi Papers *www.khadi.com*

Michael Harding *www.michaelharding.co.uk*

Sennelier *www.sennelier.fr*

Schminke *www.schminke.de*

Spectrum Artists' Paints *www.spectrumoil.com*

Winsor & Newton *www.winsornewton.com*

SUPPLIERS

UK

Cass Art *www.cassart.co.uk*

Great Art *www.greatart.co.uk*

Jackson's Art Supplies *www.jacksonart.com*

Japanese Paper Place *www.japanesepaperplace.com*

John Purcell Paper *www.johnpurcell.net*

Lawrence Art Supplies *www.lawrence.co.uk*

London Graphic Centre *www.londongraphics.co.uk*

R K Burt paper suppliers *www.rkburt.com*

USA

Daniel Smith Artists' Materials *www.danielsmith.com*

Dick Blick Art Materials *www.dickblick.com*

Jerry's Artarama *www.jerrysartarama.com*

Kremer Pigments *kremerpigments.com*

Mister Art *misterart.com*

Pearl Fine Art Supplies *www.pearlpaint.com*

Rex Art Supplies *www.rexart.com*

Utrecht Art Supplies *www.utrechtart.com*

INDEX

INDEX

CONTRIBUTORS

© **Susan Absolon**
www.susanabsolon.co.uk

© **Tomma Abts**
www.greengrassi.com
Courtesy of greengrassi, London.
Photo credits: Marcus Leith.
Untitled #13 – private collection, London.
Ihme – private collection, Paris.
Heit – collection of the Arts Council England.

© **Angela A'Court**
www.angelaacourt.com
Photo of hand holding pastel –
photo credit: Ty Cole

© **Laylah Ali**
www.pbs.org/art21

© **Philip Archer**
www.leithschoolofart.co.uk

© **Annie Attridge**
www.annieattridge.com
Courtesy of the Asya Geisberg Gallery, New York.
Photo credit: Etienne Frossard.

© **Rosemary Beaton**
www.rosemarybeaton.co.uk

© **Martin Beek**
www.flickr.com/people/oxfordshire_church_
photos

© **Helen Berggruen**
www.georgekrevskygallery.com
Courtesy of the George Krevsky Gallery,
San Francisco.

© **Oliver Bevan**
www.oliverbevan.com

© **Huma Bhabha**
grimmgallery.com
Courtesy of the Grimm Gallery, Amsterdam.

© **Andrew Bick**
www.halesgallery.com
OGVDS [Autumn] – courtesy of Hales Gallery,
London/private collection, Switzerland.
OGVDS [Spring] – courtesy of Galerie von Bartha/
private collection, Switzerland.

© **Biggs & Collings**
emmabiggsandmatthewcollings.net
Courtesy of the Vigo Gallery, London.

© **Eolo Paul Bottaro**
eolopaulbottaro.com
Collection of the City of Darebin.

© **James Bridle**
http://booktwo.org

© **Karin Broker**
www.karinbroker.com
Photo credit: Paul Hester.

© **Jemima Brown**
www.jemimabrown.com

© **Gina Burdass**
www.broadbentgallery.com
Photo credit: Peter Abrahams.

© **Simon Burder**
www.oaksfineart.co.uk
www.facebook.com/
OaksEditionsLithographyStudio

© **Mark Cazalet**
www.markcazalet.co.uk

© **Zheng Chongbin**
zhengchongbin.com

© **Rachael Clewlow**
www.jaggedart.com
Courtesy of jaggedart, London.

© **Christopher Cook**
www.cookgraphites.com
Courtesy of the Ryan Lee Gallery, New York.

© **Melodie Cook**
melodiecook.co.uk

© **Eileen Cooper** RA
www.eileencooper.co.uk

© **Richie Cumming 'Skint Richie'**
richardriach.blogspot.co.uk
Rough Cut Nation – courtesy of the artists:
Kirsty Whiten, Fraser Gray, Martin McGuinness,
Elph, Mike Inglis, DUFI, Sarah Kwan, Rachel Levine,
Aaron Sinclair, Pete Martin and the National
Galleries of Scotland.

Bull Riach – photo credit: Gordon Shaw.
Freedom Versions v1 (work in progress) –
courtesy of the artists: Rabiya Choudhry, Fraser
Gray, Martin McGuinness, Kirsty Whiten, Pete
Martin, DUFI, RUE FIVE, Mike Inglis and
Creative Stirling.

© **Tacita Dean** OBE
www.mariangoodman.com
Courtesy of Marian Goodman Gallery, New York.
Photo credit: Cathy Carver.

© **Jonathan Delafield Cook**
www.jonathandelafieldcook.co.uk

© **Jeremy Dickinson**
www.jeremydickinson.com

© **Rackstraw Downes**
www.bettycuninghamgallery.com
Courtesy of Betty Cuningham Gallery, New York.

© **Brian Dupont**
briandupont.com

© **Paul Emmanuel**
www.paulemmanuel.net
After-Image – courtesy of the Hollard Art
Collection and Art Source South Africa.

© **Katherine Englefield**

© **Jill Evans**
www.jillevans.co.uk

© **Peter Fend**
inquest.us/peter-fend
Global Feed Viewing Station – courtesy of
Ocean Earth Development Corporation.
Photo credit: John Melville.

© **Ellen Gallagher**
www.hauserwirth.com
Courtesy Hauser & Wirth.
Photo credits: *Coral Cities* – Mike Bruce;
Watery Ecstatic – Barbora Gerny.

© **Joy Girvin**
www.joygirvin.co.uk
Reacting Heart Proteins – in collaboration with,
and courtesy of, Dr Renne Germack (scientist).

© **Helena Goldwater**
www.helenagoldwater.co.uk

© Paul Gopal-Chowdhury
www.paulgopalchowdhury.com
www.artspacegallery.co.uk© Thomas Gosebruch
www.thomasgosebruch.com

© Alexandra Grant
www.alexandragrant.com

© Gwen Hardie
www.gwenhardie.com

© Alexandra Harley
www.alexandraharley.co.uk

© Alison Harper
www.theessentialschoolofpainting.com
www.alisonharperartist.com

© Frances Hatch
www.franceshatch.co.uk

© Chris Hough
chrishoughartworks.carbonmade.com

© Tony Hull
www.tonyhull.com

© Gary Hume
whitecube.com
Courtesy of White Cube, London.
Photo credit: Todd-White Art Photography.

© Albert Irvin RA
www.albert-irvin.com
Courtesy of Gimpel Fils.

© Bill Jacklin RA
www.bjacklin.com
Courtesy of Marlborough Fine Art.

© Steve Johnson
stevejohnsonart.eu
Courtesy of Davis Klemm Gallery.

© Anthony Jones
www.ayejayart.co.uk

© Jane Joseph
www.janejoseph.co.uk

© Toba Khedoori
www.davidzwirner.com
Courtesy David Zwirner,
New York/London, and
Regen Projects, Los Angeles.

© Anselm Kiefer
whitecube.com
Courtesy of White Cube, London.

© Carla Klein
www.annetgelink.com
Courtesy of Annet Gelink Gallery, Amsterdam.

© Norimitsu Kokubo
www.outsidein.org.uk
Photo credit: Satoshi Takaishi.

© Henry Kondracki
www.bbc.co.uk/arts/yourpaintings/artists/
henry-kondracki

© Tania Kovats
tania-kovats-oceans.com

© Ute Kreyman
www.utekreyman.com
Photo credit: Matthew Ward.

© Simon Laurie RSW RGI
www.simonlaurieart.com

© Christopher Le Brun PRA
christopherlebrun.co.uk
Design and Artists Copyright
Society 2014.

© Alasdair Lindsey
acornishstudio.blogspot.co.uk

© Archie McIntosh RSW RGI
www.scottishartpaintings.co.uk

© Paul Martin
www.paulmartinstudio.com

© Lisa Milroy RA
www.lisamilroy.net

© Manfred Mohr
www.emohr.com

© Sally Mole
www.sallymole.com

© Kate Morgan
www.katemorganstudio.com

© Mali Morris RA
www.malimorris.co.uk
Rain in Durango and *Wilbury* –
photo credit: Colin Mills.

© Sarah Morris
whitecube.com
Courtesy of White Cube, London.

© Muntean/Rosenblum
www.georgkargl.com
Courtesy Georg Kargl Fine Arts, Vienna.
Nemesims – photo credit: Lisa Rastl.
Untitled (We are afraid...) –
photo credit: Matthias Bildstein.

© Ciarán Murphy
grimmgallery.com
Courtesy of the Grimm Gallery, Amsterdam.

© Wangechi Mutu
wangechimutu.com
Courtesy of Susanne Vielmetter,
Los Angeles Projects.

© Paul Noble
www.gagosian.com
Courtesy of the Gagosian Gallery
(12 galleries worldwide).

© Liam O'Connor
www.liamoconnor.co.uk

© Robyn O'Neil
robynoneil.com

© Scott O'Rourke
scottorourke.co.uk

© Ant Parker
antparkerartist.com

© Stephen Peirce
www.stephenpeirce.co.uk

© Robert Perry
www.robertperry-artist.co.uk

© Sarah Pickstone
www.sarahpickstone.co.uk
Stevie and the Willow – courtesy of the
National Museums Liverpool, Walker Art
Gallery. Photo of Sarah Pickstone by
Dorothee Gillessen 2013.

© Michael Porter
www.michael-porter.co.uk

CONTRIBUTORS

© **Hayal Pozanti**
hppaintings.tumblr.com
Courtesy of the Jessica Silverman Gallery,
San Francisco.

© **Kathy Prendergast**
www.kerlingallery.com
Courtesy of the Kerlin Gallery, Dublin.

© **Narbi Price**
www.narbiprice.co.uk

© **Barbara Rae** CBE RA RE
www.barbararae.com
Photo credit: Bill Brady.

© **Alan Ramdhan**
www.outsidein.org.uk

© **Paula Rego** DBE
www.marlboroughfineart.com
Joseph's Dream – private collection.
Love – private collection.

© **Mark Reynolds**
markareynolds.com
www.pierogi2000.com
Courtesy of the Pierogi Gallery, New York.

© **Robin Rhode**
www.lehmannmaupin.com
Courtesy Lehmann Maupin, New York and
Hong Kong. Photo credit: Elisabeth Bernstein.

© **Rachel Ross**
www.rachelross.co.uk

© **Jenny Saville**
www.gagosian.com
Courtesy of the Gagosian Gallery
(12 galleries worldwide).

© **Andro Semeiko**
www.androsemeiko.com

© **Raqib Shaw**
whitecube.com/artists/raqib_shaw
Courtesy of White Cube, London.
*Ode to the Lost Moon When Innocence
Was Young* – photo credit: Ellen Broughton.
Photo of Raqib Shaw by Graeme Duddridge.

© **David Shrigley**
www.davidshrigley.com
Courtesy of Canongate Publications, London.

© **Shahzia Sikander**
www.shahziasikander.com
Courtesy of Pilar Corrias, London.
Photo credit: Andy Keate.

© **Joe Simpson**
www.joe-simpson.co.uk

© **Torsten Slama**
kimmerich.com
Courtesy of Kimmerich Gallery, New York.

© **Peter S. Smith**
peterssmith.weebly.com

© **Jen Stark**
www.jenstark.com

© **Emma Stibbon** RA
www.royalacademy.org.uk

© **Richard Talbot**
www.richardtalbot.org

© **Marion Thomson**
www.marionthomson.co.uk

© **Steve Thorpe**
www.stevethorpe.org

© **Abbi Torrance**
abbitorrance3.wordpress.com

© **David Tremlett**
www.davidtremlett.com

© **David Tress**
www.davidtress.co.uk
Courtesy of Messum's Gallery, London.

© **Heather Upton**
www.heatherupton.co.uk

© **Thomas Verny**
www.galerietrintignan.com
Courtesy of Galerie Hélène Trintignan, Montpellier.

© **Diane Victor**
www.art.co.za/dianevictor

© **Jan De Vliegher**
www.jandevliegher.be
Photo credit: Dominique Provost.
Courtesy of Mike Weiss Gallery.

© **Robin Warnes**
robin-warnes.blogspot.co.uk

© **James White**
jameswhitestudio.com
Courtesy of the Gerhardsen Gerner Gallery, Berlin.

© **Peter White**
www.peter-white.net

© **Kehinde Wiley**
kehindewiley.com
Princess Victoire of Saxe-Coburg-Gotha –
courtesy of Sean Kelly, New York.

© **Antony Williams**
www.antony-williams.com
Courtesy of Messum's Gallery, London.

© **Charles Williams**
www.stuckism.com/williams

© **Ben Wilson aka Chewing Gum Man**
foroneweekonly.com/Artists/Ben-Wilson

© **Kate Wilson**
www.oaksfineart.co.uk
www.facebook.com/katewilsonartist

© **Eleanor White**
www.bridgehouseart.co.uk

© **Cindy Wright**
www.cindywright.org

© **Lisa Wright**
lisawrightartist.co.uk

© **Sally Wyatt**

© **Daniel Zeller**
www.pierogi2000.com
Courtesy of the Pierogi Gallery, New York.